THE ILLUSTRATORS

The British Art of Illustration

1786 – 2003

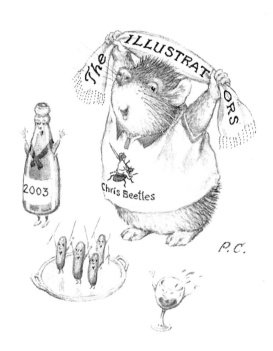

THE ILLUSTRATORS

The British Art of Illustration
1786 – 2003

CHRIS BEETLES LTD

8 & 10 Ryder Street St James's London SW1Y 6QB

Telephone – 020 7839 7551 Facsimile – 020 7839 1603

email – gallery@chrisbeetles.com website – www.chrisbeetles.com

Copyright Chris Beetles Ltd © 2003

8 & 10 Ryder Street
St James's
London SW1Y 6QB

Telephone: 020 7839 7551
Facsimile: 020 7839 1603
email: gallery@chrisbeetles.com
website: www.chrisbeetles.com

ISBN 1 871136 84 9

Cataloguing in Publication Data is
available from the British Library

Exhibition organised by Chris Beetles and Edwina Freeman

Catalogue edited by Fiona Pearce and David Wootton

Written by David Wootton, and signed contributors (please see
key on page 6)

Proof reading by Phil Tite

Design by Jeremy Brook and Fiona Pearce

Photography by Red Apple

Colour separation and printing by Waterside Press Ltd

WOnders of the Deep
CRUSTACEANS
(Hard Cases)

P.C.

Vick-Nack 606

"Birds of Paradise"

The
Hughie Bird

P.C. 605

CONTENTS

INTRODUCTION

It can be stated on good authority that established clients of Chris Beetles Ltd – and other regular readers – consider *The Illustrators* as something of an institution, as essential to the pleasures of autumn as chestnuts roasting on an open fire or the first carols of Advent. In landing on the doormat, it reawakens the child in many a recipient, being treated as a cross between a Hamley's catalogue and a favourite annual. Well, after three lean years, in which selected highlights have tended to tantalise, comes a fat year, in which the complete contents of our exhibition are again communicated in bumper format.

The Illustrators has always been intended to demonstrate the strength of a highly distinctive artistic tradition, and one in which British exponents have excelled. It has presented the widest and finest range of work available to collectors; and has increasingly supported these visual pleasures with well-researched texts, comprising details of publication, thematic essays and artists' biographies, and so providing vital literature on the subject. This year, a *team* of researchers has contributed enthusiasm, erudition and sheer effort, resulting in more complete cataloguing and a greater diversity of contextual notes.

The illustrators included here are, as ever, many and varied, extending across four centuries from Thomas Rowlandson to Paul Cox, with, between them, representatives of many major developments of the art. There are particularly strong sections of the Victorian cartoonists who contributed to *Punch* and its rivals; the masters of the Edwardian Gift Book; the women illustrators of the early twentieth century; and the creators of familiar characters of popular culture. Special features celebrate the achievements of Phil May (on the centenary of his death), William Heath Robinson (in parallel with a significant exhibition at Dulwich Picture Gallery) and Larry (*in memoriam*).

The expected favourites are joined by almost thirty artists, some of great significance, appearing in this series for the first time. These include Richard Corbould, an archetypal book illustrator of the late eighteenth century; such prodigious and prolific Victorians as Arthur Hughes, John Leighton and Joseph Noel Paton; Arthur Szyk and John Minton, who each responded very personally to living in the twentieth century; Victoria Davidson, among several notable cartoonists, who provided the look of *Lilliput*; and leading contemporary children's illustrators, Helen Oxenbury and Shirley Hughes. To add these names to the cumulative index of *The Illustrators* is to move a little nearer to the ideal comprehensiveness of Chris Beetles Ltd, and to further emphasise the many riches of the art.

David Wootton
2003

KEY

A catalogue number in green indicates that a work is illustrated and one in grey indicates that it is not.

Contributors to the text of the catalogue are indicated at the end of each biography, essay or note by their initials, and may be identified as follows:

[CB]	Carol Beetles	[HJM]	Helena Murray
[CRB]	Chris Beetles	[P&S H]	Peter and Susan Hampson
[EAF]	Edwina Freeman	[RC]	Rebecca Chapman

ILLUSTRATORS AROUND 1800

THOMAS ROWLANDSON

Thomas Rowlandson (1756-1827)

For a biography of Thomas Rowlandson, please refer to *The Illustrators*, 1996, Page 10.

Key works illustrated: W H Pyne and William Combe, *The Microcosm of London* (with Augustus Pugin) (1808-10); William Combe, *The Tour of Dr Syntax, in Search of the Picturesque* (1812); Oliver Goldsmith, *The Vicar of Wakefield* (1817)

His work is represented in numerous public collections, including the British Museum, the Tate Gallery, the Victoria and Albert Museum, the Ashmolean Museum, the Fitzwilliam Museum and Birmingham Museum and Art Gallery.

Further reading: Joseph Grego, *Rowlandson the Caricaturist*, London: Chatto and Windus, 1880; John Hayes, *Rowlandson: Watercolours and Drawings*, London: Phaidon, 1972; Ronald Paulson, *Rowlandson: A New Interpretation*, London: Studio Vista, 1972

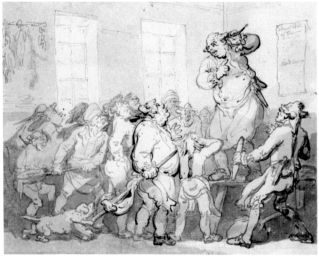

2

2

FIERCE AS STARING AJAX, FROM HIS SEAT
UPROSE WITH VISAGE STERN, THE KING OF MEAT
pen ink and monochrome watercolour; 6 ¼ x 8 inches
Provenance: B Houthakker
Illustrated (as an engraving): Peter Pindar, *The Lousiad*, London: G Kearsley, 1786-87, frontispiece
Literature: J Grego, op cit, vol i, page 204 (as *Cooks, Scullions – Hear me, every Mother's son*)
Exhibited: 'De Verzameling van Bernard Houthakker', Amsterdam Rijksmuseum, August-November 1964, no 87 (as *Hanging on Every Word: Figures in an Inn*)

FIERCE AS STARING AJAX, FROM HIS SEAT
'Peter Pindar' was the pseudonym of Thomas Rowlandson's friend John Walcot (1738-1819), a doctor and clergyman from Truro who became known for his satirical verse, particularly that which ridiculed George III. Indeed, he made his reputation with *The Lousiad* (1785), a mock-heroic poem based on a widely reported incident involving the king. It was alleged that George determined to rid his palace of vermin on discovering a louse on his dinner plate. So he ordered all his household servants to shave their heads. All but one of fifty-two servants accepted, he who refused being dismissed. The present image depicts the moment when 'the great cook-major' is still refusing to let his staff be shaved.

1

DOCTOR DOUBLEPULSE
signed and dated 18
watercolour with pen and ink
10 ½ x 7 ¾ inches

This work is similar to *Medical Despatch or Doctor Doubledose Killing Two Birds with One Stone*, published by Thomas Tegg on 20 November 1810. For a description of this work, please refer to Joseph Grego, op cit, vol ii, page 194.

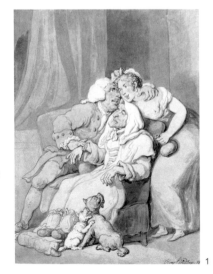

1

ISAAC CRUIKSHANK
Isaac Cruikshank (1764-1811)

For a biography of Isaac Cruikshank, please refer to *The Illustrators*, 1996, page 10.

His work is represented in the collections of the British Museum, the Cartoon Art Trust, the Victoria and Albert Museum, and the Fitzwilliam Museum.
Further reading: E B Krumbhaar, *Isaac Cruikshank. A Catalogue Raisonné. With a sketch of his Life and Work*, Philadelphia: University of Pennsylvania Press, 1966

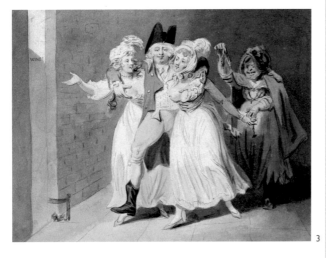

3

3

SAILOR FONDLING
watercolour
6 ¾ x 9 inches
This characteristically lively drawing does not appear in E B Krumbhaar's Catalogue Raisonné (1966).

RICHARD CORBOULD
Richard Corbould (1757-1831)

Richard Corbould was born in the Parish of St Edmund Lombard Street, in London on 18 April 1757. He studied under the landscape draughtsman, Robert Marris, the son-in-law of Arthur Devis, and lodged with him in the early 1770s. A versatile artist who tried his hand at many media and subjects, he first developed a specialism as a painter of English and Welsh landscapes in oil and watercolour. He exhibited from 1776, when he showed three works at the Free Society, and from the following year began to exhibit regularly at the Royal Academy (1777-1811), later showing also at the British Institution (1806-17).

From the early 1780s, Corbould was employed mainly as a book illustrator. He contributed to numerous periodicals – including *The Tatler*, *The Spectator* and the *Guardian* – and principally to Cooke's 'pocket editions' (1793-1802), of which the illustrations to Fielding's *Amelia* are representative. The delicate and detailed results, presented within decorative frames, are fine and characteristic examples of illustration in the Age of Sensibility.
For some years, Corbould lived off Tottenham Court Road. He died in Highgate on 26 July 1831, and was buried in the Churchyard of St Andrew's, Holborn. His two sons, George and Henry, had become artists under his tutelage, while Henry's son, Edward Henry Corbould, would become an illustrator [see page 13].

His work is represented in the collections of the British Museum, the Victoria and Albert Museum, and Birmingham Museum and Art Gallery.
Further reading: *Richard Corbould, 1757-1831, illustrator: a glimpse of the common life of Georgian Society*, London: Spink & Son, 1984

AMELIA

Henry Fielding's last novel, *Amelia*, was published in 1751. The best selling of his books in his lifetime, it was also his own favourite, being based in spirit on his loving marriage:
Captain William Booth has married the beautiful and virtuous Amelia against his mother's wishes, but with the assistance of the good parson Dr Harrison. The couple run away and, in so doing, become victims of unscrupulous London society. Careless rather than guilty, Booth is thrown into Newgate prison, and there shares a cell with Miss Matthews, a courtesan of his acquaintance. He is released on bail by the seemingly friendly Colonel James, who takes Miss Matthews as his mistress. However, while

hoping to receive a commission from the rich and powerful, he enters a life of gambling, and is supported only by the faithfulness of Amelia. In turn, she is threatened by the machinations of Colonel James and a character known only as 'My Lord', but saved by the warning of Mrs Bennet, who 'My Lord' has already ravished. Eventually, Booth is saved by Dr Harrison, who pays his debts, while Amelia discovers that she and not her sister is rightly heiress to her mother's fortune. They retire to the country to a happy life of farming.

5

THE AFFECTING INTERVIEW BETWEEN AMELIA, AND HER TWO CHILDREN
inscribed 'Amelia' and 'v2 138 c3 p177'
pen ink and watercolour
4 x 2 ¾ inches
Illustrated: Henry Fielding, Amelia, London: C Cooke, 1793, vol ii, facing page 152; Henry Fielding, *Amelia*, New York: Croscup & Sterling Company, 1902, vol ii (The Drury Lane Edition of *The Complete Works of Henry Fielding Esq in Sixteen Volumes*, vol vii), facing page 72

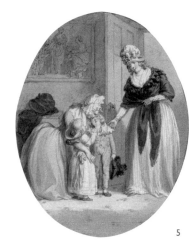

5

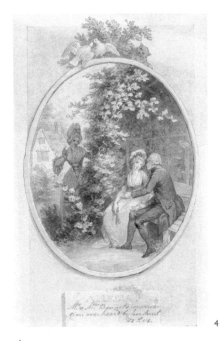

4

4

MR BENNET INTERRUPTED IN HIS COURTSHIP BY THE AUNT OF HIS FAVOURITE
inscribed 'Mr and Mrs Bennet's conversation overheard by her aunt' and 'v2 p115'
pen ink and watercolour
4 ½ x 2 ½ inches

Illustrated (in reverse): Henry Fielding, *Amelia*, 1797; Henry Fielding, *Amelia*, New York: Croscup & Sterling Company, 1902, vol ii (The Drury Lane Edition of *The Complete Works of Henry Fielding Esq in Sixteen Volumes*, vol vii), frontispiece

6

BOOTH CONSOLING MISS MATTHEWS IN HER IMPRISONMENT
inscribed 'Mr Booth endeavouring to soothe Miss Mathews' and 'p29 v1'
pen ink and watercolour
4 ¼ x 2 ½ inches
Illustrated: Henry Fielding, *Amelia*, 1797; Henry Fielding, *Amelia*, New York: Croscup & Sterling Company, 1902, vol i (The Drury Lane Edition of *The Complete Works of Henry Fielding Esq in Sixteen Volumes*, vol vi), facing page 36

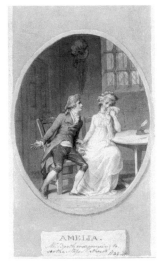

6

VICTORIAN BOOK ILLUSTRATORS

ALFRED CROWQUILL
Alfred Henry Forrester (or Forrestier), known as 'Alfred Crowquill' (1804-1892)

Alfred Henry Forrester was born in London, the son of a rich City lawyer. His elder brother, Charles, was a writer who would also make use of the pseudonym 'Alfred Crowquill'. Some of his first caricatures were engraved by George Cruikshank, including the etching *Beauties of Brighton* of 1826, which featured the two Forrester brothers dressed as bucks. In the following year, the brothers worked together on *Absurdities in Prose and Verse*, with Alfred providing the illustrations. During the ensuing decade or so, he worked for the editor John Timbs, contributing images to *The Hive* and *The Mirror*.

One of the first artists to contribute to *Punch* (1841-44), Forrester was 'highly popular with the Staff, for he was philosophically happy and jovial, and sang good songs, and was moreover, greatly sought after at a time when comic artists were few' (Spielmann, 1895, pages 449-500). However, he left after three years in order to develop as a book illustrator. His achievements in this field include *The Pictorial Grammar* (circa 1843, again with a text by his brother) and the *Comic History of the Kings and Queens of England* (circa 1850), both of which demonstrate a vein of charming fantasy. He also exhibited at the Royal Academy (1845-46), designed some sheet music covers and sculpted figures for production as Parian Ware. However, he remained best known for his work as a periodical journalist and illustrator, who regularly contributed words and images to *The Monthly Magazine* and *Bentley's Magazine*, and images to the *Illustrated London News* (1844-70) and *The Illustrated London Times* (1859).

His work is represented in the collections of the British Museum, the Victoria and Albert Museum, and the Houghton Library (Harvard College Library).

9

7

8

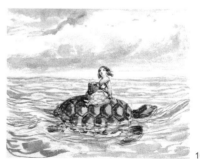

10

7
GENTLEMEN: A SERIES OF
PORTRAIT HEADS
watercolour and pencil
6 ¼ x 9 ½ inches
Taken from a sketchbook inscribed
'No 9'

8
NAVAL VETERANS
pen ink and watercolour with pencil
6 ¼ x 9 ½ inches
Taken from a sketchbook inscribed
'No 9'

9
SPORTING INCIDENT
pen ink and watercolour
8 x 6 ¼ inches

10
GONE TO SEA ON A TURTLE
monochrome watercolour and pencil
4 ½ x 5 ½ inches

11

11

CUPID & PSYCHE

inscribed with title below mount

pen and ink

3 ½ x 4 ½ inches

Numbers 11-15 are all taken from a sketchbook entitled 'Illustrations of Whimsicalities', and probably drawn for but not illustrated in Alfred Crowquill, *Absurdities: in Prose and Verse*, London: Thomas Hunt and Co; and W Morgan, 1827

12

REPRIMANDING THE DRUMMER

pen and ink

2 ¾ x 4 inches

13

THE GRAVE DIGGER

inscribed with title below mount

pen and ink

3 ¾ x 4 ¼ inches

14

CUL-DE-LAMPE: CUPID SNUFFS OUT THE CANDLE

pen and ink

2 ¼ x 3 inches

15

THE DEVIL & BARON BRAMBERG

inscribed with title below mount

pen and ink

4 x 4 inches

16

THE TEN OF HEARTS

pen and ink with bodycolour

3 ¾ x 2 ¾ inches

RANDOLPH CALDECOTT
Randolph Caldecott, RI (1846-1886)

For a biography of Randolph Caldecott, please refer to *The Illustrators*, 1996, page 157.

Key works illustrated: Washington Irving, *Old Christmas* (1875); *The House that Jack Built*, and William Cowper, *The Diverting History of John Gilpin* (1878) (the first two of his sixteen picture books printed by Edmund Evans) His work is represented in numerous public collections, including the British Museum, the Victoria and Albert Museum, the Whitworth Art Gallery (Manchester) and Worcester City Museum and Art Gallery. Further reading: Rodney Engen, *Randolph Caldecott. 'Lord of the Nursery'*, London: Oresko Books, 1976

17

17

A COURTING COUPLE

signed with initials

watercolour

6 x 4 ½ inches

PHIZ

Hablot Knight Browne, known as 'Phiz' (1815-1882)

For a biography of Phiz, please refer to *The Illustrators*, 1993, Page 19.

Key works illustrated: the novels of Charles Dickens, including *The Pickwick Papers* (1836-37); *Master Humphrey's Clock (The Old Curiosity Shop and Barnaby Rudge)* (with George Cattermole) (1841); *Martin Chuzzlewit* (1844); *David Copperfield* (1850); Augustus Mayhew, *Paved with Gold* (1858) His work is represented in the collections of the British Museum, the Victoria and Albert Museum, and Manchester City Art Gallery. Further reading: John Buchanan-Brown, *Phiz!: the Book Illustrations of Hablot Knight Browne*, Newton Abbot: David & Charles, 1978

19

18

20

18

JOURNEY THROUGH THE FOREST
watercolour with bodycolour
10 ¼ x 14 ½ inches

19

STOPPING FOR A CONVERSATION
signed
watercolour and pencil
7 x 10 ¼ inches

20

BEGGARS OUTSIDE THE IMPERIAL HOTEL
signed
pencil and pastel
14 ½ x 22 inches

21

PRESENTING A POSY
watercolour
7 ¾ x 12 inches

EDWARD HENRY CORBOULD
Edward Henry Corbould, RI (1815-1905)

Edward Henry Corbould was born at 6 Great Coram Street, in London on 5 December 1815, and educated at the Palace School, Enfield, under Dr May. He first studied under his father, the illustrator Henry Corbould, and later at Henry Sass's School and the Royal Academy Schools. His earliest designs were awarded gold Isis medals from the Society of Arts, in 1834 and 1835, and shown at the Royal Academy in the latter year. He continued to exhibit at the RA until 1874, at the Royal Society of British Artists (1835-42), and especially at the Royal Institute of Painters in Water-Colours (being elected to its membership in 1837). Highly successful as a watercolourist of literary and Biblical subjects, many of his best works were bought by Queen Victoria and Prince Albert, from 1842, with the result that he was appointed Instructor of Drawing and Painting to the Royal Family (1851-72).

In the late 1830s, Corbould also established himself as an illustrator with an edition of Thomas Moore's *Lalla Rookh* (1839). This was followed by contributions to the Art Union's editions of Milton's *L'Allegro and Il Pensoroso* (1848) and Goldsmith's *The Traveller* (1851), and to many further volumes of poetry. He also contributed to a number of periodicals, including the *Illustrated London News* (1856, 1866), *London Society* (1863), *The Churchman's Family Magazine* (1863), and *Cassell's Magazine* (1870). Most of his illustrations were produced in monochrome wash with fine ink detail. Corbould died in Kensington, London, on 9 January 1905.
His work is represented in the collections of the British Museum, Sir John Soane's Museum, the Victoria and Albert Museum, the Ashmolean Museum, Bristol Art Gallery, the Lilly Library (Indiana University), and the National Gallery of New South Wales.

Numbers 22-24 were probably published as Christmas cards by De La Rue & Co, series no 331. De La Rue published Christmas cards between 1873-1885.

22

23

24

22
HOCUS POCUS
inscribed 'A Merry Christmas'
watercolour with bodycolour
4 ¼ x 2 ¾ inches

23
THE CHILDREN'S MAGICIAN
inscribed 'A Merry Christmas and a Happy New Year'
on reverse
watercolour with bodycolour
4 ¼ x 2 ¾ inches

24
THE VICTORIAN CONJUROR
inscribed 'Hurrah! for old Christmas'
watercolour with bodycolour
4 ¼ x 2 ¾ inches

EDWARD LEAR

Edward Lear (1812-1888)

For a biography of Edward Lear, please refer to *The Illustrators*, 1996, page 63.

Key works illustrated: *Illustrations of the Family of Psittacidae or Parrots* (1830-32); John E Gray (compiler), *Gleanings of the Menagerie and Aviary at Knowsley Hall* (lithographed by J W Moore and coloured by Bayfield) (1846-48)
Key work written and illustrated: *A Book of Nonsense* (1846)
His work is represented in the collections of the British Museum, the Victoria and Albert Museum, and the Ashmolean Museum.
Further reading: Vivien Noakes, The Painter Edward Lear, Newton Abbot: David & Charles, 1991

'Surely the most beneficent and innocent of all books yet produced is the Book of Nonsense*'*

John Ruskin

There was an Old Person of Tartary, who divided his jugular artery;
But he screeched to his wife, and she said, "Oh, my life!
Your death will be felt by all Tartary!"

25

There was an Old Man of Jamaica, who suddenly married a Quaker
But she cried out—" O lack! I have married a black!"
Which distressed that Old Man of Jamaica.

26

25

THERE WAS AN OLD PERSON OF TARTARY,
WHO DIVIDED HIS JUGULAR ARTERY;
BUT HE SCREECHED TO HIS WIFE,
AND SHE SAID, 'OH MY LIFE!
YOUR DEATH WILL BE FELT BY ALL TARTARY!'
inscribed with title
pen and ink on silk
5 ½ x 9 inches

26

THERE WAS AN OLD MAN OF JAMAICA,
WHO SUDDENLY MARRIED A QUAKER
BUT SHE CRIED OUT — 'O LACK!
I HAVE MARRIED A BLACK!'
WHICH DISTRESSED THAT OLD MAN OF JAMAICA.
inscribed with title
pen and ink on silk
5 ½ x 9 inches

There was a Young Lady of Sweden, who went by the slow train to Weedon;
When they cried, "Weedon Station!" she made no observation,
But thought she should go back to Sweden. 27

There was a Young Lady of Hull, who was chased by a virulent Bull;
But she seized on a spade, and called out—"Who's afraid!"
Which distracted that virulent Bull. 28

27

THERE WAS A YOUNG LADY OF SWEDEN,
WHO WENT BY THE SLOW TRAIN TO WEEDON;
WHEN THEY CRIED, 'WEEDON STATION!'
SHE MADE NO OBSERVATION,
BUT THOUGHT SHE SHOULD GO BACK TO SWEDEN.
inscribed with title
pen and ink on silk
5 ½ x 9 inches

28

THERE WAS A YOUNG LADY OF HULL,
WHO WAS CHASED BY A VIRULENT BULL;
BUT SHE SEIZED ON A SPADE.
AND CALLED OUT — 'WHO'S AFRAID!'
WHICH DISTRACTED THAT VIRULENT BULL
inscribed with title
pen and ink on silk
5 ½ x 9 inches

29

THERE WAS AN OLD PERSON WHOSE HABITS,
INDUCED HIM TO FEED UPON RABBITS;
WHEN HE'D EATEN EIGHTEEN,
HE TURNED PERFECTLY GREEN,
UPON WHICH HE RELINQUISHED THOSE HABITS.
inscribed with title
pen and ink on silk
5 ½ x 9 inches

There was an Old Person whose habits, induced him to feed upon Rabbits;
When he'd eaten eighteen, he turned perfectly green,
Upon which he relinquished those habits. 29

ARTHUR HUGHES
Arthur Hughes (1832-1915)

Probably the most important follower of the Pre-Raphaelite Brotherhood, Arthur Hughes was born in London on 27 January 1832. He revealed great artistic ability as a pupil at Archbishop Tenison's Grammar School. Consequently, he was allowed to attend the Government's School of Design at Somerset House at the age of fourteen, in 1846, and work under Alfred Stevens. A year later, he entered the Royal Academy Schools on a studentship; in 1849 he won a silver medal for antique drawing and exhibited at the Royal Academy for the first time. On reading the periodical, *The Germ*, in 1850, he converted to Pre-Raphaelitism, and mixed with members of the group. Their enthusiasm for his work led him, in 1852, to paint *Ophelia*, his first major Pre-Raphaelite painting. It was particularly admired by John Everett Millais, whose own version of the Shakespearean subject was exhibited at the same time at the Royal Academy. As a result of establishing a friendship with Millais, Hughes developed a series of paintings of lovers' trysts. The most notable of these was *April Love* (1855), which Ruskin described as 'exquisite in every way' and considered buying; instead it was purchased by the young William Morris, struck by Ruskin's assessment. Hughes further emphasised Pre-Raphaelite affiliations by contributing *The Passing of Arthur* to the frescoes in the Oxford Union (1857) and by helping to found the Hogarth Club (1858).

Hughes was of such a shy and retiring character that, in about 1858, he withdrew from the metropolis to live a quiet family life in Kew Green. From this time, he became better known as an illustrator than as a painter, and contributed to such seminal children's books as Thomas Hughes's *Tom Brown's Schooldays* (1869) and George MacDonald's *At the Back of the North Wind* (1871). However, he continued to produce romantic paintings, which he latterly exhibited at such novel and fashionable venues as the Grosvenor Gallery and the New Gallery. He also took on pupils and studio assistants, notably Albert Goodwin (1869), and involved himself in public life as an examiner at the South Kensington Schools (from 1886). His first solo show, held at the Fine Art Society in 1900, and devoted to landscapes, demonstrated his continuing ability to develop and experiment. He died in Kew Green on 22 December 1915.

His work is represented in numerous public collections, including the British Museum, the Tate Gallery, the Victoria and Albert Museum, the Ashmolean Museum, Birmingham Museum and Art Gallery, and Manchester City Art Gallery.
Further reading: Leonard Roberts and Stephen Wildman, *Arthur Hughes. His Life and Works*, Woodbridge: Antique Collectors' Club, 1997 (with a Catalogue Raisonné)

'The perfectly illustrated books are things like At the Back of the North Wind, or Alice's Adventures in Wonderland, and for the very reason that there is no great gulf between the imagination and power of expression of Arthur Hughes and George MacDonald, or Tenniel and Lewis Carroll.'

Forrest Reid (*Illustrators of the Eighteen Sixties*, London: Faber & Gwyer, 1928, page 23)

30

HE WAS ENTRANCED WITH HER LOVELINESS

signed with monogram

pen and ink

3 ¼ x 2 ½ inches

Provenance: Harold Hartley
Illustrated: *Good Words for the Young*, 1 June 1870, page 425, 'At the Back of
the North Wind' by George Macdonald; George Macdonald, *At the Back of
the North Wind*, London: Strahan & Co, 1871, page 270
Literature: Leonard Roberts & Stephen Wildman, *Arthur Hughes. His Life
and Works*, Woodbridge: Antique Collectors' Club, 1997, page 258:
catalogue raisonné B18
Exhibited: 'Book Illustration of the "Sixties"', National Gallery, Millbank,
January-December 1923, no 140; and Whitechapel Art Gallery, February-
March 1924, no 140

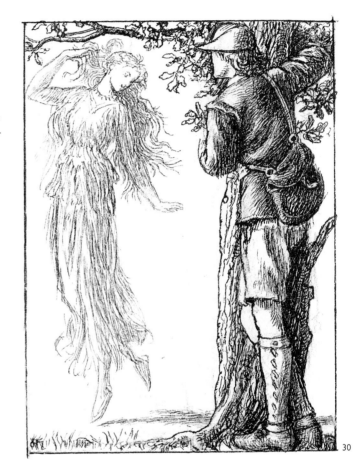

30

AT THE BACK OF THE NORTH WIND

'The magazine *Good Words for the Young*, begun by the evangelical publisher
Alexander Strahan in November 1868, provided a perfect vehicle for
MacDonald's inventively moralising stories, and naturally he turned to
Hughes for their illustration. Their first new collaboration proved to be
the finest: *At the Back of the North Wind*, published in parts between
November 1868 and October 1870, with Hughes making no fewer than
seventy-seven designs. Cut by the Dalziels, at their best these are among
the most extraordinary illustrations of their age, to be ranked alongside
Henry Holiday's…*Hunting of the Snark* and John Tenniel's…*Alice*. The art
critic D S MacColl vividly remembered as a child "the first wave of
Preraphaelite romance that came with the dark coils of the North Wind's
hair and the strangeness of that world of imagery". In true Pre-Raphaelite
tradition, motifs from his easel paintings are re-used and refined in such
illustrative work - "Down to the Sea-Shore" in the *North Wind*, for instance,
echoes *L'Enfant Perdu* [1866-67]…
 'MacDonald was appointed editor of *Good Words for the Young* in
November 1869, giving Hughes a great deal of work over the next two
years, chiefly illustrating MacDonald's own stories.' (Stephen Wildman in
Roberts and Wildman, op cit, page 26)

KATE GREENAWAY

Kate Greenaway, RI (1846-1901)

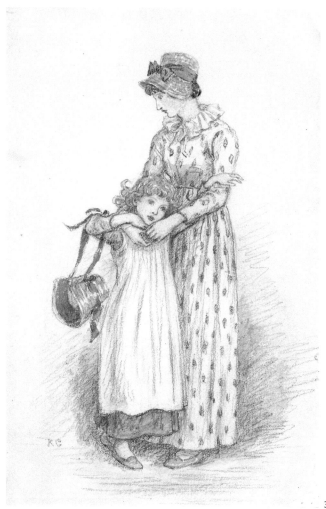

For a biography of Kate Greenaway and an essay on her relationship with John Ruskin, please refer to *The Illustrators*, 1996, pages 46-50; for another essay on the artist, see *The Illustrators*, 2001, pages 1-4.

Key works written and illustrated: *Under the Window* (1878); *The Kate Greenaway Almanack* (appearing between 1888-97)
Her work is represented in the collections of the British Museum, the Victoria and Albert Museum, and the Ashmolean Museum.
Further reading: Rodney Engen, *Kate Greenaway: A Biography*, London: Macdonald, 1981; M H Spielmann and G S Layard, *Kate Greenaway*, London: Adam and Charles Black, 1905

31

31

MOTHER AND DAUGHTER
signed with initials
pencil and watercolour
7 x 4 ¾ inches

VICTORIAN FAIRY ILLUSTRATORS

ADELAIDE CLAXTON
Adelaide Claxton (circa 1840-1905)

Adelaide Claxton was the younger daughter of Marshall Claxton, the Bolton-born historical painter and illustrator, and the sister of Florence Claxton, who also became an artist. She studied mainly under her father and also briefly at Carey's School of Art.

In 1850, Adelaide and Florence accompanied their father to Sydney, in Australia, where he hoped to sell his work and that of the others and to found an art school. He held the first exhibition of paintings in Australia, which was not very successful. However, he did give lessons to young artists, including some in oil painting to Conrad Martens. The family travelled on to Ceylon and India, where Marshall Claxton disposed of most of his paintings. They returned via Egypt and the Holy Land, arriving back in England in 1858.

From that date, the Claxton sisters worked as illustrators and wood engravers for a number of publications. Adelaide specialised in images of children, often featuring a ghost or apparition, and of women and their place in society. She contributed to the *Illustrated London News* (1858), *The Illustrated Times* (1859-66), *London Society* (1862-65, 1870) and *Judy* (1871-79), and turned her hand to advertising artwork. She also exhibited at the Society of Women Artists (1858-96), the Royal Academy (1864-67) and the Royal Society of British Artists (1865-76).

In 1874, Claxton married, becoming Mrs George Turner, but continued to work under her maiden name. She collaborated with Charles H Ross, the editor of *Judy*, on *A Shillingworth of Sugar Plums* (1876), illustrated Ross's *'Stage Whispers' and 'Shouts Without'* (1881), contributed to Grenville Murray's *Sidelights on English Society* (1881), and compiled and illustrated *Brainy Odds & Ends* (1900).

Her work is represented in the collections of the British Museum, the Victoria and Albert Museum, the Walker Art Gallery (Liverpool), and the Yale Center for British Art.

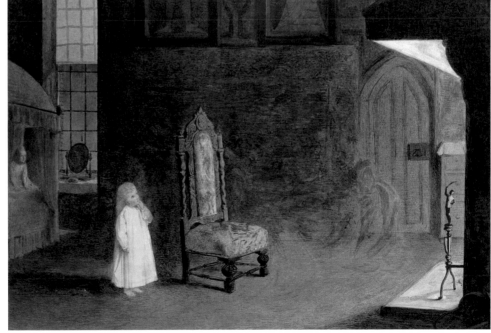

32
OOH GHOSTIES
watercolour
19 x 28 inches

JOSEPH NOEL PATON

Sir Joseph Noel Paton, RSA (1821-1901)

Joseph Noel Paton was born in Dunfermline, Fife, on 13 December 1821. He was inspired by his father who, while working as a damask designer, was a keen antiquarian and collector. (The collection, inherited by Paton, is now in the National Museum of Scotland, Edinburgh.) From his earliest years, his imagination was fired by his reading, and he made drawings based on tales of Celtic romance and legend, in addition to episodes from the Bible and ancient history. He developed talents for both literature and art, and would become a poet and critic as well as a painter and sculptor.

On completing his education at a local school, Paton spent three years in his father's profession, becoming head designer at a large sewn-muslin factory at Paisley, Strathclyde. Then in 1842, he left Scotland for London where, in the following year, he entered the Royal Academy Schools. Though he did not take up a studentship, his time at the Schools proved important to his artistic development, for he met and befriended a younger, precocious student, John Everett Millais.

Paton's aptitude for literary subjects enabled him to work as both illustrator and painter. He contributed to Samuel Carter Hall's *The Book of British Ballads* (1842, 1844) and Mrs Hall's *Midsummer Eve: A Fairy Tale of Love* (1847), two landmarks in the construction of the Victorian imagination. He also entered the competitions for the decoration of the rebuilt Houses of Parliament, a project on which the health of British history painting seemed so strongly to depend. He established his reputation in England with his two prizewinning entries, *The Spirit of Religion* (1845) and especially *The Reconciliation of Oberon and Titania* (1847). He had already exhibited his first, small version of its pendant, *The Quarrel of Oberon and Titania*, in Edinburgh in 1846, as his diploma work on becoming an associate of the Royal Scottish Academy.

Paton was invited by Millais to join the newly founded Pre-Raphaelite Brotherhood. Though sympathetic with its ideals, he declined, for he disliked London and preferred to return to Scotland. As a result, he practised and promoted its principles in the Scottish capital, recording the natural world in almost uncanny detail, and capitalising on his mimetic skills in order to convincingly represent the supernatural. This he demonstrated triumphantly with the large version of *The Quarrel of Oberon and Titania*, judged to be the painting of the exhibition when shown, in 1850, at the Royal Scottish Academy. He was elected a full academician in the same year.

Paton's approach to landscape painting was influenced not only by the example of the Pre-Raphaelites but by the writings of their champion John Ruskin. Paton met Ruskin through Millais and, in 1853, attended the lectures that he gave in Edinburgh on Architecture and Painting. Soon after, he went on painting trips with his brother, the artist Waller Hugh Paton, to the Isle of Arran (1854 and 1855), possibly to Loch Lomond (1858), and later to the Continent (1861 and 1868).

By the late 1850s, Paton was as well known and admired in England as in Scotland, through his exhibits at the Royal Academy (1856-83) and his illustrations to Charles Kingsley's *The Water Babies* (1863). He was appointed Queen's Limner for Scotland in 1866, and knighted a year later.

His work as an original imaginative painter culminated in 1867, with the completion of *The Fairy Raid* and its exhibition at the Royal Academy. Five years later, he declined the invitation of Lewis Carroll to illustrate *Through the Looking-Glass and What Alice Found There*, the author's second great work of fantasy, stating that John Tenniel remained the ideal artist for the job. Instead, he devoted his remaining time to painting religious subjects in an academic manner comparable to that of his compatriot William Dyce. He died in Edinburgh on 26 December 1901. His sons Frederick Noel Paton and Ronald Noel Paton were also artists.

His work is represented in the collections of the British Museum, the National Gallery of Scotland, and the Art Gallery and Museum, Kelvingrove (Glasgow).

Further reading: Francina Irwin (editor), M H Noel-Paton and J P Campbell, *Noel Paton, 1821-1901*, Edinburgh: The Ramsay Head Press, 1990; *Joseph Noel Paton*, Scottish Arts Council, 1967

33

OBERON AND PUCK LISTENING TO THE 'SEA-MAID'S' MUSIC
A MIDSUMMER NIGHT'S DREAM
signed with initials and dated '28th June 1848'
inscribed with title and dedicated 'to MP from her "affectionate
connection" JNP May 1864' below mount
pen and ink
10 ¾ inches diameter

33

OBERON AND PUCK LISTENING TO 'THE SEA-MAID'S' MUSIC

In the wake of the enormous success of his paintings of Oberon
and Titania, Paton produced numerous small fairy pictures, including
several more based on A Midsummer Night's Dream. (See, for example,
Puck and the Fairy of 1847, reproduced in *Summer Show*, London: Chris
Beetles Ltd, 1999, page 4.) The present drawing, originally dated 1848, is
probably the first of several attempts by Paton to depict one particular
episode described but not dramatised in Shakespeare's play. In Act II,
Scene i, Oberon, King of the Fairies, says to his sidekick, Puck:

> Thou rememb'rest
> Since I once sat upon a promontory,
> And heard a mermaid on a dolphin's back
> Uttering such dulcet and harmonious breath
> That the rude sea grew civil at her song,
> And certain stars shot madly from their spheres
> To hear the sea-maid's music.

Oberon's description acts as an atmospheric prelude to his instruction to
Puck to pick love-in-idleness (the wild European pansy also known as
heartsease). The juice of that plant makes 'man or woman madly
dote / Upon the next live creature that it sees' and so significantly affects
the action of the play; Titania, Oberon's Queen, becomes 'enamour'd of an
ass', while two young Athenian couples find the complexity of their

affections further compounded. Paton seems to have been interested in
'the sea-maid's music' as a parallel to that botanical power, music being
'the food of love' (*Twelfth Night*, Act I, Scene i). As such, it was also a
parallel to *Puck and the Fairy*, another representation of the desire that
controls the play. Indeed, Paton had originally intended his last painting of
the present subject, *Oberon Listening to the Sea Maid* (exhibited at the
Grosvenor Gallery in 1883), to act as the pendant to a version of *Puck and
the Fairy*.

Given this suggestion of emotional intensity, it may seem surprising
that Paton should dedicate the work, in May 1864, to 'MP', almost
certainly Margaret Paton, the wife Waller Hugh Paton, his brother and
fellow painter. Yet, he may have intended it to mark their second wedding
anniversary, its Shakespearean subject generally signifying nuptials. After
all, the 1847 version of *Puck and the Fairy* had become similarly associated
with the marriage of Paton's sister, Amelia, to David Octavius Hill, a
union also solemnised in 1862.

CHARLES DOYLE
Charles Altamont Doyle (1832-1893)

For a biography of Charles Doyle, please refer to *The Illustrators*, 1997, page 17.

His work is represented in the collections of the Victoria and Albert Museum, and the Huntington Library (San Marino, California). Further reading: Michael Baker, *The Doyle Diary*, London: Paddington Press, 1978 (a facsimile of Charles Doyle's sketchbook for 1889); Rodney Engen, Michael Heseltine and Lionel Lambourne, *Richard Doyle and his Family*, London: Victoria and Albert Museum, 1983; Daniel Stashower, *Teller of Tales. The Life of Arthur Conan Doyle*, London: Penguin Books, 1999; Robert R Wark, *Charles Doyle's Fairyland*, San Marino: The Huntington Library, 1980

'My father, Charles Doyle, was in truth a great unrecognised genius. His mind was on strange moonlight effects, done with extraordinary skill in watercolours; dancing witches, drowning seamen, death coaches on lonely moors at night, and goblins chasing children across churchyards.'

Sir Arthur Conan Doyle

"O! I AM SO GLAD TO SEE YOU"

5TH JULY 1888.

35 36

34

A CONTENTION
watercolour with pen and ink
7 x 10 ½ inches

34

Numbers 35 to 41 are all taken from a sketch book of the 1880s.

35

UTALIZING A BEARD EASILY
inscribed with title
pen and ink
5 ¼ x 4 ¾ inches

36

O! I AM SO GLAD TO SEE YOU
inscribed with title and dated '10th July 1888'
pen and ink
5 x 4 inches

37

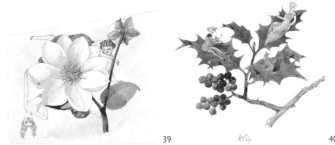

39 Holly 40

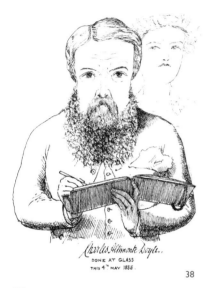

38

41

37
FRIGHTFUL TURN-UPS
inscribed with title
pen and ink
3 x 7 ¾ inches

38
SELF-PORTRAIT
signed and dated 'done at glass this
4th May 1888',
and also inscribed 'That's his guardian
angel over the left, utterly disgusted'
pen and ink
6 x 4 ½ inches

39
FLOWER FAIRIES
pen ink and watercolour
5 ½ x 6 ½ inches

40
JOLLY
inscribed with title
watercolour with pen and ink
6 x 6 ¾ inches

41
THE INDIAN FAIRY
watercolour with pen and ink
7 x 5 ¼ inches

VICTORIAN PUNCH CARTOONISTS

JOHN LEECH

John Leech (1817-1864)

For a biography of John Leech, please refer to *The Illustrators*, 1996, page 132.

Key works illustrated: Charles Dickens, *A Christmas Carol* (1844) (and the subsequent Christmas Books); R S Surtees, *Mr Sponge's Sporting Tour* (1853) and *Handley Cross* (1854); began to contribute to *Punch* in 1841 and, on joining the staff two years later, produced its first political 'cartoon' (the first ever to use that term)

His work is represented in numerous public collections, including the British Museum, the Victoria and Albert Museum, the Fitzwilliam Museum, Manchester City Art Gallery and the Houghton Library (Harvard College Library).

Further reading: Simon Houfe, *John Leech and the Victorian Scene*, Woodbridge: Antique Collectors' Club, 1984

42

THE LOVE BALLAD
signed with initials
watercolour with pen and ink
2 ½ x 2 ¼ inches

43

THE SEASIDE VISIT
signed and dated 54
pencil with watercolour
8 ½ x 6 ¼ inches

44

THE MYSTERY OF THE TRUNK
signed
watercolour with pen and ink
3 ½ x 3 ¼ inches

43

42

44

JOHN TENNIEL
Sir John Tenniel, RI (1820-1914)

For a biography of John Tenniel, please refer to *The Illustrators*, 1997, Page 14.

Key works illustrated: Thomas Moore, *Lalla Rookh* (1861); Lewis Carroll, *Alice's Adventures in Wonderland* (1865); Lewis Carroll, *Through the Looking-Glass* (1872); chief political cartoonist of Punch (1864-1900)
His work is represented in the collections of the British Museum and the Victoria and Albert Museum.
Further reading: Rodney Engen, *Sir John Tenniel: Alice's White Knight*, Aldershot: Scolar Press, 1991

'THE OLD MAN OF THE SEA'
The British public is here shown to be entirely absorbed in attending to the phenomenally 'interesting topic' of the 'Tichborne Case' to the exclusion of other issues of the day. The case concerned the attempt of a Claimant to prove himself to be Sir Roger Tichborne, Baronet, and thus heir to rich estates in Hampshire. Indeed, he possessed sufficient personal resemblance and family knowledge to convince the Dowager Lady Tichborne, despite being inappropriately portly. Yet, at the end of a long trial of seventy days, he lost his case (1871-72). The Defendants exposed him as Arthur Orton, a butcher's son, who had earlier emigrated from Wapping to Australia, and stated that the real 'Roger' had been lost at sea. At the end of an even longer second trial (1873-74), the Claimant was found guilty of the criminal charge of perjury and sentenced to fourteen years penal servitude, of which he lived to serve ten. His counsel, Serjeant Ballantine, also faced charges, though the landmark case made his reputation, and he continued to plead for his client, even publishing a book in his defence. Reminiscent of a contemporary sensation novel, the matter of the case continues to fire the imagination and has recently provided the subject of a feature film. The corpulent Claimant, recounting his supposed 'return from the sea', suggested to John Tenniel his use of a metaphor from those tall tales *The Arabian Nights*, of Sinbad carrying The Old Man of the Sea.

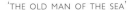

45

45
'THE OLD MAN OF THE SEA'
Sinbad (as representing the British public): 'I can't be expected to attend to any of you, with this "interesting topic" on my shoulders!'
signed with monogram
pencil
8 ¼ x 6 ¼ inches
Illustrated: *Punch*, 18 November 1871, page 209

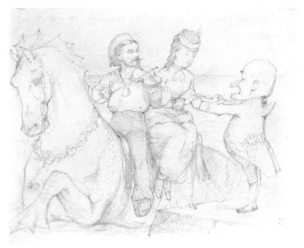

46

47

BRINGING HOME THE BRIDE

On the 23 January 1874 Queen Victoria's second son Alfred, Duke of Edinburgh married Grand Duchess Marie, daughter of the Emperor of Russia. The celebrations took place at the Winter Palace, St Petersburg and the couple arrived at Gravesend on 7 March. Seen here in sailors uniform and playing the violin, Alfred had shown early enthusiasm for the navy and was assigned to his first ship in 1858 at the age of fourteen. He worked his way up through the ranks and by the time of his marriage he was already in command of HMS Galetea. He was said to have learnt to play the violin secretly in his spare time to surprise his parents. Victoria's first son Albert, later Edward VII, had brought his bride Princess Alexandra of Denmark to England in 1863 whose beauty and good-natured demeanour had created enormous public affection for her. The new royal bride however, never won the hearts of the British people. She was considered bad-mannered and haughty and she in turn resented her lesser position in English society. [EAF]

47

'THE VOICE OF THE TURTLE'

Gog: 'What's all this here about, brother Magog?'

Magog: 'They wants to enlarge the "Corporation", brother Gog!'

Turtle: 'Enlarge the Corporation? – Ha! Ha! they can't do that without me!'

signed with monogram

pencil

8 ¼ x 6 ¼ inches

Illustrated: *Punch*, 7 November 1874, page 195

46

BRINGING HOME THE BRIDE

'Welcome my darling! we've made a pet of Alexandra and we'll make a pet of you!'

signed with monogram

pencil

6 x 8 inches

Illustrated: *Punch*, 14 March 1874, page 111

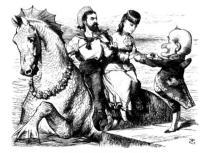

BRINGING HOME THE BRIDE.
"WELCOME, MY DARLING! WE'VE MADE A PET OF ALEXANDRA, WE'LL MAKE A PET OF YOU!"

'THE VOICE OF THE TURTLE'

The Lord Mayor in his state
Is a wonder to see,
But although he is great
He still greater shall be
To the West and the North
He shall stretch his domain;
Unto Tyburn go forth:
Over Pimlico reign

Temple Bar is a token,
An omen they say,
Of a barrier that's broken,
To vanish away.
An enlarged Corporation
On turtle will fare
At the glorification
Of a grander Lord Mayor.

This cartoon, published on the eve of the
Lord Mayor's Show in November 1874,
highlighted the ongoing debate in parliament
about the expansion of the Corporation of
London. Earlier that year, Temple Bar had
been found to be structurally unsound and
the Corporation of London made plans to
remove the bar and widen the street.

The Turtle appears frequently as
representative of the City of London as,
traditionally, turtle soup is often on the
menu at civic banquets.

Gog and Magog are two giant statues
that stand at the entrance to the Guildhall,
where the Lord Mayor's procession ends.
They represent the last two survivors of a
race that supposedly inhabited Britain
before the Romans. [EAF]

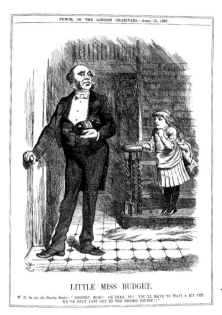

LITTLE MISS BUDGET.

W. H. Sm-th (the Family Butler). "DESSERT, MISS? OH DEAR, NO! YOU'LL HAVE TO WAIT A BIT YET. WE'VE ONLY JUST GOT TO THE SECOND COURSE!!"

48

LITTLE MISS BUDGET
W H Sm-th (the family butler): 'Dessert, Miss?
Oh dear, no ! You'll have to wait a bit yet. We've
only just got to the second course!!'
signed with monogram
pencil
8 x 6 ¼ inches
Illustrated: *Punch*, 16 April 1887, page 187
Exhibited: 'Dropping the Pilot', Wilhelm-
Busch-Museum, Hanover, November 1990-
January 1991

48 [Illustrated here is the wood engraving as it
appeared in *Punch*]

LITTLE MISS BUDGET

The budget of 1887 was delayed by a parliamentary debate on the Irish Crimes Bill. In a decade where Gladstone had frequently sought to raise Irish matters in the Commons, leading Conservatives – like W H Smith – were keen to see an end to the preoccupation with the Irish Question at the expense of other pressing issues. Smith is here depicted trying to bring 'Closure' into parliament and bemoaning the lengthy session that has kept the budget waiting in the wings. His guise as a butler betrays his humble roots.

At this time the Right Honourable William Henry Smith (1825-1891) was serving as First Lord of the Treasury and Leader in the Commons in Lord Salisbury's Conservative cabinet. A wealthy public figure and philanthropist, he had amassed his fortune through expanding his family bookbinding business by using the growing network of railways to set up station newspaper stalls. In 1848 he had brokered an exclusive contract with the London and North Western Railway thereby eliminating the sale of cheap salacious material for which railways had become infamous; for this reason he was nicknamed 'Old Morality' by Punch. In his first foray into politics in 1868 he won Westminster for the Conservatives defeating the philosopher John Stuart Mill. This was a typical example of wealthy middle-class support deserting the Liberal party in droves for the Tories in the late nineteenth century. Though he was a loyal Tory backbencher, many resented his political success, in particular his appointment as First Lord of the Admiralty; for he lacked naval experience, and was not a member of the upper class. Gilbert and Sullivan immortalised him as Sir Joseph Porter KCB in HMS Pinafore (1878), the character who had risen from newsboy to admiral without ever having gone to sea. [EAF]

CHARLES KEENE
Charles Samuel Keene (1823-1891)

For a biography of Charles Keene, please refer to *The Illustrators*, 1997, Page 44.

Key works illustrated: Douglas Jerrold, *Mrs Caudle's Curtain Lectures* (1866); contributed to *Once a Week*; chief social cartoonist of *Punch* (1864-1890)
His work is represented in numerous public collections, including the British Museum, the National Portrait Gallery, the Tate Gallery, the Victoria and Albert Museum, the Ashmolean Museum, the Fitzwilliam Museum and the National Gallery of Scotland.
Further reading: Simon Houfe, *The Work of Charles Samuel Keene*, Aldershot: Scolar Press, 1995.

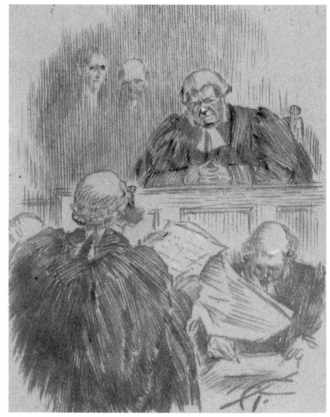

50

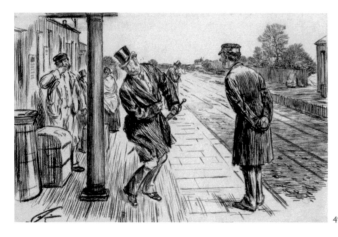

49

49

'THE NEWS'
Season-ticket holder (airily): 'Morning, Station-Master. anything fresh?'
Station-Master ('bit of a wag'): 'N-no, sir, not that I've– ah! – yes – now I think of it, Sir – that's fresh paint you're leaning agai– ! '[violent pas seul, with language to match]
signed with initials
pen and ink
6 x 9 ½ inches
Illustrated: *Punch*, 9 April, 1887, page 178
Exhibited: 'The Fine Art of Illustration', Fine Art Society, July 2001

50

COUNSEL'S OPINION
Judge (testily, to persistent junior): 'Sir if you don't know how to behave as a gentleman in court, I can't teach you!'
Junior (pointedly): 'quite so, my lud, quite so!' [proceeds]
signed with initials
pen and ink
5 x 4 inches
Illustrated: *Punch*, 6 July 1889, page 11
Exhibited: 'The Fine Art of Illustration', Fine Art Society, July 2001

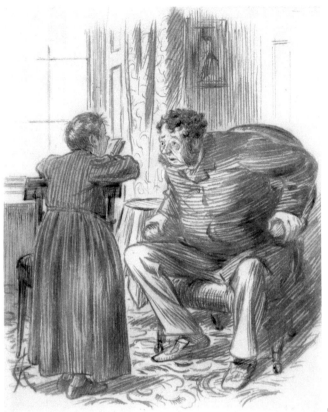

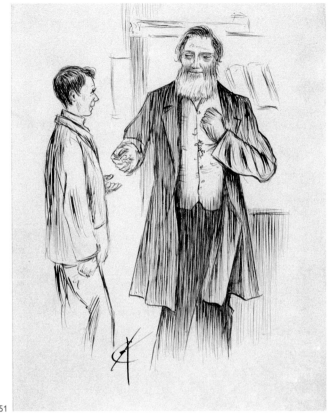

51

52

51

ANTHROPOPHAGOUS.

Little nephew: 'Uncle you must be a sort o' cannibal, I – '

Uncle (on a visit): 'A what, Sir ! ? Wha'd'yer mean, Sir? '

Nephew: 'Cause Ma' said, you was always livin' on somebody ! '

signed with initials

inscribed with 'no 15' on reverse

pen and ink

7 x 6 inches

Illustrated: *Punch*, 13 August, 1887, page 70

Exhibited: 'The Judge Evans Collection', Goupil Gallery, May–July 1918, no 160

52

MORE COMPLIMENTS OF THE SEASON

Pompous Merchant (to the office boy): 'There George!' (giving Christmas-box) 'and I hope you'll have a pleasant Christmas, and that you'll spend it decently, and avoid intemp -'

George: 'Thank you, Sir ! the same to you, Sir!'

signed with monogram and inscribed with title

pen and ink

9 ¼ x 6 inches

Illustrated: *Punch*, 23 January, 1886, page 40

GEORGE DU MAURIER
George Louis Palmella Busson du Maurier, RWS (1834-1896)

For a biography of George du Maurier, please refer to *The Illustrators*, 1996, Pages 138-139.

Key work written and illustrated: *Trilby* (1895); chief society cartoonist of *Punch* (1864-96) His work is represented in numerous public collections, including the British Museum, the National Portrait Gallery, the Victoria and Albert Museum, the Ashmolean Museum, the Fitzwilliam Museum, Manchester City Art Gallery and the National Gallery of Scotland.
Further reading: Leonée Ormond, *George du Maurier*, London: Routledge & Kegan Paul, 1969

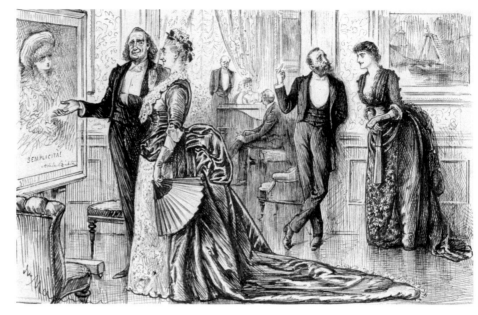

53

NOTE TO NUMBERS 53 AND 56

The comic incomprehension of the English, French and German nations, and their mutual struggle with foreign languages was a stock-in-trade for Du Maurier. His own comfort in European culture was born of a French father and education in Paris and Antwerp.

He had a mimic's ear for the no-mans's-land of strugglish lingua franca, and a mischievous regard for the phonetic possibilities of the linguistically challenged, and so took any chance to 'bronounce the cherman very vell'.

Even the Dutch did not escape his teasing, for the story is told by his biographer Leonée Ormond of how he was often mistaken for Sir Lawrence Alma-Tadema by 'enthusiastic ladies' extolling the beauty of his representations of marble and roses. His reply was always in Tadema's foreign accent, while clasping them firmly by the hand, ' gom to me on my chewsdays'. He often wondered whether they went. [CRB]

53

HOW THE DISTINGUISHED AMATEUR'S REPUTATIONS ARE MADE, SOMETIMES.

Herr Silbermund (the great pianist) to Mrs Bonamy Tatler: 'Ach! Lady Crichton has, for bainting, ze most remarrgaple chenius! Look at zis! It is equal to Felasquez!'

M Languedor (the famous painter) to Miss Gushington: 'Ah! for ze music, Miladi Cretonne has a talent quite exceptionnel! listen to zat! It surpasses Madame Schumann!' (whence it gets about that on the very highest professional authority, Lady Crichton's music and painting (which are just on a par) are of the very highest artistic order!'

signed and inscribed with title
signed, inscribed with instructions to printer and dated 'Apr 27. 87 Bayswater' below mount
pen and ink
6 ¼ x 10 inches
Illustrated: W D Howells (foreword), *English Society, sketched by George du Maurier*, London: Osgood, McIlvaine & Co, 1897, [unpaginated]

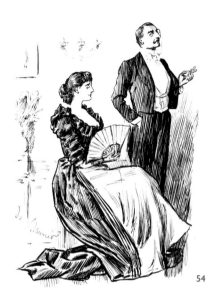

54

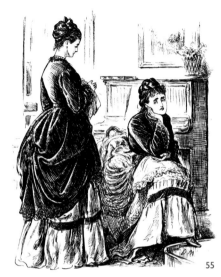

55

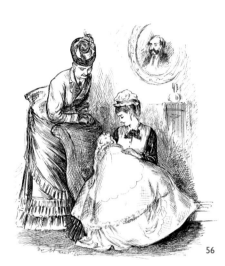

56

54

A COMPROMISE AND A COMPENSATION

'Look here Maggie. you say you want to come
with me to Paris merely to order some new
frocks – why you can get everything you require
in Bond Street'. 'Oh, thanks dearest! that's all I
wanted!'

signed
*signed and inscribed with the artist's address below
the mount*
inscribed with title on reverse
pen and ink
6 x 4 ¼ inches
Illustrated: *Punch*, 16 May 1896, page 239

55

AGGRAVATING FLIPPANCY

Useful sister (to ornamental sister, who has been
bewailing the dullness of her existence for the
last hour): 'Bella, you're the most egotistical
creature I ever met in my life!'
Bella (who always gets out of everything with a
joke): 'well, Jane, if I am egotistical, at all events its
only about myself!'

signed with initials
inscribed with title on original mount
pen and ink
8 x 6 ½ inches
Provenance: William Lever, 1st Viscount
Leverhulme
Illustrated: *Punch*, 12 April 1873, page 155

56

WAITING FOR THE VERDICT

The German nurse: 'Is it a Cherman or an English
paby?'
The Mamma: 'well I don't know. you see she was
born in England, but my husband is German'
The German nurse: 'Ach soh! zen ve vill vait to
see vat lenkvetch she vill schbeak, and zen ve vill
know!'

signed
pen and ink
6 x 4 ¼ inches
Illustrated: *Punch*, 8 January 1876, page 292

LINLEY SAMBOURNE
Edward Linley Sambourne (1845-1910)

For a biography of Linley Sambourne, please refer to *The Illustrators*, 1996, Page 144.

Joined the staff of *Punch* in 1871; became its chief political cartoonist (1901-10)
His work is represented in the collections of Linley Sambourne House and the Victoria and Albert Museum.
Further reading: Simon Jervis and Leonée Ormond, *Linley Sambourne House*, London: The Victorian Society, 1980; Robin Simon (editor), *Public Artist Private Passions: the world of Edward Linley Sambourne*, London: Leighton House Museum, 2001

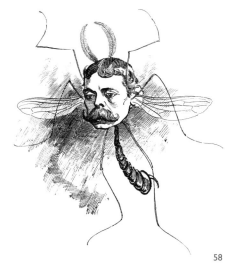

'There is a midge at Westminster
A gnatty little thing
It bites at night
This mighty mite
But no one feels it's sting,
It's noise persistent, shrill,
— so some say there's no sting,
but 'tis all "hum".

58

58

PUNCH'S FANCY PORTRAITS NO 47
LORD RANDOLPH CHURCHILL MP
signed
pen and ink
3 x 3 ½ inches
Illustrated: *Punch*, 3 September 1881, page 99

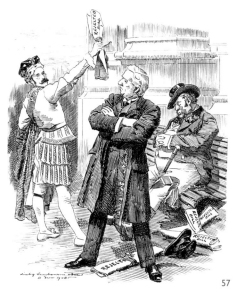

57

57

BOILING OVER WITH APATHY
Prime Minister: 'Insult me six times more and I won't be answerable for myself, and heaven knows what would happen if I appeal to my friend here who already has great difficulty in controlling his indignation.'
signed and dated '11 December 1908'
inscribed with title and 'Punch' and dated '16 December 1908' on original mount
pen and ink,
12 ½ x 10 ½ inches
Illustrated: *Punch*, 16 December 1908, page 443

BOILING OVER WITH APATHY
Herbert Asquith succeeded as Liberal Prime Minister in April 1908 when Campbell-Bannerman resigned following a heart attack. He faced a formidable obstacle in his first term in the shape of a hostile House of Lords seemingly determined to block any Liberal legislation. In addition, seven seats were lost to the Conservatives in by-elections that year.

Asquith allowed the Lords to reject all the bills without comment which seemed to many an unusual course of action when his predecessors had behaved so differently in similar circumstances. Campbell-Bannerman was particularly vocal in his frustration about the Lords' behaviour and promised to 'give them a good hard knock' (*Punch*, 1908, page 428). Most famously, the mighty Liberal Premier Gladstone had delivered a fist-clenched attack on the House of Lords when they threw out his beloved controversial Home Rule Bill. [EAF]

PHIL MAY

PHIL MAY
Philip William May, RI RP NEAC (1864-1903)

For a biography of Phil May, please refer to *The Illustrators*, 1996, pages 148-149; for a caricature of the artist by E T Reed, see *The Illustrators*, 1999, Page 46.

Key works illustrated: William Allison, 'The Parson and the Painter' (serialised in *St Stephen's Review* 1890); *Phil May Annuals* (1892-1904); contributed to *Punch* (from 1893), *Guttersnipes* (1896)
His work is represented in numerous public collections, including the British Museum, the National Portrait Gallery, the Tate Gallery, the Victoria and Albert Museum, Leeds City Art Gallery, the Walker Art Gallery (Liverpool), and the Art Gallery and Museum, Kelvingrove (Glasgow).
Further reading: David Cuppleditch, *Phil May. The Artist and His Wit*, London: Fortune Press, 1981; Simon Houfe, *Phil May. His Life and Work, 1864-1903*, Aldershot: Ashgate, 2002

A CELEBRATION OF THE WORK OF PHIL MAY
At the turn of the 1890s, Phil May was a penniless young artist in need of work, who had recently returned to London from Australia. Fortuitously, the majority of British magazines were seeking talented new draughtsmen, for innovative methods of photomechanical reproduction had made possible an increased number of drawn illustrations. May renewed a connection with the *St Stephen's Review* and, in 1890, began to illustrate its comic serial 'The Parson and the Painter'. This account of metropolitan social events as seen by a country parson made his name almost overnight. The drawings by May that subsequently appeared in *Punch* and other periodicals, and in the artist's own annuals, soon epitomised the essential modernity of popular illustration. Even now, they seem to comprise a direct yet selective representation of city life, at once spontaneous and economical. They construct an affectionate caricature of the working-class streets, honouring the resilience of the inhabitants, while minimising their more threatening characteristics. Thus they relate most closely to the music-hall song or monologue rather than any purely visual medium. May himself personified the 'knut', a flashy man about town often portrayed by music-hall artistes. He dressed in an exaggerated version of the style admired by cockney 'arries, which included, as an essential item, a loud suit of black and white check. The costume was ideal for a figure whom James McNeill Whistler considered the summation of 'black and white art'.

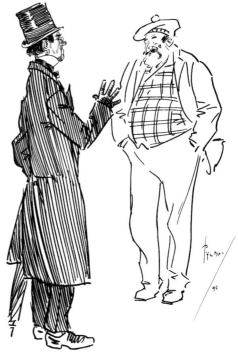

59

59
MINISTER: 'HOO IST SANDY I NEVER SEE YOU AT THE KIRK THE NOO?'
SANDY: 'I CARNA STAND YOU LONG SERMONS.'
MINISTER: 'AH WELL, Y'ELL BE GANGIN TO A PLACE WHERE THERE'LL BE NAY SERMONS AT ALL NEITHER LONG NOR SHORT.'
SANDY: 'IT'LL NAY BE FOR THE WANT OF MINISTERS THER.'
signed and dated 95
signed and inscribed with title on original mount
pen and ink
8 ½ x 6 ½ inches
Provenance: William Lever, 1st Viscount Leverhulme, acquired from the Fine Art Society, 29 June 1897, for 6 guineas
Illustrated: *The Phil May Folio*, London: W Thacker & Co, 1904, page 245

May greatly admired the *Punch* artist, Charles Keene, whom he dubbed 'the daddy of the lot of us!', but even in his captionless drawings, May was intrinsically the funnier of the two. In turn, he himself was sometimes called 'the grandfather of British illustration', and was very influential upon the next generation of draughtsmen, especially such colleagues of the London Sketch Club as Bert Thomas and Frank Reynolds. They both learned from his stylistic qualities and from his approach to society, which was coloured by a lack of snobbishness best exemplified by *Guttersnipes* (1896). Over time, some of the most widely consumed and most effective visual media – notably advertising and the allied commercial arts – have been affected in look and tone by the legacy of May.

The drawings included here comprise a further celebration of the work of Phil May in the centenary of his death. In September 2002, Chris Beetles Ltd displayed a group of works in order to launch Simon Houfe's book, *Phil May. His Life and Work, 1864-1903*; during this August, it lent four works to the exhibition, 'Phil May: The Art of Leaving Out', mounted by the Cartoon Art Trust.

61

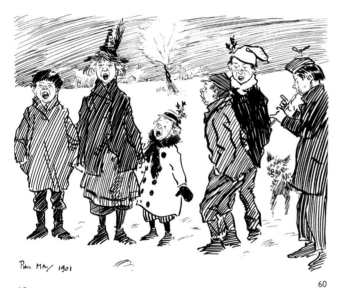

60

60

CAROL SINGERS

signed and dated 1901

pen and ink; 5 x 6 ¼ inches

Drawn for a Christmas card for Mr & Mrs J Y W MacAlister

Exhibited: 'Phil May: The Art of Leaving Out', Cartoon Art Trust,

August 2003

61

YOUNGSTER (WHO HAS JUST GOT A PENNY TO SPEND): ''OW MUCH IS THEM GRAPES MISTER?'

SHOPKEEPER (AMUSED): 'THEY ARE FOUR SHILLINGS AND SIXPENCE A POUND, MY LAD.'

YOUNGSTER: 'WELL, THEN, GIVE US A 'APORTH O' CARROTS. I'M A DEMON FOR FRUIT.'

signed and dated 95; signed and inscribed with title on reverse

pen and ink; 8 x 5 ½ inches

Illustrated: *Punch*, 1 June 1895, page 255

Literature: David Cuppleditch, *Phil May The Artist & His Wit*, London: Fortune Press, 1981, page 115

Exhibited: Fine Art Society, June 1965, no 33;

'Phil May: The Art of Leaving Out', Cartoon Art Trust, August 2003

62

62

SEXTON (TO A DIVINE WHO IS SPENDING HIS HOLIDAYS IN THE COUNTRY, AND WHO, ON THE SUDDEN ILLNESS OF THE VILLAGE PARSON, VOLUNTEERED TO TAKE THE DUTIES): 'A WORSE PREACHER WOULD HAVE DONE FOR US, SIR, BUT WE COULDN'T GET ONE!'
signed
signed and inscribed with title on original mount
pen and ink
7 x 4 ¾ inches
Illustrated: *Punch*, 21 November 1896, page 251

63

A FRENCH DUEL
signed and dated 91
pen and ink
11 ½ x 13 ¾ inches

64

AN IMPORTANT JUNCTION
'You mind your fader gets my boots reddy by four o'clock, 'cos i'm goin' to a party!'
signed and dated 94
pen and ink
8 x 6 ¼ inches
Illustrated: *Punch*, 22 September 1894, page 144; *Phil May, Sketches from 'Punch'*, London: *Punch*, 1903, page 7

64

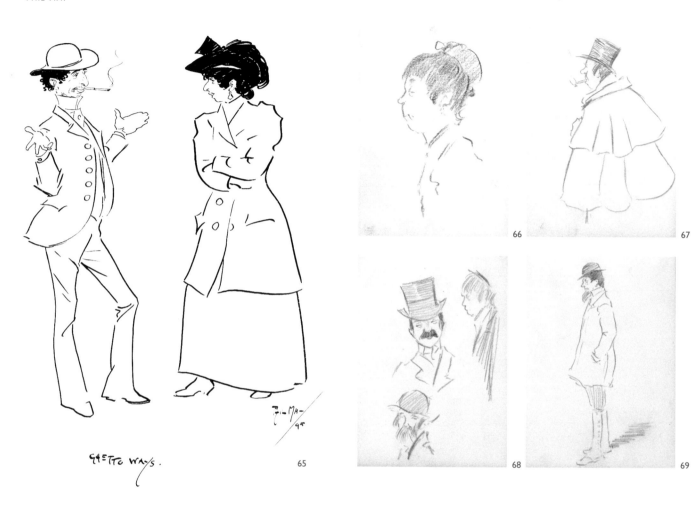

GHETTO WAYS.

65

66

67

68

69

65

GHETTO WAYS
signed, inscribed with title and dated 95
pen and ink
10 x 8 inches
Illustrated: *The Phil May Folio*, London:
W Thacker & Co, 1904, page 115

66

PROFILE OF WOMAN
pencil
4 ¾ x 3 ½ inches

67

CLOAKED GENT WITH PIPE
pencil
4 ¾ x 3 ½ inches

68

THREE HEAD STUDIES
pencil
4 ¾ x 3 ½ inches

69

STANDING MALE FIGURE
pencil
4 ¾ x 3 ½ inches

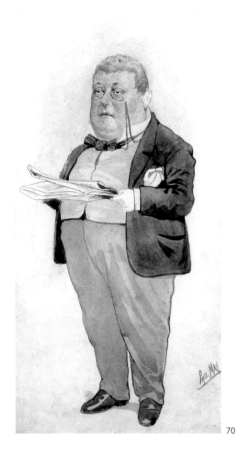

70

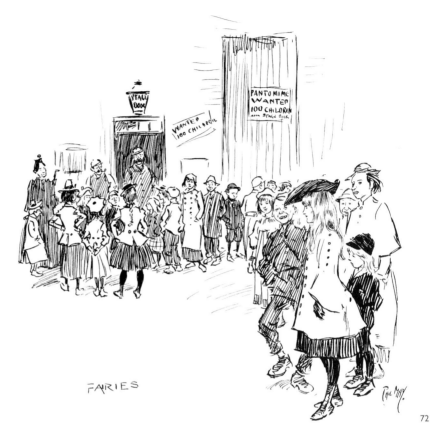

FAIRIES

72

70

GENTLEMAN READING A NEWSPAPER

signed

watercolour

12 x 6 inches

71

ET JE TOMBE EN SOLDAT!

signed with initials and inscribed with title

pen and ink

3 x 3 ¼ inches

This image is said to have been drawn by Phil May in Romano's after the opening night of the Covent Garden season on 10 May 1897.

72

FAIRIES

signed and inscribed with title

pen and ink

8 ¾ x 7 ¼ inches

Illustrated: *Phil May's Gutter-snipes*, London: The Leadenhall Press, 1896, [unpaginated]

'As is the case with the true humorist, the tender side of May's nature is very obvious. He revels in practical jokes, in low humour, and knockabout farce. He plays the poor Gutter-snipes' games upon the paper and shares in their squalid happiness. Not less does he sympathise in their wretchedness and misery, in their illness, poverty, and utter wretchedness. So profound is the humanity of his drawings that we are almost tempted to overlook the fine composition of his pictures, which is inevitably right, and the instinctive balance of his light and shade.' (An unsigned review of *Guttersnipes* in the *Magazine of Art*, November 1896, page 103)

HARRY FURNISS

HARRY FURNISS

Harry Furniss (1854-1925)

For a biography of Harry Furniss, please refer to *The Illustrators*, 1996, page 158.

Parliamentary caricaturist for *Punch* (1880-94); founded *Lika Joko* and the *New Budget* (both 1894)
His work is represented in numerous public collections, including the British Museum, the National Portrait Gallery and the Victoria and Albert Museum.
Further reading: *Harry Furniss*, London: National Portrait Gallery, 1983

73

73
INTERIORS AND EXTERIORS NO 78
OUR MODEL VILLAGE
inscribed 'Our model village' below mount
pen and ink
7 ¼ x 10 inches
Illustrated: *Punch*, 24 August 1889, page 94

INTERIORS AND EXTERIORS NO 78
Harry Furniss, one of the most prolific and inspired artists who worked for Punch, started his series 'Interiors and Exteriors' in 1885. He was already submitting several such sequences to the magazine and had been given the prestigious task of illustrating the weekly 'Essence of Parliament'. Furniss was particularly famed for his inspired doodles and witty caricatures. Indeed, Gladstone never recovered from the famous deep-winged collars that Furniss immortalised him wearing.
Ever determined to prove his versatility, Furniss drew 'Interiors and Exteriors' as a take on Richard Doyle's 'Manners and Customs of Ye Englyshe'. As with Doyle's original they satirise the political preoccupations and social issues of the day. Here, Furniss has represented the epitome of the Victorian model village such as Bourneville and Port Sunlight, built by industrial entrepreneurs to house their workers. It is a clean environment complete with a new railway, a fresh water supply and a place to play cricket so that no person is left un-catered for. Even the pensioner has a place to perch with his dog. [EAF]

74

GLADSTONE AT THE DISPATCH BOX

signed on original mount

inscribed 'M G scratching his head' on reverse

pen and ink

8 ½ x 6 inches

Provenance: William Lever, 1st Viscount Leverhulme

Similar to the wood engraving *Mr Gladstone. 'I have seen the flower in his buttonhole fade under his flow of eloquence'*, published in Harry Furniss, *The Confessions of a Caricaturist*, London: T Fisher Unwin, 1901, vol ii, page 165

75

THE GRINDER AND THE PIEMAN

Rob the grinder tossing with a pieman after changing the half-crown given to him by Miss Tox

signed with monogram

inscribed with title below mount

pen ink and watercolour

10 ½ x 7 inches

Illustrated: Charles Dickens, *Dombey and Son*, London: The Educational Book Co, 1910 (Charles Dickens Library, vol ix), facing page 544

76

76

OLIVER IN THE GRIP OF SYKES

signed with monogram

pen and ink

8 ½ x 12 ½ inches

Illustrated: Charles Dickens, *Dombey and Son*, London: The Educational
Book Co, 1910 (Charles Dickens Library, vol ix), facing page 144

77

SOME PEOPLE OUGHT TO HAVE MUTES FOR SERVANTS IN VANITY FAIR

signed with monogram

pen and ink with watercolour

11 ½ x 7 ¾ inches

Illustrated: William Makepeace Thackeray, *Vanity Fair. A novel without a hero,
illustrations by the author and Harry Furniss*, London: Macmillan and Co,
1911 (The Harry Furniss Centenary Edition), facing page 479

RIVALS TO VICTORIAN PUNCH

The proliferation of periodicals during the Victorian period marked an attempted response to, and control of, a market of unparalleled complexity, comprising many shades of political opinion, social aspiration and economic power. *Punch* played a particularly interesting role in this complex market, from its foundation in 1841. Gradually, it would influence almost every kind of contemporary magazine, and especially the degree and character of the humourous content.

Founded a year later, in 1842, the *Illustrated London News* presented itself as a weekly family newspaper, appealing to a wide audience through its mix of visual and verbal formulations of current affairs. If, in practice it was more limited in both its range and its readership (middlebrow, middle class), it still found it necessary to temper overtly serious coverage with humourous elements. In so doing it 'borrowed a style of satire which was very much that of *Punch*', even 'relying...on a group of *Punch* artists' (Houfe, 1978, page 72).

When the *Graphic* was founded – by John Leighton [see pages 42-43] – almost thirty years later, in 1869, it was less a rival to *Punch* than to the *Illustrated London News*. Like the contemporary cheap comic papers, it was aimed at 'the man of less educated type', and so structured the news in almost exclusively visual items. Dark images of social deprivation were again moderated with humour partly inspired by *Punch*. However, in keeping with attempts to interest a lower class of reader, it made use of the strip cartoon, a form better associated with *Fun* and *Judy*.

As *Punch* had altered in identity from radical to conservative, it left a gap for a comic periodical of more liberal outlook, a role that was filled, from 1861, by *Fun*. Then, six years later, *Judy* was founded as a twopenny rival to both *Punch* and *Fun*, which would appeal to a lower class of readership, and particularly to women. In terms of party politics, it was Conservative, and Disraeli was its hero. If it was obviously opposed to the pro-Gladstonian position of *Fun*, it even accused *Punch* of a 'senile lack of traditional patriotism' (Kunzle, 1990, page 316).

Yet such apparent political antitheses were as much a result of opportunism as of principles. From 1872, *Fun* and *Judy* were both owned by the Dalziels and could be played off each other; as could *Ally Sloper's Half-Holiday* which the editor Gilbert Dalziel added to the stable in 1884. In fact, such cheap comic papers rivalled *Punch* in only the vaguest of ways, pandering instead to the aspirations of certain sectors of the lower classes. As indicated by the cartoons of Du Maurier, *Punch* was for those who had made it.

Politically, socially and spiritually, *Punch* tended to speak for the establishment. Artists who had ideological disagreements, such as the Roman Catholic Richard Doyle, or who had highly maverick personalities, such as Harry Furniss, found resignation easier than assimilation. However, only one comic draughtsman of the late nineteenth century retained complete independence from *Punch* and still managed to affect the thinking of the politically-minded upper middle classes. Carruthers Gould distinguished himself as a committed Liberal with a talent for drawing, rather than a mercenary professional artist. He made his name in 1887 as cartoonist of the then Liberal daily, the *Pall Mall Gazette*. When it was taken into Conservative ownership, in 1892, Gould defected with other members of the editorial team to start the rival *Westminster Gazette*. Two years later, he founded his own popular monthly, *Picture Politics*.

Just as *Punch* had partly instigated the lively variety of Victorian periodicals so, late in the period, it was forced to respond to its rivals. Change began in 1891 with the death of Charles Keene, which brought to an end the triumvirate he had shared with George du Maurier and John Tenniel. The sense of the status quo which it had so supported was then brought clearly into question by the distinctive qualities of younger cartoonists. Notable among these was E T Reed, who had first contributed to *Punch* in 1889. Though his draughtsmanship had a polish akin to that of Tenniel, he used it to revive the fanciful spirit of Doyle, and so perhaps suggested the original radicalism on which *Punch* had been founded.

JOHN LEIGHTON

John Leighton, FSA FZS, also known as 'Luke Limner' (1822-1912)

John Leighton was a 'Renaissance man' of the Victorian period, combining talents as a multifaceted designer, an illustrator and photographer, a writer and lecturer, and an administrator and magazine publisher. Descended from the Leightons of Ulysseshaven, Forfarshire, Scotland, he was born in the parish of St James's, London on 15 September 1822. His maternal grandfather was the artist, James Baynes, while his father and uncle worked together as 'J & J Leighton, bookbinders'. He was educated at Wellington House Academy, and studied under Henry Howard RA, the neo-classical painter, and Thomas Seddon, the Pre-Raphaelite landscapist. Beginning to work as a designer and illustrator from the mid 1840s, he entered Art Union competitions and produced images for publication: a series of outline drawings entitled *Talent will make its way* (1844) and an uncredited set of illustrations to William Cowper's *The Diverting History of John Gilpin* (1845). From that latter year, he designed bookbindings, aligning himself to his family's specialism, and working particularly closely with his cousin Robert, of leading binders Leighton, Son & Hodge. He developed into the most productive binding designer of the Victorian period, and was the first such to sign his work. Meanwhile, he sustained successful careers as an illustrator and writer.

In 1847, Leighton began to use the name of 'Luke Limner' for a variety of activities, and especially as the creator of a series of mostly comic books, which he both wrote and illustrated. Among these were three volumes concerning the Brown family: *London Out of Town* (1847), *Money* (1848) and *Christmas Comes But once a Year* (1850).

Leighton was interested in promoting the arts in general, and technical innovations in particular, often through lectures and publications. This interest first manifested itself in 1851, when he served on Prince Albert's Commission of the Great Exhibition, and received medals for both his service and his exhibits. (He would take an equivalent role and receive equivalent honours in Paris in 1855 and 1867, and Philadelphia in 1867, as well as again in London in 1862). That he could balance the serious and humourous aspects of his personality and talents was indicated by the simultaneous publication of his satirical volume, *The Rejected Contributions to the Great Exhibition of All Nations* (1851). Soon after, he published the more straightforward *Suggestions in Design* (1852). With Seddon and others, he founded the North London School of Drawing, the first such institution for artisans; while with Roger Fenton he founded the Photographic Society (now the Royal Photographic Society of Great Britain) (1853). He was elected a fellow of the Society of Arts (1851) and a member of the Society of Antiquaries (1855). During the same decade, he also began an extensive series of Continental travels.

Though there seemed a danger of his neglecting his own creativity, Leighton continued to work regularly as an illustrator, and began to collaborate with his brother Henry, who engraved the plates. He published *The Royal Picture Alphabet* (1856) and *Comic Art-manufactures* (circa 1860), illustrated Richard Pigot's anthology, *Life of Man* (1866) and, in his most important work as an illustrator, contributed to the *Lyra Germanica* (1861, 1868). He was also commissioned by Messrs Goodall and Sons to design a series of Christmas cards in 1862, the first year that such ephemera were generally available for purchase, and he has been credited with introducing the robin as a motif. Furthermore, he began to work for periodicals, contributing to *Good Words* (1864), *Once a Week* (1866) and *London Society* (1868), among others. He was proprietor of *The Gentleman's Magazine* (1866-67), one of the proprietors of the *Illustrated London News*, and founder proprietor of the *Graphic* (from 1869), for which he designed the title page which remained in use for over sixty years.

Ingenious and energetic, Leighton seems to have maintained an interest in almost every issue of the day, and only the most outstanding can be mentioned:

He contributed suggestions to the Royal Academy Commission, being in favour of that institution's move to Burlington House, and reporting on its art library (1868).

He influenced the modification and improvement of official dress at the Court of St James, in 1869, and in the following year published 'a tract against the evils of female corsetry' (King, 1998, page 245).

He devised a scheme for dividing London into hexagonal superficial miles, for the use of municipal administrators, the Post Office, and other organisations. He printed it in full in the *Graphic* of February 1870. Later, he developed a related scheme for the 'Unification of London', exhibiting the plans in Paris (1878) and eventually publishing them (1895). A companion volume concerned *Tubular Transit for London* (1902).

He attended the International Copyright Congresses in Antwerp (1877) and Paris (1878).

He made three unsuccessful attempts to contest the seat of the Borough of St Pancras as a Liberal Unionist (1885-91) and published a lecture on the 'Advantages of a System of a Postal Ballot' (1888).

An active member of the Ex-Libris Society, he was Chairman for a year (1891), and edited, illustrated and wrote most of its journal for three (1894-97).

Though Leighton decreased his work as a binding designer in these later years, he continued to illustrate. One important project was his own *Paris under the Commune* (1871), in which he described his experiences of a

78

political uprising during which his studio was destroyed. He also illustrated *The Poems of William Leighton* (1894) and contributed to *Dalziel's Bible Pictures* (1881). As late as the 1890s, as he entered his seventies, he revived his humourous vein, in contributing cartoons to periodicals, including *Ariel* (1890), *Fun* (1890-92) and *Punch* (1900-1902). At their best they combined something of the humour of Du Maurier and the draughtsmanship of May.

For most of his career, Leighton lived at 12 Ormonde Terrace, Primrose Hill. However, in the final year of his life, he moved to Harrow, dying there on his birthday, 15 September 1912. Fittingly, his remains rest locally in the family mausoleum which had been built to his design. His work is represented in the collections of the Museum of Fine Arts (Boston) and the Philip Hofer Collection (Harvard University).

Further reading: Edmund M B King, 'The book cover designs of John Leighton FSA', *The British Library Journal*, vol xxiv, no 2, Autumn 1998, pages 234-255; Sybille Pantazzi, 'John Leighton 1822-1912. A Versatile Victorian Designer: his designs for book covers', *The Connoisseur*, vol clii, April 1963, pages 262-273

78

THE FIRST REHEARSAL
signed
inscribed with title on original mount
pen and ink
9 ½ x 16 inches
Provenance: William Lever, 1st Viscount Leverhulme

FRANCIS CARRUTHERS GOULD

Sir Francis Carruthers Gould, RBA (1844-1925)

For a biography of Francis Carruthers Gould, please refer to *The Illustrators*, 1996, page 157.

Contributed to the *Pall Mall Gazette*, *Truth* and the *Westminster Gazette*; founded *Picture Politics* (1894).
His work is represented in the collections of the British Museum, the National Portrait Gallery and the Victoria and Albert Museum.

80

DANGEROUS LIGHT AND LEADING
The frequent references to Sir Edward Carson's speeches and actions in Ulster, made in excuse of violence and lawlessness, go to prove the dangerous character of the example he is setting
signed with initials
inscribed with title and publication details on original mount
pen and ink with monochrome watercolour
7 ¼ x 9 ½ inches
Illustrated: *Westminster Gazette*, 3 September 1913, page 3

79

79

HE HAS JOBBED HIS LAST
signed with initials
pen and ink
8 ½ x 13 ½ inches
Illustrated: *Truth*, Christmas number, 25 December 1892, page 23

HE HAS JOBBED HIS LAST
Hardinge Stanley Giffard, first Earl of Halsbury (1823-1921) was elected Conservative member for Launceston in 1877. He was made Lord Chancellor three times; in Lord Salisbury's first government in 1885 and again in 1886 until he lost his position to Lord Herschell in 1892, the year of this cartoon. He would serve with the Conservatives again between 1895 and 1905. He received some criticism for the appointments he made while in this post, often choosing men for their politics and family rather than their legal prowess. [EAF]

DANGEROUS LIGHT AND LEADING
Sir Edward Carson (1854-1935), 1st Lord Carson of Duncairn, one of the most successful lawyers of his age, acted as Crown Prosecutor during the Irish land agitation (1888-91), defended Queensberry in the first trial of Oscar Wilde (1895) and was involved in the 'Winslow Boy' case. A fierce opponent to Home Rule, he left parliament in 1912 to establish a provisional government in Belfast in apparent readiness for what he regarded as inevitable civil war. He recruited 80,000 men to form the Ulster Volunteer Force (UVF), a paramilitary organisation determined to resist, by violent means if necessary, the imposition of Home Rule in Ireland. [EAF]

81

WILLIAM GILES BAXTER
William Giles Baxter (1856-1888)

For a biography of William Giles Baxter, please refer to *The Illustrators*, 1996, page 172.

Principal illustrator of *Ally Sloper's Half-Holiday* (1884-86); drew the character of 'Choodle' for *C H Ross's Variety Paper* (1886-88)
His work is represented in the collections of the Victoria and Albert Museum.
Further reading: James Thorpe, 'A Great Comic Draughtsman', *Print Collectors' Quarterly*, 1938

83

81

HANWELL LUNATIC ASYLUM
signed with initials and inscribed 'after Phil May'
pen and ink
9 ¼ x 10 ½ inches
This image is based on one of a series of cartoons by Phil May, 'From Dottyville', published in *Punch*, 21 August 1897, page 82.

82

MR ASQUITH GOES OUT GUNNING
signed with initials
inscribed 'Mr Asquith goes out with his gun' and dated 'Feb 1911' on original mount
pen and ink
4 ¾ x 5 inches
Illustrated: *Westminster Gazette*, 22 February 1911, page 3

83

OIRLAND ALL THERE, ONCE AGAIN
THE O', EQUAL TO THE OCCASION, WELCOMES THE PRINCE AND PRINCESS OF WALES TO THE SHORES OF THE EMERALD ISLE TO THE TUNE OF 'COME BACK TO ERIN.' HOOROOH!
signed
pen and ink
10 ¾ x 13 inches
Illustrated: *Ally Soper's Half-Holiday*, 11 April 1885, front cover

WILLIAM FLETCHER THOMAS

William Fletcher Thomas (1862-1922)

For a biography of William Fletcher Thomas, please refer to *The Illustrators*, 1996, page 172.

His work is represented in the collections of the British Museum.

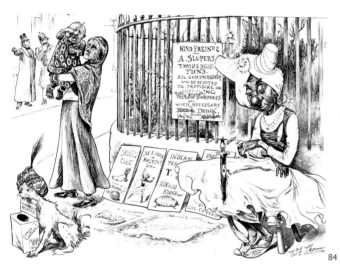

84

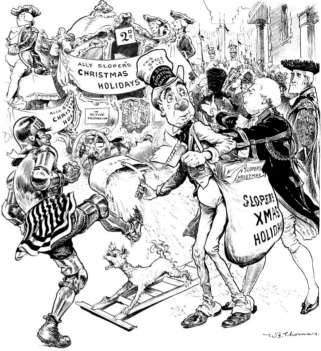

85

84

CHARITY — THAT BEGINS AT HOME

'I am afraid that poor Papa's suspension from Parliament has temporarily unhinged his colossal intellect. Nothing else, I am sure, can account for his descending to the unspeakable meanness in which he was detected the other afternoon. Of course, it's just possible that he may have meant to properly account for the money later on, but it was distinctly unfortunate that the first few donations were expended in liquid refreshment. Dad says his only error was in not asking Mr Moses to "stand in with him in the swag" – whatever that may mean. As it is, it seems lucky that Papa was merely discharged with caution' – Tootsie.

signed

pen and ink

9 ¼ x 12 ½ inches

Illustrated: *Ally Sloper's Half-Holiday*, 30 January 1897, front cover

85

ADVT

'Really it is as Ma says, the more you do for people nowadays the less you are thought of. If they don't want their silly coach decorated in an artistic manner, why on earth didn't they say so at once and have done with it, instead of letting poor Pa go to all that time and trouble, and then turn round on him like that? Here has he gone to no end of worry and expense over his magnificent Christmas number, which he is actually going to give away for the paltry sum of 2d. and then, when he tries to tell people of it, they get as huffy as you please!' – Tootsie

signed

pen and ink

11 x 10 ½ inches

Illustrated: *Ally Sloper's Half-Holiday*, 11 November 1905, front cover

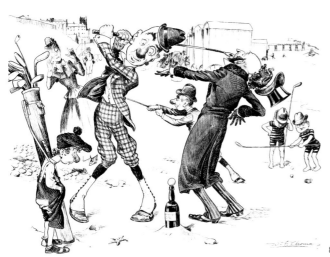

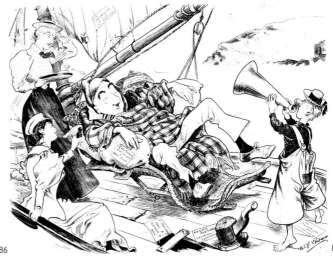

86

GOLF AT CROMER

'Poor Pa's love of sport is intense; he hadn't been in Cromer twenty-four hours when he started a Golf Club. The entrance fee is whatever you like to give, and the annual subscription is arranged on the same agreeable system. At present, however, Papa is the only duly qualified member; the children are merely honorary members. They play on the beach all day long, much to the annoyance and danger of the visitors. The casualties up to now are Miss Miffin, Spinster, of Bloomsbury, an eye put out; and Lord Frink, of Grosvenor Square, choked through swallowing his teeth.' – Tootsie.

signed

pen and ink

9 ½ x 12 ½ inches

Illustrated: *Ally Sloper's Half-Holiday*, 25 July 1891, front cover

87

SLOPER'S COLLAPSE AT ABERYSTWYTH

'After a seaside tour brimful of adventures and escapades, poor Pa has at length collapsed at Aberystwyth. If Dad was a man of average calibre, it is doubtful whether he could pull through. but, unfortunately though, for his enemies, he is a man that always arises to the occasion, even if he does not, as a rule arise from his bed until eleven o'clock in the morning. He is, therefore, with the assistance of "Tootsie Belle" and several of the "Friv" girls, almost convalescent, and may be expected in London on Monday or Tuesday next.' – Tootsie

signed

pen and ink

9 ¾ x 12 ½ inches

Illustrated: *Ally Sloper's Half-Holiday*, 28 September 1895, front cover

ALFRED BRYAN

Charles William Grineau, known as 'Alfred Bryan' (1852-1899)

One of the most outstanding cartoonists of the late nineteenth century, Alfred Bryan was particularly admired by Max Beerbohm. He began his career in the early 1870s, working for *Judy* as both political cartoonist and theatrical caricaturist. He then contributed to *Ally Sloper's Half-Holiday*, which was founded in 1884 in order to develop the most potent of *Judy's* characters. His best known work comprised theatrical caricatures for *Entr'Acte*, weekly cartoons as 'our Captious Critic' for the *Illustrated and Sporting News*, and political cartoons as Chief Cartoonist of *Moonshine*. He also contributed to the *Hornet*, the *Idler* and the Christmas number of the *World*, and illustrated a number of sheet-music covers. His son was the painter and printmaker Bryan de Grineau, and he numbered James Affleck Shepherd among his pupils. He died in London on 17 May 1899.

His work is represented in the collections of the Victoria and Albert Museum, and Brighton Art Gallery.

88

SIR HENRY IRVING AS EDGAR, MASTER OF RAVENSWOOD

Henry Irving (1838-1905) became lessee and manager of the Lyceum Theatre in London in 1871, and immediately established a long association with Ellen Terry, by playing Hamlet to her Ophelia. In 1890, they acted together in *Ravenswood*, a dramatisation by Hermann Merivale of Sir Walter Scott's *The Bride of Lammermoor* (1819). This popular Romantic novel had already proved a great success on stage earlier in the century as Donizetti's opera, *Lucia di Lammermoor* (1835); while Irving had performed in another dramatised version of the novel at the outset of his career. In 1890, Irving played the dominant role of Edgar of Ravenswood, who loves Lucy, the sister of his enemy, Lord Henry Ashton. When Lucy is forced to marry the Lord of Buclaw, she goes mad and stabs her husband. Ravenswood dies in quicksand on his way to confront her family. The play received mixed reviews, being in the old outdated tradition of melodrama. However, the first performance, on 20 September 1890, 'was enlivened by a fracas in the stalls' as Willie Wilde, Oscar's brother, and Joseph Hatton responded heatedly to the loud and unfavourable comments of an American member of the audience (Madeleine Bingham, *Henry Irving*, New York: Stein and Day, 1978, page 245).

88

SIR HENRY IRVING AS EDGAR, MASTER OF RAVENSWOOD
signed with monogram, inscribed 'Lyceum' and dated 'Sept 1890'
pen ink and watercolour
7 ½ x 5 ¼ inches

E T REED

EDWARD TENNYSON REED

Edward Tennyson Reed (1860-1933)

For a biography of Edward Tennyson Reed, please refer to *The Illustrators*, 1996, page 172.

Contributed to the *Bystander* and the *Sketch*; parliamentary caricaturist for *Punch* (1894-1912) His work is represented in the collections of the British Museum, the National Portrait Gallery and the Victoria and Albert Museum. Further reading: Shane Leslie (editor), *Edward Tennyson Reed*, London: Heinemann, 1957

89

90

'THIS FREEDOM' FROM THE POLITICAL STEW

After four years at the head of a coalition government, David Lloyd George came under heavy criticism from all sides over his unscrupulous methods, manipulation of the press, ruthless opportunism and the Honours scandal that had damaged his reputation.

Sensing that he had few days left as Prime Minister, he delivered a speech to the Manchester Reform Club in which he claimed that he found office 'a shackle' and above all 'would welcome [and] love freedom'. His wish was granted within a fortnight but he maintained a high profile as a political columnist both in Britain and America. From this pulpit he attacked the succeeding government on most policies, particularly in foreign affairs; in September 1924 he highlighted the failures of the government in a speech to the Welsh National Council. [EAF]

89
'THIS FREEDOM' FROM THE POLITICAL STEW
Chef David (after his cooks tour of Wales where he received the Freedom of several towns): 'Well, well, indeet, look you! To turn out a cook like meee to make way for cooks like them! To gootness! Dit you efer see such a mess over the place!'
signed with monogram
pencil; 14 ¾ x 10 ½ inches
Illustrated: *Bystander*, 19 September 1923, page 952

90
FORTUNES IN FACES
An American film magnate is searching for a common face which will bring fortune to it's owner. In the representative selection seen above, our artist has even included a caricature of himself – on the off chance we presume!
signed with monogram
pencil
12 ¼ x 8 ¾ inches
Illustrated: *Bystander*, 23 July 1924, page 209

"Mon, ye'd a thocht it was juist irresees-tible, b't Paisley didna seem tae care aboot it !!"

"Brilliant writer - this Countess of Oxford - 'muses me intense-ly !! So racy." "Wonder who sh- -Oh! ah 'f course : I 'member !!!"

"Oxford for Ever."

"WAR HAS BEEN DECLARED AGAINST THE GERMAN EMPIRE - " (AUGUST 1914.)

"Why, of course ! - It's little Lloyd-George ! - A mere Commoner after all !!"

- Lucky I didn't notice him - - Something awfully plebeian about him !!"

91

Herbert Henry Asquith (1852-1928) had been Liberal Prime Minister of Britain from 1908 to 1916. He was responsible for the Parliament Act of 1911, limiting the power of the House of Lords, and led Britain during the first two years of the First World War when a coup within the Liberal Party resulted in Lloyd George taking over. This caused a rift not only between the two men, but also amongst the Liberals, who never recovered from the split. He returned to parliament to represent Paisley after the 1923 election. In 1925, he accepted a peerage as Earl of Oxford and was created a Knight of the Garter shortly afterwards.

Asquith's wife, Lady Margot Asquith, was a legend in her own lifetime as a society hostess and wit. She published two volumes of autobiography as well as travel diaries, memoirs and one autobiographical novel. [EAF]

91

PATIENT 'OXON'

Mr Asquith, after much heart-searching and his usual consideration for others, agrees to adorn 'another place'– to which he takes the hearty good wishes of everyone (not excluding our artist, though you might not think it!)

signed with monogram and inscribed with extensive captions
pencil
15 x 11 ¾ inches
Illustrated: *Bystander*, 4 February 1925, page 230

UNEXPECTED HAPPENINGS

George Lansbury (1859-1940) was a radical socialist reformer and active campaigner against poverty and unemployment. Elected Labour MP in 1910, he resigned in 1912 to stand in support of women's suffrage. The following year he was imprisoned for making speeches in favour of suffragettes who were involved in illegal activities. He went on hunger strike and was eventually released under the notorious Cat and Mouse Act. He founded and edited the *Daily Herald* (1912-22), became Mayor of Poplar in 1921, and was re-elected to Parliament in 1922 helping to establish a genuine system of unemployment benefit. He became leader of the Labour Party (1931-35) and also leader of the Opposition. In March 1925 he delivered a speech in which he claimed that the dole was a regrettable but necessary measure because every man should cherish the right to work. Far from agreeing, the press seized on this remark and chose to present it as a volte-face. [EAF]

92

UNEXPECTED HAPPENINGS

Now that Lansbury condemns the 'Dole' we mustn't be surprised if – for instance –

1. The Hottenham Totspurs win the boat race
2. Mussolini fells to the earth anyone who gives him the Fascisti salute
3. A distinguished K C declines for any fee whatever, to harry some wretched woman in the law courts
4. Charles Chaplin warns the public generally against those demoralising cinemas
5. Messers Augustus John and Epstein decide to dress like ordinary human beings and so pass unheralded by the press

signed with monogram
pencil
16 ½ x 11 ½ inches
Illustrated: *Bystander*, 25 March 1925, page 723

93

THE LION'S SHARE — AT LAST!

1924 was an inauspicious year for Ramsay Macdonald and the Labour Party. The party had seen accelerated levels of support since its formation in 1900, but while Macdonald had been elected Britain's first Labour Prime Minister in January 1924, he was still a minority leader and his government lasted only ten months. Furthermore, it was a year plagued with mounting foreign tensions. In an attempt to alleviate these and help the domestic economy, MacDonald tried to forge foreign alliances by recognising the Soviet government, and started negotiations to retrieve debts. Although the Russians returned some money, MacDonald had to agree to a further loan. This only served to confirm the worst suspicions of Labour's opponents who forced a general election. Four days before the election, a letter to the British Communist Party purporting to have been written by Grigori Zinoviev, President of the Comintern of the Soviet Union, was leaked to the British press. It contained a call to Communists to mobilise 'sympathetic forces' in the Labour Party to support an Anglo-Soviet treaty and to encourage 'agitation-propaganda' in the armed forces. The letter was almost certainly a forgery but, even though the Kremlin denounced it, in the atmosphere of Red paranoia it was sufficient to ensure that Baldwin's Conservatives won a landslide victory. This cartoon highlights what was to become even more apparent as the decade moved on; that their relationship with Russia was really the feature that most distinguished the foreign policies of the Labour and Conservative governments of the inter-war years. [EAF]

93

THE LION'S SHARE — AT LAST!

John Bull: 'Keeper MacDonald, it seems to me that the bear here has been somewhat pampered of late at the expense of the lion. I need not tell you keeper Baldwin, to see that Leo gets <u>his</u> fair share at feeding time!'

signed with monogram

pencil

14 x 10 ¼ inches

Illustrated: *Bystander*, 5 November 1924, page 385

95

A MOVE FOR THE BETTER

In 1925, Alfred Gilbert's famous statue of Eros in Piccadilly Circus was temporarily moved to Embankment Gardens while work on the underground took place. [EAF]

94

A MOVE FOR THE BETTER

Now that Eros has lost his Piccadilly 'pitch' some of his fellow-statues may have a similar fate in store. It would be as well for the authorities to begin to consider how best to combine utility with these enforced peregrinations.

signed with monogram and inscribed with extensive captions
pencil
14 ½ x 11 inches
Illustrated: *Bystander*, 25 February 1925, page 408

STICKING TO THE LAST

Lloyd George relieved Asquith as Prime Minister in December 1916 and proved an energetic war leader. In November 1917 he founded the Supreme War Council, a council of European leaders formed to oversee the progress of the war offensive. In the same month he made a speech in Paris, ostensibly to defend the council against its sceptics, but with underlying criticism of recent military strategy. Unsurprisingly this provoked resentment amongst the generals but also with the British press who ran headlines such as 'HANDS OFF THE ARMY'. [EAF]

95

STICKING TO THE LAST

John Bull: 'I back you solidly, Mr Lloyd George, but don't forget that I believe in my generals too. Be as much like Pitt as you can, but don't take on Wellington's job as well!'

signed with monogram
pencil
14 x 10 inches
Illustrated: *Bystander*, 21 November 1917, page 405

96

97

NELSON EXPECTS — WILSON DOESN'T!

The autumn of 1916 saw the Allies reach their lowest position thus far in the First World War. Huge losses had been suffered in the battle of the Somme that summer and conscription had had to be implemented to feed the army's needs. American involvement appeared to be the only way out of the stalemate but, despite the strong ties with Britain, President Woodrow Wilson had declared a policy of strict neutrality. However, after the sinking of the Lusitania in which 128 American passengers were killed, public opinion in the United States started to change, particularly when, in January 1917, Germany announced unrestricted submarine warfare. The publication of the Zimmerman telegram in the same year, suggesting Germany's support for Mexican territorial claims in Texas, finally pushed Wilson into declaring war on the German government. Vice Admiral Lord Nelson KB (1758-1805), England's most heroic war leader, lost the sight of his right eye while helping the army ashore at Calvi in Corsica. However, the eye itself was not disfigured as is commonly believed. [EAF]

96

NELSON EXPECTS — WILSON DOESN'T!
Wilson: 'Well! durn'd if I see any signal reason why a good Amurrican sh'd take any par-ticlar side in this fight!' Nelson: 'Look here Mr. President, as the inventor and the owner of the copyright, I must protest! You're bringing the 'blind eye' business into absolute disrepute!'
signed with monogram
pencil; 15 ¼ x 10 ¼ inches
Illustrated: *Bystander*, 25 October 1916, page 169

THE RIGHT 'PARTY' SPIRIT AT CHEQUERS

Sir James Craig (1871-1940) was made the first Prime Minister of Northern Ireland in June 1921. He had been a Unionist MP for Down and had spent most of his time at Westminster as a fierce opponent to the Irish separatist movement. With Sir Edward Carson, Craig was responsible for the creation of the Ulster Volunteer Force. William Thomas Cosgrave (1880-1965) was the first elected president of the Executive Council of the Irish Free State. An Irish revolutionary, he had been a founder member of Sinn Fein in 1905 and had fought in the Easter Rising of 1916. He steered the country through civil war in 1922-23 and was responsible for the domestic administration of Ireland which had by then assumed 'dominion' status. Both statesmen were involved with the Boundary Commission of 1923 which was responsible for fixing the Irish Border. [EAF]

97

THE RIGHT 'PARTY' SPIRIT AT CHEQUERS
Encouraged by the survival of both, Sir James Craig and President Cosgrave, Mr MacDonald will doubtless welcome these suggestions for other little tete-a-tetes of equally genial couples inscribed with picture captions
pencil
9 x 16 inches
Illustrated: *Bystander*, 18 June 1924, page 870

SOME THINGS WE MISS AT WEMBLEY
The British Empire Exhibition was held at Wembley in 1924. The largest effort of its kind which had then been attempted in Britain, it had over 100,000 visitors on its opening day. It aimed to promote trade and co-operation between the countries of the British Empire which, at that time, amounted to nearly a quarter of the world. The centrepiece was a newly-built Wembley Stadium and exhibits from every part of the Empire represented almost all industry and art; including, most memorably, a life-size model of the Prince of Wales made entirely out of butter. The figures represented here all served the first Labour government of 1924:

PS: Philip Snowden (1869-1937), later Viscount Snowden, Chancellor of the Exchequer in the first Labour cabinet.

RM: Ramsay MacDonald (1886-1937), the first Labour Prime Minister in 1924.

JW: John Wheatley (1869-1930), Minister for Health in 1924 and responsible for the Wheatley Act, the single most important domestic achievement of the 1924 government, designed to assist local authorities to subsidise housing.

JRC: John Robert Clynes (1869-1949), Lord Privy Seal and Deputy Leader of the House of Commons. He had been responsible for the vote of no-confidence in the previous government.

TS: Thomas Shaw (1850-1937), Baron Shaw, later 1st Baron Craigmyle, Lord of Appeal.

SW: Sidney Webb (1859-1947), later Baron Passfield, social reformer, historian and President of the Board of Trade in MacDonald's cabinet.

JHT: James Henry Thomas (1847-1949), an active trade-unionist and Colonial Secretary in the 1924 cabinet.

H: Richard Burdon (1856-1928), Viscount Haldane of Cloan, Lord Chancellor in 1924 for the second time. A former Liberal, he had already served in this position in 1912 to 1915.

HS: Herbert Samuel, later 1st Viscount Samuel (1870-1963), the only Liberal amongst this group, he served as 1st High Commissioner of Palestine from 1920-1925. He was also a philosopher and close friend of Sidney Webb. [EAF]

98

SOME THINGS WE MISS AT WEMBLEY
Our artist having forseen his appointment as official decorator of the 'Political Valhalla' at Wembley (next to the Bier-Halle!) has sent us a few specimens of the 'exhibits'. They are done now so we may as well publish them!

signed with monogram and inscribed with the initials of the subjects
pencil
15 ¾ x 11 ½ inches
Illustrated: *Bystander*, 30 April 1924, page 324

EDWARDIAN ILLUSTRATORS

NORMAN GARSTIN

Norman Garstin, RBC NEAC (1847-1926)

Norman Garstin was born in Caherconlish, County Limerick, Ireland on 28 August 1847. Early in life his father committed suicide and his mother developed a severe form of muscular paralysis; as a result, he was brought up by his grandparents. His grandfather did not welcome his desire to paint, and encouraged him either to enter the church, as he had done, or the army, as had Norman's father. Eventually, he attended Cork Engineering College, and then worked in an architect's office in London, but his progress in this direction was hampered by his lack of aptitude for mathematics. So, prompted by a meeting with an old friend, he departed for South Africa to make his fortune in the diamond fields of Kimberley. Instead, he became a journalist as co-founder, sub-editor and leader writer of the *Cape Times*.

Garstin returned to Ireland in the late 1870s, and entered a period in which he painted in the summer and hunted in the winter. Despite losing an eye, he decided to study art formally; so he attended Charles Verlat's Academy in Antwerp alongside Frank Bramley and Fred Hall (circa 1880); and under Carolus-Duran in Paris (in the early 1880s). During this period,

he developed an admiration for Degas and undertook a number of painting trips: across France, and into Italy (1884), Spain and Morocco (1885). The results included a number of fresh scenes of exteriors and interiors.

Garstin returned to England in 1886 and, soon after his marriage, settled in Cornwall, living first in Newlyn and then in Penzance. He became central to the innovative group of *plein-air* painters working in the area, many of whom, like him, were members of the New English Art Club. He was described by the Newlyn School's leader, Stanhope Forbes, as their 'intellectual mentor … as well as a much-loved figure'. Though he exhibited widely, his masterpiece, *The Rain it Raineth Every Day*, failed to be shown at the Royal Academy Summer Exhibition in 1889 through lack of space. Increasingly in need of money, he turned from landscapes to costume genre and scenes of upper-class life. He also wrote, lectured, and led a regular Summer Painting School to northern France. Most notable among his pupils were Harold Harvey and his own daughter, Alethea Garstin. In addition to a number of solo shows, he held an exhibition of watercolours with Alethea at Walker's Gallery in 1924. He died in Penzance on 22 June 1926.

While never conventionally an illustrator, Garstin demonstrated a great flair for design not only in his painting but through his interest in stencil-cutting. The work included here reveals a knowledge and understanding of such great contemporary illustrators and poster artists as William Nicholson and James Pryde (who worked together as the Beggarstaff Brothers).

His work is represented in the collections of the Tate Gallery, the Victoria and Albert Museum, and Penlee House and Gallery (Penzance).
Further reading: *Norman and Alethea Garstin*, St Ives: Penwith Gallery, 1978

99
THE HORSEMAN
signed
watercolour and bodycolour on tinted paper
13 ¾ x 11 ¼ inches
Literature: Norman Garstin, 'On Stencil Cutting: An open letter', *Studio*, vol xlii, 1908, pages 304-305
Exhibited: 'The 20th Century Show', Chris Beetles Ltd, November 1996, no 5

99

WILLIAM HATHERELL

William Hatherell, RBC RI ROI RWA (1855-1928)

William Hatherell was born at Westbury-on-Trym, near Bristol on 18 October 1855, and was educated at private schools. He worked in the City before studying art, from 1877, at the Royal Academy Schools and, under Fred Brown, at Westminster School of Art. Beginning his career as a painter, he showed work at the Royal Academy from 1879, and became a member of several exhibiting societies: the Royal Institute of Painters in Water-Colours (1888), the Royal Institute of Painters in Oils (1898), the Royal West of England Academy (1903) and the Royal British Colonial Society of Artists.

From the late 1880s, Hatherell increasingly applied his skills as a painter to his commissions as an illustrator, the new photographic methods of reproduction enabling him to work in oil on board as well as watercolour and pen and ink. He gained a reputation for refusing to produce hasty results, and became particularly expert in representing historical and literary subjects. Living in London, he joined the staff of the *Graphic* in 1892, contributed to other periodicals, and illustrated books. But he became equally popular in the United States, where his work appeared most notably in *Harper's New Monthly Magazine* and an edition of Mark Twain's *The Prince and the Pauper* (1909). His illustrative achievements led to his election as an honorary member of the Langham Sketching Club and a corresponding member of the American Society of Illustrators. He died in London on 7 December 1928.

His work is represented in the collections of the Victoria and Albert Museum, and Birmingham Museum and Art Gallery.

100

100

SHE HESITATED, AND IN THE REFLECTED LIGHT SHE LIFTED THE SHAWL COVERING THE CHILD, WITH A GESTURE AS THOUGH SHOWING IT TO SOMEONE STANDING BEHIND HER, OR PERHAPS MAKING A LAST APPEAL TO THE PITILESS HEAVENS, NOW SPANGLED WITH STARS.

signed
inscribed with title and dated 'Summer no 1906' on reverse
bodycolour
16 ¼ x 12 ½ inches
Illustrated: *Graphic*, Summer number, 1906, page 11, 'The Vain Sacrifice'

GORDON BROWNE
Gordon Browne, RBA RI (1858-1932)

101

Gordon Browne was the son of Hablot Knight Browne, who remains best known as 'Phiz', the essential illustrator of Dickens. He was born in Banstead, Surrey on 15 April 1858, and educated privately, before studying at Heatherley's School of Fine Art and the South Kensington Schools. His father became partly incapacitated by illness in 1867, and so he began to work as an illustrator while still a student in order to contribute to the family income. Work on Ascott R Hope's *The Day After the Holidays* (1875) was soon followed by numerous commissions for books and periodical contributions, and by the turn of the century he had proved extraordinarily prolific as a cartoonist as well as an illustrator. Early achievements include 550 drawings for an edition of the *Works of William Shakespeare* (1888-90), and three books of illustrated nonsense rhymes for children published under the pseudonym 'A Nobody' (1895-1900). Enormously painstaking and highly talented, he failed to equal the fame of his father only because his work appeared too widely and in cheap editions, so that he never became associated with a single significant author.

Astonishingly, Browne found time to develop a parallel career as a painter. He exhibited oils and watercolours from 1886, mainly at the Royal Society of British Artists (being a founder member in 1891) and the Royal Institute of Painters in Water-Colours (RI 1896). Browne died at his home in Richmond, Surrey on 27 May 1932.

His work is represented in the collections of the British Museum, the Victoria and Albert Museum, Townley Hall Gallery (Burnley), Doncaster Art Gallery, and Hove Library.

101
NIGHT FLIGHT
signed with initials
pen and ink
11 ¼ x 8 ¾ inches

STEPHEN REID

Stephen Reid, RBA (1873-1948)

Stephen Reid was born in Aberdeen, and studied locally at Grays School of Art, and then in Edinburgh at the Royal Scottish Academy. He developed a particular interest in historical subjects, and was influenced in this direction by the work of Edwin Austin Abbey. His illustrations first appeared in *The Temple Magazine* (1896-97) and other periodicals; while from the turn of the century he also illustrated books, including myths and legends, as well as other classics. Also a painter, he exhibited in London and the provinces, and was elected to the membership of the Royal Society of British Artists (1906). He died in Hampstead on 7 December 1948.

His work is represented in the collections of Gloucester City Museum and Art Gallery and the Museum of Reading.

102

HENRY JUSTICE FORD

Henry Justice Ford (1860-1941)

'a prime favourite with the small people'
Gleeson White

For a biography of Henry Justice Ford, please refer to *The Illustrators*, 2002, page 19.

Key work illustrated: Andrew Lang, *The Blue Fairy Book* (1889, with Percy Jacomb-Hood; the remainder of the series being illustrated by Ford alone)
His work is represented in the collections of the Victoria and Albert Museum.

103

102

CHARLES DICKENS: A TRIBUTE TO GENIUS
signed and dated 1912
pen and ink; 13 ¼ x 9 ¾ inches
Illustrated: *The Connoisseur*, April 1912, page 223

103

THE LITTLE TAILOR IN THE BRANCHES
signed
inscribed with title below mount
pen and ink
5 ¾ x 7 ½ inches
Probably drawn for but not illustrated in Andrew Lang (editor), *The Blue Fairy Book*, London: Longmans, Green and Co, 1889, 'The Brave Little Tailor'

ROBERT ANNING BELL

Robert Anning Bell, RA RWS NEAC (1863-1933)

104

For a biography of Robert Anning Bell, please refer to *The Illustrators*, 1996, pages 21-22.

Key work illustrated: John Keats, *Poems* (1897)
His work is represented in the collections of the Victoria and Albert Museum.

104

INDEX TO ILLUSTRATIONS
signed
pen and ink
3 ¼ x 9 ½ inches

JOHN ROBERT MONSELL

John Robert Monsell (born 1877)

J R Monsell was born in Cahirciveen, County Kerry, Ireland on 15 August 1877. After the early death of his father, he was brought up in County Limerick and educated at St Columba's College, Rathfarnham, Dublin. In 1896, he moved to London with his sister, Elinor, who had won a scholarship to the Slade School of Art. (She later married the writer Bernard Darwin and is best remembered for her illustrations to his series of 'Mr Tootleoo' books.) Monsell seems to have had no formal artistic training, and began to produce illustrations while telling a group of children his story *The Pink Knight*. The success of the publication of this volume, in 1901, led him to pursue illustration as a profession. By studying the work of such favourite illustrators as Randolph Caldecott and Walter Crane, he soon developed a confident line and sense of design. The resulting drawings were published in numerous periodicals – such as *Little Folks* – sometimes accompanying his stories, and as book illustrations. He also designed book jackets for the historical novels written by his wife, Margaret Irwin, aided by an early love of heraldry. His correspondence and papers are held by Cambridge University Library.

105

THE CHRISTMAS WORLD & HIS WIFE
HA! HA! MERRY CHRISTMAS!
signed and dated 09
pen ink and watercolour with bodycolour
13 ¼ x 9 ¼ inches

MASTERS OF THE GIFT BOOK: ARTHUR RACKHAM AND EDMUND DULAC

EDMUND DULAC
Edmund Dulac (1882-1953)

Edmund Dulac was born in Toulouse, in France, on 22 October 1882. His father was a commercial traveller who supplemented his income with some work as an art dealer and restorer. Also an amateur painter, he encouraged his son's talents in the same field.

Educated at the Petite Lycée through the 1890s, Dulac then enrolled at the local university to study Law. At the same time, he took classes at the Ecole des Beaux-Arts, initially to sustain a hobby. However, after two years, he weighed his boredom with Law against success at art school (as marked by a prize). So, once he had obtained the intermediary degree of a B Litt, he persuaded his parents to let him attend the Ecole on a full-time basis. During each of the following three years he won an art-school prize. At the same time, he established himself as an Anglophile: taking English lessons from a fellow lodger, reading about English illustration and design, dressing in the English manner, and even changing the spelling of his Christian name from the French form 'Edmond'. As a result, he became known among his fellow students as *l'anglais*.

In 1904, Dulac left for Paris, where – on the strength of a scholarship – he joined the Académie Julian under Jean-Paul Laurens (who had himself studied and taught in Toulouse). However, he remained in the city for just three weeks, hating its atmosphere and finding that he had already outgrown Laurens' academic training. Though he exhibited portraits at the Paris Salon in 1904 and 1905, he returned to Toulouse, there embarking on a brief and unsuccessful marriage.

In the autumn of 1904, Dulac visited England in the hope of interesting publishers in his potential as an illustrator. He arrived at an opportune moment, there being a demand for illustrators who could respond to the innovative technology of three-colour half-tone printing. J M Dent was so impressed with his work as to immediately commission a set of sixty watercolours for a new edition of the novels of the Brontë sisters. And if the results provoked mixed reviews, they nevertheless made the artist's name. He was soon invited to become a regular contributor to the *Pall Mall Magazine*.

Dulac settled properly in London in August 1905, taking lodgings in Holland Park and joining the London Sketch Club. Then, in the autumn of the following year, he took his portfolio to Ernest Brown of the Leicester Galleries to see if they might sponsor him as they had sponsored Arthur Rackham.

In 1904, the Leicester Galleries had commissioned Rackham to make a set of coloured drawings of *Rip Van Winkle* by Washington Irving and, while retaining the originals for exhibition, sold the reproduction rights to William Heinemann. This enterprise led to the establishment of the illustrated Gift Book, in which classic tales of wonder were presented in luxurious format.

Ernest Brown responded to Dulac, asking him to produce a set of drawings for *Stories from the Arabian Nights*, and then sold the rights to Hodder and Stoughton; in so doing, he instigated a rivalry which further strengthened a publishing phenomenon. When the resulting illustrations were concurrently exhibited at the Leicester Galleries and published with a text by Laurence Housman, in 1907, Dulac was revealed as a master of Orientalism, and a pattern was set for the production and presentation of his work. Of the books to appear soon after, *The Rubáiyát of Omar Khayyám* (1909) exploited the same exotic vein. By contrast, Rackham was identified with an occidental, and specifically Germanic, folk culture.

Dulac married again in 1911, and a year later became a British subject. From about this time he became a member of the circle of Edmund and Mary Davis, significant patrons of the arts, and through them befriended Charles Ricketts and Charles Shannon, and also W B Yeats. They offered Dulac a more sophisticated aesthetic environment than that of the London Sketch Club, and perhaps suggest better parallels for the range and character of his talents.

Until 1913, Dulac worked in a relatively naturalistic style with a subdued blue tonality. Then he gradually heightened his palette and stylised his compositions, drawing on a profound interest in Middle and Far Eastern Art. This was signalled by the publication of *Princess Badoura*, another of the 'Stories from the Arabian Nights' retold by Housman [see page 60]. That this direction was right for him was confirmed, in the autumn, when he and his wife joined the Davises on their yacht for a cruise through the Mediterranean. He was most seduced by the Arabic look of Siros and the Islamic culture of Tunis.

The development of Dulac's work was marked not only by this refinement of style, but by an increasingly versatility. In the spring of 1914, he exhibited his first caricatures at the International Society [for two similar examples, see page 63]. Then, soon after the outbreak of the First World War, he fulfilled a commission by the *Daily Mail* to design a set of charity stamps in aid of the Children's Red Cross. Further projects emerged in the form of charity gift books, including *Edmund Dulac's Picture Book for the Red Cross* (1915); the design – and also the music – for Yeats's play, *At the Hawk's Well* (1916); and writing of his own.

In 1918, Dulac saw the publication of Nathaniel Hawthorne's *Tanglewood Tales*, his last gift book for Hodder and Stoughton. However, it was as much a beginning as an end, its basis in late Greek vase painting extending an increasing preoccupation with flat, and often rich, decoration. The richness soon culminated in his illustrations to Léonard Rosenthal's *Au Royaume de la Perle* (1919), a non-fiction history of pearls. Taking his cue from the opulence and opalescence of his subject, he introduced surfaces that appear enamelled, gilded and studded with gems. Much of his subsequent work may be related to Art Deco.

Dulac began to depend less on book illustration, and portrait painting became his major source of income. Equally skilled at exaggerating the human likeness, he contributed a series of caricatures to the weekly newspaper, *The Outlook* (1919-20), and occasionally crafted caricature models (firstly of George Moore in 1919). It was through the editor of *The Outlook*, E R Thompson, that Dulac met the translator Helen Beauclerk. As he became gradually estranged from his wife, Beauclerk took over as his companion; and when she turned to writing novels, in 1925, he illustrated the results. In the same period, he embarked on a long association with the Hearst magazine, *American Weekly* (1924-51), contributing many themed covers. Ever willing to test his versatility, he modelled his first medals (1926); decorated a smoking room for the great luxury liner, *The Empress of Britain* (1930); and designed various products, including a chocolate box for Cadbury's and playing cards for De La Rue (both 1935).

On the outbreak of the Second World War, Dulac moved with Beauclerk to the Dorset village of Morcombelake to stay with her mother. With the founding of Free France, in 1940, he was visited there by Colonel de Gaulle who commissioned him to design banknotes and postage stamps. He considered this project the culmination of his career.

At the end of the war, Dulac returned to London, and again turned to book illustration, with a series of classics for children for the Limited Editions Club of New York. He completed three titles, including Milton's *Comus*, which proved his last work and was posthumously published in 1954. He died on 25 May 1953, from a heart attack brought on by a demonstration of flamenco dancing. The Leicester Galleries held a memorial show in the December of that year.

His work is represented in numerous public collections, including the British Museum, the Cartoon Art Trust, the Imperial War Museum, the London Museum, the Victoria and Albert Museum, the Fitzwilliam Museum, New York Public Library and Texas University.
Further reading: *Edmund Dulac: Illustrator and Designer*, Sheffield City Art Galleries, 1983; Ann Conolly Hughey, *Edmund Dulac. His Book Illustrations. A Bibliography*, Buttonwood Press, 1995; Colin White, *Edmund Dulac*, London: Studio Vista, 1976

THE STORY OF PRINCESS BADOURA

Camaralzaman is the only male heir to King Shahzaman of Khaledan, yet he refuses to marry. So his father incarcerates him. Through the agency of genies, Princess Badoura is brought to his cell from China. In turn, each falls in love with the sleeping figure of the other and, through an exchange of rings, they undergo a form of wedding ceremony. After Badoura is returned to her own bed, she insists that a 'beautiful youth' visited her at night. Her father, King Gaiour, calls for her to be cured of this madness and offers the successful doctor her hand in marriage, while threatening to execute any who fail. She tells her story to Marzavan, her nurse's son, and he seeks successfully for Camaralzaman. Camaralzaman, like Badoura, seems to be suffering from insanity, but he revives when Marzavan speaks of her. His father is so pleased by the improvement in his condition that he allows Camaralzaman out of his sight. Thus he is able to escape with Marzavan and return with him to China. Disguised as a doctor, he is given access to Badoura, and cures her by revealing himself [No 106].

Some while after his marriage to Badoura, Camaralzaman dreams of his father, 'lying as at the point of death'. So bride and groom set out to visit him. One day, on the journey, while Badoura is at rest, Camaralzaman discovers that she owns a talismanic stone. Before he has a chance to examine it properly, it is taken from him by a bird. After following the bird for many miles, he arrives at a city. There he is befriended by a gardener, who tells him that he must wait for a year for the merchant ship that will take him to Khaledan, and so to his father and his wife.

Meanwhile, Badoura has realised that Camaralzaman and the talisman that binds him to her are both missing. She decides to continue the journey, but takes the precaution of dressing in her husband's clothes, with a slave girl in her stead. On their arrival at the city of Ebony, the disguise proves successful, and they are treated as honoured guests. Indeed, King Amanos offers Badoura the hand of the Princess Hayatelnefoos and his kingdom, and she is forced by the situation to accept. After three days of frigid marriage, Badoura tells the princess her story and begs her forgiveness. She agrees and they become friends.

One day, a merchant ship arrives at the city of Ebony, and Badoura is convinced that it brings news of Camaralzaman. She buys jars of olives from the captain, and discovers gold at the bottom of each and, more decisively, the talisman. (For Camaralzaman had retrieved it while working with the gardener [No 107] and had hidden it and his gold in the olive jars, intending to set out with them to meet Badoura. However, he had been halted in his plans by the gardener's death.) The captain is sent by Badoura to find the man who owns the olive jars, and he returns with Camaralzaman. When the two meet, Badoura is still disguised as a male ruler, while Camaralzaman appears thin and poorly dressed. However, she recognises him, and the two are eventually reconciled, Camaralzaman becoming the King of the Ebony Isles.

ILLUSTRATING THE ORIENT:
PRINCESS BADOURA AND AFTER

Edmund Dulac was best known in his lifetime for his illustrations to tales from the *Arabian Nights*, published in various books and periodicals between 1907 and 1951. In identifying himself with the oriental medieval tales known also as *The Thousand and One Nights*, he was following a long-established cultural tradition, and one that was specifically European. For while the Islamic world has never considered the work to be 'part of the classical Arabic literary tradition, Europeans have certainly valued it highly as an insight into the medieval Near East' (Joanna Desmond, *Tales from the Arabian Nights*, London: the Libraries and Arts Service of Kensington & Chelsea, 1997, page 4). There have been many translations since the early eighteenth century, and many illustrated editions since the nineteenth.

Before the emergence of Dulac, illustrators of *The Arabian Nights* tended to use familiar occidental forms of naturalism. One notable exception was Walter Crane, who applied a greater, if eclectic, understanding of Far Eastern aesthetics to his picture book, *Aladdin or the Wonderful Lamp* (1875). Over thirty years later, the young Dulac sustained the western approach when he first tackled the subject in his *Stories from the Arabian Nights* (1907). For though the asymmetrical compositions may suggest *Japonisme*, his solid figures and their props sit in space as secure as that of old master painting.

Princess Badoura (1913) therefore holds a particularly seminal position in Dulac's oeuvre, for it was the first work in which he matched style to subject. At this point in his career, he had not travelled beyond Britain and France, and the oriental world that he constructed remained one of his own imagining. However, it was informed increasingly by an impressive cultural knowledge as well as by such existing representations as Leon Bakst's exotic designs

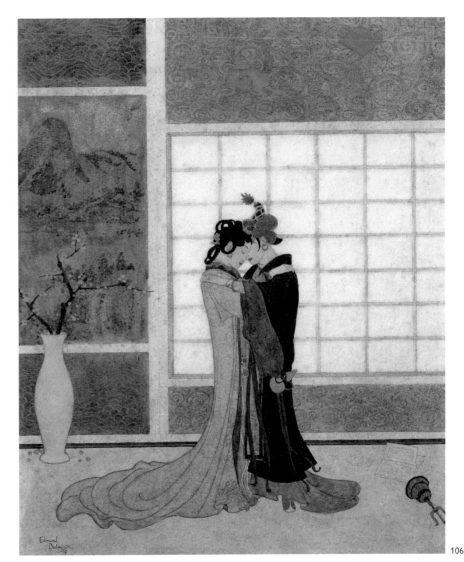

106

106

CAMARALZAMAN CURES BADOURA
She ran forth, and threw herself into the arms of Camaralzaman
signed and dated '13
watercolour
12 x 9 ½ inches

Illustrated: Laurence Housman (retold by), *Princess Badoura. A tale from the Arabian Nights*, London: Hodder and Stoughton, 1913, facing page 48
Exhibited: 'Some British Illustrators', Fine Art Society, 1965, no 98

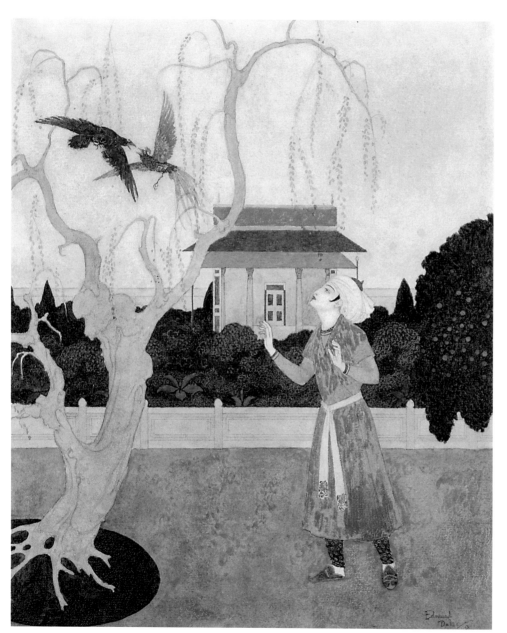

107

107

PRINCE CAMARALZAMAN AND
THE BIRDS
In the leaves overhead he saw one
furiously attacking another with
beak and claw
signed and dated '13
11 ¾ x 9 ½ inches
Illustrated: Laurence Housman
(retold by), *Princess Badoura. A tale
from the Arabian Nights*, London:
Hodder and Stoughton, 1913,
facing page 72
Exhibited: 'Some British
Illustrators', Fine Art Society,
1965, no 108

for Diaghilev's Ballets Russes. So the illustrations to *Princess Badoura* draw more thoroughly on oriental principles – of flat planes, patterned shapes and decorative surfaces – with specific Chinese and Persian elements reflecting various narrative episodes. The lettering in English on the title page and elsewhere in the book is in a font that Dulac derived from Arabic, and demonstrates an exploration of Eastern languages and scripts equivalent to his art historical studies. (Edward Dennison Ross, the Director of the School of Oriental Studies, and Professor of Persian, would later express amazement at his knowledge of Persian art, which was 'then still an esoteric field' (Colin White, op cit, page 86)).

This heightened engagement with the East surely made Dulac keen to travel. So, in the autumn of 1913, he and his wife accepted an invitation from Edmund and Mary Davis to join them on their yacht for a cruise of the Mediterranean. He recorded the places that he visited in diaries and sketchbooks, and responded particularly to colour and texture, describing the places that he encountered as if they were richly decorative landscape paintings. Most inspiring were the cities suggestive of *The Arabian Nights*: Hermopolis (on Siros) and Tunis. He 'experienced... the satisfaction of recognizing the accuracy of his earlier work' (op cit, page 65), and gathered much material for subsequent projects.

While the success of *Princess Badoura* and the inspiration of travels led Dulac immediately to produce the illustrations to *Sinbad the Sailor* (1914), the spirit of Arabia gradually emerged in a wide variety of his work: In 1916, Dulac drew an affectionate caricature of E D Ross as 'a turbaned Sultan' in 'a pastiche of a Persian miniature' (op cit, page 86). In 1926, while chairman of the Film Society, he produced credit titles in his Anglo-Arabic script for Lotte Reiniger's silhouette film, *The Adventures of Prince Achmed*, based on a tale from *The Arabian Nights*. In about 1935, he designed a set of playing cards, in five suits, on Moghul motifs for the Persian market, which was printed by Thomas De La Rue and Sons. Then, in 1947, he devised the new emblem of a stylised olive tree for the Ottoman Bank which still remains in use.

This summary of activities seems to suggest that with each decade Dulac's style came closer to his sources and was increasingly accepted by the culture from which those sources derived. Yet, in parallel, he continued to interpret *The Arabian Nights* for a western public, in his series of covers for *American Weekly* (in 1925 and 1950-51). Undoubtedly, until the end of his career, 'he could still convey the feeling of an unattainable Eastern paradise better than any of his contemporaries' (op cit, page 182), and for many audiences; and this at the same time as adapting and absorbing other exotic and vernacular styles, from that of Medieval Europe through Ancient Greece to traditional Japan. The work on *Princess Badoura* was not only instrumental in the Persian strand of Dulac's career, but in his radical – almost global – versatility.

108

109

108

ISIDORE DE LARA

signed, inscribed 'Apollon Isidoros' in Greek and dated 1917

signed, dated 1917 and dedicated 'to S A Serenissime Madame la Princesse de Monaco' below mount

watercolour with bodycolour

13 ½ x 9 ¾ inches

In 1892 the song writer Isidore de Lara was praised for his opera, *The Light of Asia*. seven years later he dedicated another opera, *Messaline*, to the Princess of Monaco.

109

PERFECT PEACE (MR BALFOUR)

A REMINISCENCE OF SAN REMO

signed, inscribed with title and dated 20

pen and ink

10 x 7 inches

Exhibited: 'Exhibition of Works by Edmund Dulac', Leicester Galleries, June 1920, no 61

ARTHUR RACKHAM

Arthur Rackham, VPRWS (1867-1939)

For a biography of Arthur Rackham, please refer to *The Illustrators*, 1999, pages 97-98; for essays on various aspects of the artist's achievement, refer to *The Illustrators*, 1997, pages 124-125; *The Illustrators*, 1999, pages 98-99; and *The Illustrators*, 2000, pages 14-15.

Key works illustrated: S J Adair-Fitzgerald, *The Zankiwank and the Bletherwitch* (1896); R H Barham, *The Ingoldsby Legends* (1898); Mrs Edgar Lewis (translator), *Fairy Tales of the Brothers Grimm* (1900); Washington Irving, *Rip Van Winkle* (1905); J M Barrie, *Peter Pan in Kensington Gardens* (1906); William Shakespeare, *A Midsummer Night's Dream* (1908); Richard Wagner, *The Rhinegold and The Valkyrie* (1910); Richard Wagner, *Siegfried and The Twilight of the Gods* (1911); Charles S Evans, *Cinderella* (1919); Edgar Allen Poe, *Tales of Mystery and Imagination* (1935)
His work is represented in numerous public collections, including the Victoria and Albert Museum, the Butler Library (Columbia University), New York Public Library and the University of Texas.
Further reading: James Hamilton, *Arthur Rackham: A Life with Illustration*, London: Pavilion Books, 1990

110

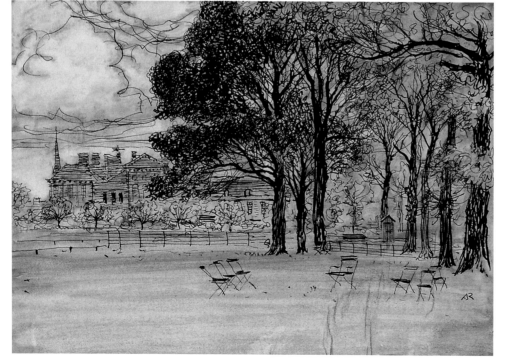

111

110
THE SAPLING
signed on reverse
pen and ink
3 ½ x 3 inches

111
KENSINGTON GARDENS
signed with initials
pen ink and watercolour
7 ¼ x 10 inches
Associated with J M Barrie, *Peter Pan in Kensington Gardens*, London: Hodder and Stoughton, 1906

112
GULLIVER'S COMBAT WITH THE WASPS
signed and dated 1909
inscribed with title and publication details
on reverse
pen ink and watercolour
8 ½ x 6 inches
Illustrated: Jonathan Swift, *Gulliver's Travels into Several Remote Nations of the World,* London: J M Dent & Co, 1909, facing page 96
Exhibited: 'Works by Arthur Rackham', Leicester Galleries, December 1909, no 44

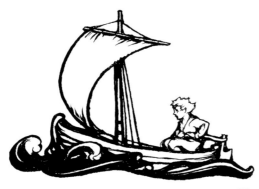

113

114

116

The INGOLDSBY LEGENDS

MIRTH & MARVELS

BY THOMAS INGOLDSBY Esqre

ILLUSTRATED BY ARTHUR RACKHAM ARWS

LONDON·J·M·DENT & CO ·1907·

115

113
A CHILD'S FUTURE
pen and ink
2 ½ x 3 inches
Illustrated: Algernon Charles
Swinburne, *The Springtide of Life*,
London: William Heinemann,
1918, page 61

114
THE POOR LITTLE PAGE TOO,
HIMSELF GOT NO QUARTER
signed and dated 98
*inscribed with title and publication
details below mount*
pen and ink; 10 ½ x 7 inches
Illustrated: [Rev R H Barham],
The Ingoldsby Legends, or *Mirth &
Marvels*, by Thomas Ingoldsby Esquire,
London: J M Dent & Co, 1898,
page 108

115
FRONTISPIECE TO THE 1907
SECOND EDITION OF THE
INGOLDSBY LEGENDS
pen and ink
6 ½ x 4 ¼ inches
Illustrated: [Rev R H Barham],
The Ingoldsby Legends, or *Mirth &
Marvels*, by Thomas Ingoldsby Esquire,
London: J M Dent & Co, 1907

116
OLD WOMAN AT A SPINNING
WHEEL
signed and inscribed 'Hardangerfjord'
watercolour and pencil
8 ½ x 5 ¼ inches

117

118

119

120

117

THE RIVER ARUN AT AMBERLEY,
SUSSEX
signed
watercolour
9 ¾ x 7 inches

118

THE INGOLDSBY LEGENDS
ink and gold print
8 x ¼ x 5 ½ inches
Preparatory drawing for [Rev R H
Barham], *The Ingoldsby Legends*, or
*Mirth & Marvels, by Thomas Ingoldsby
Esquire*, London: J M Dent & Co,
1898

119

THE INGOLDSBY LEGENDS:
THE GATE
pen and ink with bodycolour
8 x 5 ½ inches
Drawn for but not illustrated in
[Rev R H Barham], *The Ingoldsby
Legends*, or *Mirth & Marvels, by
Thomas Ingoldsby Esquire*, London: J
M Dent & Co, 1907, cover or
title page

120

FATHER FRANCIS
signed with initials
pen and ink
4 x 2 ¾ inches
Illustrated: [Rev R H Barham],
The Ingoldsby Legends, or *Mirth &
Marvels, by Thomas Ingoldsby Esquire*,
London: J M Dent & Co, 1898,
page 177, 'The Lady Rohesia'

121

122

121

NOW ST MEDARD DWELT ON THE
BANKS OF THE NILE
signed with initials and dated 98
inscribed with title and story title
below mount
pen and ink
6 x 9 inches

Illustrated: [Rev R H Barham],
The Ingoldsby Legends, or *Mirth &*
Marvels, by Thomas Ingoldsby Esquire,
London: J M Dent & Co, 1898,
page 495, and 1907, page 424,
'St Medard'

122

THEY CAN'T FIND THE RING
signed
pen ink and watercolour
7 ½ x 5 ½ inches
Illustrated: [Rev R H Barham],
The Ingoldsby Legends, or *Mirth &*
Marvels, by Thomas Ingoldsby Esquire,

London: J M Dent & Co, 1898,
page 139, 'The Jackdaw of
Rheims'

123

123
CALLING SHAPES, AND BECKNING
SHADOWS DIRE
signed and dated 1914
pen ink and watercolour
12 x 9 ¾ inches
Illustrated: John Milton, *Comus*,
London: William Heinemann,
1921, plate viii

124

127

124

SIR CHRISTOPHER HATTON HE
DANCED WITH GRACE
signed with initials
inscribed with title and poem title
below mount
pen and ink; 4 ½ x 3 ½ inches
Illustrated: [Rev R H Barham],
*The Ingoldsby Legends, or Mirth &
Marvels, by Thomas Ingoldsby Esquire,*
London: J M Dent & Co, 1898,
page 577, and 1907, page 577,
'The House-warming!!'

125

THE DEAD DRUMMER
signed with initials
pen and ink
3 x 6 ½ inches
Illustrated: [Rev R H Barham],
*The Ingoldsby Legends, or Mirth &
Marvels, by Thomas Ingoldsby Esquire,*
London: J M Dent & Co, 1898,
page 425, and 1907, page
362, 'The Dead Drummer'

126

I TOOK HIM HOME TO NO 2
signed and dated 98
inscribed with title and publication
details
pen and ink; 6 x 4 inches
Illustrated: [Rev R H Barham],
*The Ingoldsby Legends, or Mirth &
Marvels, by Thomas Ingoldsby Esquire,*
London: J M Dent & Co, 1898,
page 391, 'Misadventures
at Margate'

127

THE FAST RUNNING STREAM
signed
watercolour
7 x 5 inches

128

129

128

LADY WITH FAN

pencil

14 x 7 inches

Provenance: The Estate of Barbara
Edwards, the artist's daughter,
Phillips Son & Neale sale, 1990

129

THE ENJOYMENT OF A GARDEN

signed

inscribed 'A Garden Terrace' below mount

pen and ink

3 ½ x 5 ¼ inches

Illustrated: S Reynolds Hole, *Our Gardens* (Haddon
Hall Library series), London: Dent, 1899, page 3

130

BOY AND GIRL DANCING

pen and ink

3 x 4 inches

THE BROTHERS ROBINSON

WILLIAM HEATH ROBINSON
William Heath Robinson (1872-1944)

For a biography of William Heath Robinson, please refer to *The Illustrators*, 1999, pages 72-73; for essays on various aspects of his achievement, refer to *The Illustrators*, 1996, pages 112-113; *The Illustrators*, 1997, pages 124-125, *The Illustrators*, 1999, pages 73-74; and *The Illustrators*, 2000, pages 17-18.

Key works illustrated: *The Poems of Edgar Allan Poe* (1900); *The Works of Mr Francis Rabelais* (1904); *Hans Andersen's Fairy Tales* (1913); Shakespeare, *A Midsummer Night's Dream* (1914); Walter de la Mare, *Peacock Pie* (1918); contributed to the *Bystander* (from 1905) and the *Sketch* (from 1906)
Key works written and illustrated: *The Adventures of Uncle Lubin* (1902); *Bill the Minder* (1912)
His work is represented in the collections of the British Museum, the Cartoon Art Trust, and the Victoria and Albert Museum.
Further reading: Geoffrey Beare, *The Brothers Robinson*, London: Chris Beetles Ltd, 1992; Geoffrey Beare, *Heath Robinson Advertising*, London: Bellew, 1992; Geoffrey Beare, *The Illustrations of W Heath Robinson*, London: Werner Shaw, 1983; James Hamilton, *William Heath Robinson*, London: Pavilion Books, 1992; John Lewis, *Heath Robinson. Artist and Comic Genius*, London: Constable, 1973

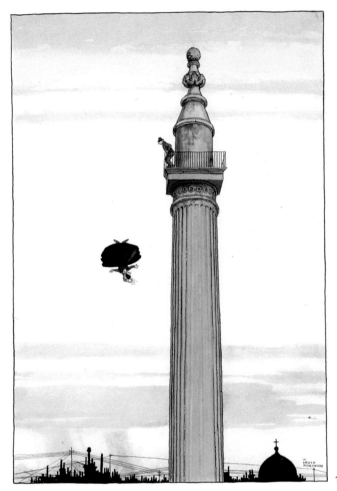

131

131
A DAY OUT WITH AUNTIE
signed
pen ink and monochrome watercolour
15 x 10 ¼ inches
Illustrated: *Sketch*, 7 February 1917, page 129
Exhibited: 'The Brothers Robinson', Chris Beetles Ltd, February-March 1992, no 388

132
HE HAD HIS EYES ALWAYS FIXED UPON ONE OF HER SLAVES
signed with initials
inscribed with title and publication details below mount
pen and ink
9 ¼ x 18 inches
Illustrated: *The Arabian Nights*, London: George Newnes, 1899, page 465, 'The Story of Abou Hassan'

133
PLACED HIM AS HE DESIRED
signed with initials
inscribed with title and 'Abou Hassan, p 527'
5 ½ x 14 inches
Illustrated: *The Arabian Nights*, London: George Newnes, 1899, page 466, 'The Story of Abou Hassan'

134
THE GRAND VIZIER LED HIM
signed with initials and inscribed 'Mesrour walked before him' and 'Abou Hassan, p 513'
11 x 7 ¼ inches
Illustrated: *The Arabian Nights*, London: George Newnes, 1899, page 456, 'The Story of Abou Hassan'

"FIRE WAS BROUGHT IN"

136

135
FIRE WAS BROUGHT IN
signed with initials and inscribed with title and 'Amina' twice
6 ½ x 14 inches
Illustrated: *The Arabian Nights*, London: George Newnes, 1899, page 93, 'The Story of Amene'

136
HE FILLED UP THE JAR WITH OLIVES
signed with initials
inscribed 'and covered them over with olives' and 'Ali Cogia, p 435' below mount
10 ½ x 15 inches
Illustrated: *The Arabian Nights*, London: George Newnes, 1899, page 444, 'The Story of Ali Cogia'

137
THE GRAND VIZIER FRYING THE FISHES
inscribed with title
pen and ink
12 x 8 inches
Illustrated: *The Arabian Nights*, London: George Newnes, 1899, page 31, 'Further Adventures of the Fisherman'

138
A SMALL STREAM WHICH I CROSSED
signed and dated '99
inscribed '"Crossed" (Arabian Nights pt 3) "Third Calender"' below mount
pen and ink
13 ¾ x 10 inches
Illustrated: *The Arabian Nights*, London: George Newnes, 1899, page 75, 'The History of the Third Calender'

139

THE MOTOR PLOUGH

143

144

142

HE TURNED THE MOUTH
DOWNWARDS
pen and ink
12 x 8 inches
Illustrated: *The Arabian Nights*,
London: George Newnes, 1899,
page 19, 'The Story of the
Fisherman'

143

THE MOTOR PLOUGH
signed and inscribed with title
pen ink and watercolour with pencil
7 ½ x 14 ¼ inches

139

A CADI, WITH FOUR WITNESSES
ENTERED
signed with initials and inscribed with
title and 'Amina'
13 ½ x 10 ½ inches
Illustrated: *The Arabian Nights*,
London: George Newnes, 1899,
page 90, 'The Story of Amene'

140

ABOU HASSAN WAS IN THE MOST
INEXPRESSIBLE AMAZEMENT
signed with initials
inscribed with title and publication
details below mount
10 ¾ x 16 inches
Illustrated: *The Arabian Nights*, London:
George Newnes, 1899, page 455,
'The Story of Abou Hassan'

141

I LED THIS WEARISOME LIFE FOR A
WHOLE MONTH
signed with initials
pen and ink
15 ½ x 11 ½ inches
Illustrated: *The Arabian Nights*,
London: George Newnes, 1899,
page 74, 'The History of the Third
Calendar'

144

THE TALKING THRUSH
pen ink and monochrome watercolour
12 ¼ x 8 ½ inches
Illustrated: W H D Rouse, *The
Talking Thrush and Other Tales from
India*, London: J M Dent & Co,
1899, cover

147

148

146

149

147
THE DUCK POND
inscribed with title
pen and ink with pencil
9 ¼ x 9 inches

145
A MILK MAID
signed and inscribed with title and
'to hang from trees'
watercolour with pen ink and pencil
13 x 10 inches

146
THE DONKEY INCUBATOR
signed with initials and inscribed with
title
pen and ink with pencil
9 ½ x 14 ½

148
OX TAIL SOUP TANK
signed with initials
pen and ink with pencil
9 x 8 ¾ inches

149
THE BEEIST
signed and inscribed with title
watercolour with pen ink and pencil
10 ½ x 10 inches

150

151

152

153

150

CROWS AND RAVENS FLEW OUT
OF THE OPENINGS

signed with initials
inscribed with story title below mount
pen and ink
8 x 11 inches
Illustrated: *Hans Andersen's Fairy
Tales*, London: Constable & Co,
1913, page 99, 'The Snow Queen'

151

WORK, CLOWN, WORK

signed and inscribed with title
pen and ink
22 x 15 ¼ inches
Illustrated: *The Works of Rabelais*,
London: Grant Richards, 1904,
vol ii, page 157

152

MY HATCHET, LORD JUPITER, MY
HATCHET

signed and inscribed with title
pen and ink
22 x 15 ½ inches
Illustrated: *The Works of Rabelais*,
London: Grant Richards, 1904,
vol ii, page xxi

153

THE POOR SOT DARE NOT
DEFEND HIMSELF

signed and inscribed with title
pen and ink
22 x 17 ¾ inches
Illustrated: *The Works of Rabelais*,
London: Grant Richards, 1904,
vol i, page 245
Exhibited: 'W Heath Robinson
(1872-1944)', Chris Beetles Ltd,
March 1987, no 20

154

154

THE OFFICER HAD HIS HANDS FULL
*signed and inscribed 'the officer had
his hands full, never wanting patients'*
pen and ink
23 x 18 ½ inches
Illustrated: *The Works of Rabelais*,
London: Grant Richards, 1904,
vol ii, page 261

155

OLIVIA: 'BUT WE WILL DRAW THE
CURTAIN AND SHOW THE PICTURE'
TWELFTH NIGHT, ACT I, SCENE V
signed
*watercolour with bodycolour and
pencil*
21 x 11 inches
Illustrated: *William Shakespeare's
Twelfth Night*, London: Hodder &
Stoughton, 1908, facing page 26

156

157

156

CABINET COUNCILLORS WERE WALKING ABOUT BAREFOOTED

inscribed with story title below mount

pen and ink

8 ½ x 6 ¼ inches

Illustrated: *Hans Andersen's Fairy Tales*, London: Constable & Co, 1913, page 113, 'The Snow Queen'

157

AND PLAY WITH THE SWEET LITTLE CREATURES

inscribed with title below mount

pen and ink

11 x 8 inches

Illustrated: Miguel de Cervantes, *The Adventures of Don Quixote*, London: Dent, 1953, page 273

Exhibited: 'The Brothers Robinson', Chris Beetles Ltd, February-March 1992, no 317

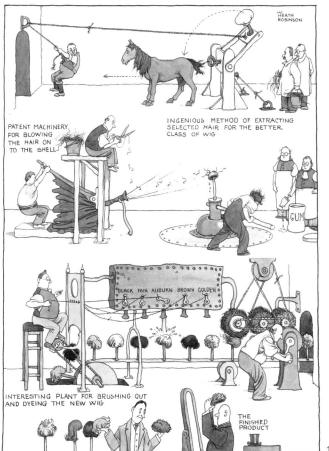

158

INTERESTING SIDELIGHTS ON THE
WIG INDUSTRY (MASS
PRODUCTION FOR THE MILLIONS)
signed and inscribed with title and captions
pen ink and pencil with monochrome
watercolour
15 ¾ x 11 inches
Illustrated: *Hutchinson's Magazine*,
May 1926, page 529

159

NEW SEASIDE SPORTS
signed and inscribed with captions
pen ink and monochrome watercolour
15 x 12 inches
Illustrated: *Humorist*, 5 August
1939, page 115

160

THE NEW MOVABLE WALLS FOR
FLATS — ENABLING NEXT DOOR
NEIGHBOURS TO HOLD LARGER
PARTIES BY MUTUAL
ARRANGEMENT ON DIFFERENT
DATES
signed and inscribed with title and
'Sunday Graphic'
pen ink and monochrome watercolour
14 ½ x 10 ½ inches
Probably illustrated in the
Sunday Graphic

THE SUNK BATH
TO AVOID EMBARRASSING SITUATIONS 161

THE DRAUGHT UNDER THE DOOR 162

161

THE SUNK BATH TO AVOID
EMBARRASSING SITUATIONS
inscribed with title
pen and ink
5 ¾ x 4 ¾ inches
Illustrated: W H Robinson and K
R G Browne, *How to live in a flat*,
London: Hutchinson & co, 1936,
page 16

162

THE DRAUGHT UNDER THE DOOR
inscribed with title
pen and ink
4 x 5 ½ inches
Illustrated: W H Robinson and K
R G Browne, *How to live in a flat*,
London: Hutchinson & Co, 1936,
page 115

163

THE CONVERSION OF AN OLD
FASHIONED SCULLERY TO A
BATHROOM
inscribed with title
pen and ink
7 x 5 ½ inches
Illustrated: W H Robinson and K
R G Browne, *How to Live in a Flat*,
London: Hutchinson & Co, 1936,
page 81

164

THE FRESH AIR PARLOUR
MABLEDENE MANSIONS TOOTING
VALE
inscribed with title
pen and ink
11 x 6 ½ inches
Illustrated: W H Robinson and K
R G Browne, *How to Live in a Flat*,
London: Hutchinson & Co,1936,
page 26

THIN WALLS 165

166

A FESTIVAL OF HEATH ROBINSON

Autumn 2003 comprises a festival of Heath Robinson. This quintessential English illustrator is not only a featured artist in this annual Illustrators show, but will be seen in an important and comprehensive exhibition at Dulwich Picture Gallery from 5 November 2003 to 18 January 2004. In this museum show, 130 works will portray the often forgotten range of his genius. Not only will they confirm the mechanical inventive whimsy that earned him the soubriquet the 'Gadget King', but a beautiful collection of his best illustrative artwork will replace him among the greatest pre-war gift book illustrators such as Arthur Rackham and Edmund Dulac. This rarely seen collection is owned by the William Heath Robinson Trust which conserves the remarkable gift left by Heath Robinson's daughter Joan Brimsmead. Money raised by this popular show will contribute to the founding of a permanent home for his artwork – a Heath Robinson Museum in Pinner where the artist lived for many years.

During the first two weeks of the run, Dulwich Picture Gallery will also host a big commercial show of Heath Robinson's work presented by Chris Beetles Ltd. The exhibition of over 100 works for sale will be hung in the spacious and light Linbury Room. Though there will be a selection of great illustrative work from classics such as *Hans Andersen's Fairy Tales*, *Rabelais* and A *Midsummer Night's Dream*, this selling show will delight with full sized cartoons of 'machine and inventions' for the *Tatler* and *Sketch* magazines. The entertainment continues with a show within the show. For the first time, over sixty pictures show off the lightness of being 'at home' with Heath Robinson: the conundrum of banal domestic events furnished with endless complex machines, time-saving gadgets and wonderfully pointless appliances. These are mysterious graphic events, all in the name of *How to Live in a Flat* (1936), *How to be a Perfect Husband* (1937) and *How to be a Motorist* (1939).

Dulwich Picture Gallery, Linbury Room, 5-16 November 2003

Gallery Road
Dulwich Village
London SE21 7AD
020 8693 5254

165
THIN WALLS
inscribed with title
pen ink and monochrome watercolour
4 ¾ x 5 ¼ inches
Illustrated: W Heath Robinson and K R G Browne, *How to Live in a Flat*, London: Hutchinson & Co, 1936, page 116

166
COMPENDIUM
signed
inscribed with title below mount
pen ink and monochrome watercolour
4 ¾ x 4 ¼ inches
Illustrated: W H Robinson and K R G Browne, *How to be a Perfect Husband*, London: Hutchinson & Co, 1937, page 62

CHARLES ROBINSON

Charles Robinson, RI (1870-1937)

For a biography of Charles Robinson, please refer to *The Illustrators*, 1997, pages 96-97.

Key works illustrated: Robert Louis Stevenson, *A Child's Garden of Verses* (1895); Percy Bysshe Shelley, *The Sensitive Plant* (1911); Oscar Wilde, *The Happy Prince* (1913)
His work is represented in the collections of the Victoria and Albert Museum, and Townley Hall Gallery (Burnley).
Further reading: Geoffrey Beare, *The Brothers Robinson*, London: Chris Beetles Ltd, 1992

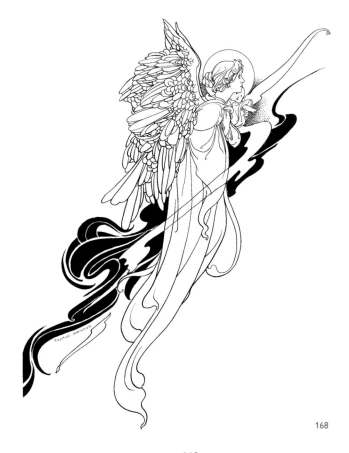

168

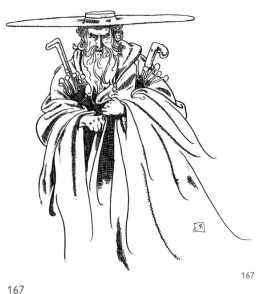

167

167

OLE LUKOIE
signed with initials
pen and ink
11 ½ x 11 ½ inches
Illustrated: *Andersen's Fairy Tales*,
London: J M Dent & Sons, 1899,
page 479, 'Ole Lukoie, the Dustman'
Exhibited: 'The Brothers Robinson',
Chris Beetles Ltd,
February-March 1992, no 25

168

ANGEL WITH A BABY
signed
pen and ink
19 ½ x 15 inches
Illustrated: *Andersen's Fairy Tales*,
London: J M Dent & Sons, 1899,
fourth end paper

169

SENT A FOWLER TO CATCH HIM
signed
pen and ink
8 x 11 ¾ inches
Illustrated: William Canton
(editor), *The True Annals of
Fairyland: The Reign of King Herla*,
London: J M Dent & Co, 1900,
page 23, 'The Valiant Blackbird'
Exhibited: 'The Brothers Robinson',
Chris Beetles Ltd,
February-March 1992, no 56

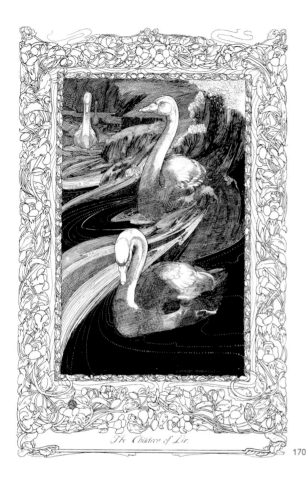

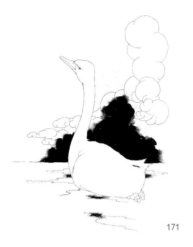

171

172

170

THE CHILDREN OF LIR
signed and dated 1900
pen and ink
18 ¾ x 12 inches
Illustrated: William Canton
(editor), *The True Annals of
Fairyland: The Reign of King Herla*,
London: J M Dent & Co, 1900,
page 250, 'The Doom of the
Children of Lir'
Literature: *Brush and Pencil*,
Chicago, July 1901, page 196

171

THE DUCKLING HAD NEVER SEEN
ANYTHING AS BEAUTIFUL BEFORE
*inscribed with title and story title
below mount*
pen and ink with coloured pencil
5 ¾ x 4 ½ inches
Illustrated: Walter Jerrold
(editor), *The Big Book of Fairy Tales*,
London: Blackie and Son, 1911,
page 47, 'The Ugly Duckling'

172

BEGORRAH! SAID ONE OF THE
COURTIERS
inscribed with title
pen and ink
4 ½ x 1 ¾ inches
Illustrated: J M Gibbon
(compiler), *The True Annals of
Fairyland: The Reign of Old King
Cole*, London: J M Dent & Co,
1900, page 114
Exhibited: 'The Brothers Robinson',
Chris Beetles Ltd,
February-March 1992, no 153

173

SHE SAW AN ANGEL STANDING
THERE IN LONG WHITE ROBES
AND WINGS WHICH REACHED
FROM HIS SHOULDERS TO THE
GROUND
signed
pen and ink, 16 x 8 ¾ inches
Illustrated: *Andersen's Fairy Tales*,
London: J M Dent & Sons, 1899,
page 97, 'The Red Shoes'
Exhibited: 'The Brothers Robinson',
Chris Beetles Ltd,
February-March 1992, no 13

THOMAS HEATH ROBINSON
Thomas Heath Robinson (1869-1953)

Thomas Heath Robinson was born in Islington, North London, on 19 June
1869. He attended local schools before studying at Islington School of Art
(from 1885). Following the profession of his father, Thomas Robinson, he
published his first illustrations in 1893, to a story by Mrs M E Braddon, in
Pall Mall Magazine. Two years later, George Allen gave him his first commission
for a book, Frank Rinder's retelling of legends from *Old World Japan*. He rose
to the occasion on this and subsequent projects, soon becoming one of the
leading black-and-white artists of his age. Specialising in historical subjects,
which he represented with both care and flair, he illustrated over thirty
books and contributed regularly to magazines during the first decade of his
career. His hard work continued to prove successful until the outbreak of
the First World War, and his family life – in Hampstead (from 1902) and
then in Pinner (from 1906) – was happy. But he then succumbed to such
hardships of war as paper shortages and slackening demands for books.
While his fortunes were slow to revive, he continued to paint and etch, as
well as illustrate, and was an active member of the Langham Sketching
Club. He even taught himself Greek. From 1926, his skill as an illustrator
was again in demand, though mostly for children's annuals and cheap
productions. Following the death of his wife, in 1940, Robinson moved to
St Ives, in Cornwall, dying there in February 1953.

Further reading: Geoffrey Beare, *The Brothers Robinson*, London: Chris
Beetles Ltd, 1992

175

NOËL

174

175

PAR LE SENTIER
ON THE PATH BY L DE COURMONT
pen and ink
9 x 8 ¾ inches
Illustrated: Bernard Minssen
(selected by), *A Book of French Song
for the Young*, London: J M Dent &
Co, 1899, page 53

174

NOEL
pen and ink
9 x 8 ¾ inches
Illustrated: Bernard Minssen
(selected by), *A Book of French Song
for the Young*, London: J M Dent &
Co, 1899, page 35

176

A CHILD'S BOOK OF SAINTS
pen and ink
15 x 12 ½ inches
Illustrated: William Canton, *A
Child's Book of Saints*, London: J M
Dent & Co, 1898, cover and spine

MEMBERS OF THE LONDON SKETCH CLUB AND THE SAVAGE CLUB

LEONARD RAVEN-HILL
Leonard Raven-Hill (1867-1942)

Leonard Raven-Hill was born in Bath on 1 March 1867, the son of William Hill, a law stationer. He was educated at Bristol Grammar School and Devon County Grammar School, and first studied at Bristol School of Art. Following his move to the Lambeth School of Art, in London, he contributed his first cartoons to *Judy* with the signature 'Leonard Hill' (1885). At that time, he shared lodgings with Charles Shannon, and fell under the influence of Charles Ricketts. Possibly on Ricketts' recommendation, he moved to Paris to study under Bouguereau and Morot at the Académie Julian (1885-87); while there, he exhibited at the Paris Salon. In London, he exhibited history paintings and illustrations at the Royal Society of British Artists (1887-90) and the Royal Academy (1889-98), and held solo shows at the Fine Art Society and other dealers.

Best known as a cartoonist and illustrator, Raven-Hill developed his approach by working with Phil May, and would become a member of the Savage Club. He was employed as Art Editor of *Pick-me-up* (from about 1890) and founded the *Butterfly* (1893) and the short-lived *Unicorn* (1895). Contributing to *Punch* from 1895,

177

he acted as second cartoonist to Bernard Partridge from 1910 to 1935 when failing eye-sight necessitated his retirement. In drawing the topical themes of the week, he was compared to Charles Keene, an artist whom he had studied closely. However, he was one of the most versatile of Edwardian artists, and was greatly admired for both the revealing humour of his First World War cartoons, and for his later illustrations to Rudyard Kipling's *Stalky and Co* (1929). His second wife was Marion Jean Lyon, *Punch*'s advertising manager. He died at Ryde on the Isle of Wight on 31 March 1942.

His work is represented in the collections of the British Museum, the National Portrait Gallery, the Tate Gallery, the Victoria and Albert Museum, Birmingham City Museum and Art Gallery, and Townley Hall Gallery (Burnley).

177
MARKET-DAY HUMOURS
LOCAL WIT: 'I ZAY, MR AUCTIONEER, DO THIC SIGNIFY TH' AGE 'O THAT PEG?'
signed, inscribed with title and dated 1897
pen and ink
6 x 9 ½ inches
Illustrated: *Punch*, 17 April 1897, page 183

GEORGE BELCHER
George Frederick Arthur Belcher, RA (1875-1947)

For a biography of George Belcher, please refer to *The Illustrators*, 1997, pages 98-99.

Contributed regularly to *Punch* (from 1911); member of the Savage Club His work is represented in the collections of the British Museum, the Cartoon Art Trust, the Tate Gallery, the Victoria and Albert Museum, and Townley Hall Gallery (Burnley).

179

178

178
ACQUAINTANCE: 'SO YER OFF TOMORRER'
BLUE JACKET: 'YES WORSE LUCK. LOOK AT THE LOVELY PROMENADE 3 MILES LONG AND PUBS OPEN ALL DAY. WHY THE ADMIRAL WHOSE SHIP IS OFF THE ISLE OF MAN WANTS TO GO AWAY, EAVEN ONLY KNOWS'
signed
inscribed with title and 'For Edward Squire...Primrose Club' below mount
charcoal with watercolour
12 ¼ x 16 ¾ inches
Illustrated: *Punch*, 10 October 1923, page 351

179
CUSTOMER (TO VILLAGE HANDYMAN): 'WHAT A LOT OF LITTLE WHEELS YOU HAVE ALL OVER THE PLACE! WHAT ARE THEY FOR?'
HANDYMAN: 'WELL, YOU SEE, SIR, EVERY TIME I MEND A CLOCK I HAVE A CUPFUL OF WHEELS OVER.'
signed and inscribed 'You've got a drawerfull of wheels, here, where on earth do you get hem all from [?] well when I mends a clock I get so many wheels I don't know what to do with 'em'
pencil
14 x 13 inches
Illustrated: *Punch*, 3 May 1933, page 485

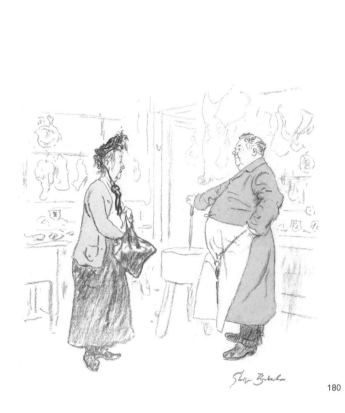

180

182

180

BUTCHER: 'HAS YOUR HUSBAND GOT ANY WORK, MRS GREEN?' CUSTOMER: 'NO 'E 'AINT DOIN' NOTHIN'. YER SEE 'E'S BIN WAITIN' FOR YEARS EXPECTING TO START ON THE CHANNEL TUNNEL'
signed and inscribed with title
charcoal with monochrome watercolour
13 x 13 ¼ inches
Illustrated: *Punch*, 30 January 1929, page 121

181

NO, MR JENKINS DON'T TAKE ME TO ASCOT. YER SEE IT AIN'T QUITE THE "AIL-FELLER-WELL-MET" WHAT THE DERBY IS
signed
inscribed with title below mount
charcoal with watercolour
11 x 15 ½ inches
Illustrated: *Punch*, 27 June 1923, page 619

182

PACKED!
Actor: 'Were you at Harry's funeral?'
Acquaintance: 'No; were there many there?'
Actor: 'Terrific, dear boy; terrific! we were turning 'em away.'
signed
charcoal and watercolour
13 x 9 ¼ inches
Illustrated: *Tatler*, 25 August 1920, page 261

183

TALK, LADY? WHEN 'E GETS A-GOING THE OTHER BIRDS CAN'T 'EAR THEIRSELVES THINK!
signed
charcoal
12 ½ x 12 ½ inches
Illustrated: *Punch*, 13 February 1935, page 193

FRANK REYNOLDS

Frank Reynolds, RI (1876-1953)

For a biography of Frank Reynolds, please refer to *The Illustrators*, 1997, page 99.

Made his name with full-page comic drawings for the *Sketch* (from 1900); began to contribute to *Punch* in 1906, joined the staff in 1919, and became Art Editor in 1920; President of the London Sketch Club between 1909-10 His work is represented in the collections of the Imperial War Museum, the Victoria and Albert Museum, the Fitzwilliam Museum and Townley Hall Gallery (Burnley).
Further reading: A E Johnson, *Frank Reynolds RI*, London: A & C Black, 1907.

185

184

184
MILKMAN: 'I SEE YOUR GUVNOR'S PHOTO IN THE PAPER THIS MORNIN'
COOK: 'WHY, WHATS 'E DONE?'
MILKMAN: 'WELL, IT SEEMS 'ES ONE OF THE 'ANGMEN AT THE ROYAL ACADEMY'
signed and inscribed with title below mount
pen and ink; 7 x 5 ¼ inches
Illustrated: *Punch*, 11 May 1921, page 361

185
CHAIRMAN OF COMMERCIAL CONFERENCE (IN SEARCH OF A SLOGAN): 'HOW I WISH SHEDLOCK WERE HERE — IT WAS HE WHO GAVE US — "DON'T FRET — HAVE A GASPERETT"'
signed
inscribed with title below mount
pen and ink; 12 x 9 ¾ inches
Illustrated: *Punch,* Almanack for 1936, 4 November 1935, [unpaginated]

186

187

186

HOST: 'HEAVENS, LAURA! THEY'RE
HERE ALREADY AND I WANTED TO
RUN THROUGH THAT GOLF-STORY
AGAIN WITH YOU'
signed with initials
inscribed with title below mount
pen and ink
9 x 7 inches
Illustrated: *Punch*, 11 April 1934,
page 393

187

LOOK MUM – BURGLARS!
signed
inscribed with title below mount
pen ink and crayon
6 x 9 inches
Illustrated: *Punch*, 31 July 1946,
page 90

BERT THOMAS
Herbert Samuel Thomas, MBE PS (1883-1966)

For a biography of Bert Thomas, please refer to *The Illustrators*, 1997, pages 101-102.

Contributed to *Punch* (from 1905). Made his name in November 1914 with his cartoon, *Arf a mo, Kaiser*, drawn for the *Weekly Dispatch* to advertise a tobacco fund for soldiers; In March 1942 designed the poster *Is Your Journey Really Necessary?* for the Railway Executive Committee; he was a member of the London Sketch Club
His work is represented in the collections of the British Museum, the Imperial War Museum, the National Portrait Gallery, the Victoria and Albert Museum, and the University of Kent Cartoon Centre.

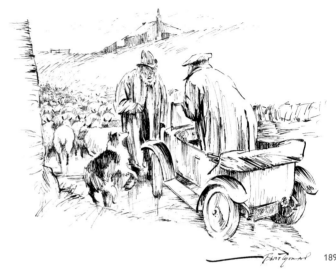

189

188

188

MALEFACTOR: 'BLIMEY WOT LUCK — I SPENDS SIX MUNCE MAKIN' FRIENDS WIV THE DORG AN' GOES AN' TREADS ON THE PERISHIN' CAT.'
signed
inscribed with title below mount
signed and inscribed 'Pinner' on reverse
pen and ink
8 ½ x 12 ¼ inches
Illustrated: *Punch*, 13 October 1926, page 396

189

DON'T THINK EE CAN PASS SUR. BUT EF EE GETS OUT OILL GIF EE A AND TO LIFT THE MOTEY-CAR OVER UN
signed
inscribed with title below mount
signed and inscribed 'Pinner' on reverse
pen and ink
9 ¼ x 11 ¼ inches
Illustrated: *Punch*, 3 November 1926, page 480

190

SERGEANT: 'THE ORDER IS THAT NO ONE IS TO REFER TO THE NATIVE POPULATION AS "CHINKS" — IT SEEMS THE WORD IN CHINESE MEANS A 'OLE IN THE WALL'
signed
inscribed with title below mount
signed and inscribed 'Pinner' on reverse
pen and ink
8 ½ x 12 ½ inches
Illustrated: *Punch*, 27 April 1927, page 452

BERTRAM PRANCE

Bertram Prance (1889-1958)

Bertram Prance was born in Bideford, Devon, on 5 December 1889, the son of a shipping merchant. He was educated at the local School of Art and Science, and then furthered his studies by subscribing to Percy Bradshaw's 'Press Art School', a correspondence course. By the early 1910s, he was contributing cartoons and illustrations to numerous periodicals, which would eventually include the *Humorist*, *London Opinion*, *Nash's Magazine*, *Passing Show*, *Punch* and the *Strand Magazine*. A friend of William Heath Robinson, he followed the pattern of many a popular illustrator by becoming a member of the Savage Club and the London Sketch Club (and served as President of the latter in 1948). During the 1940s, he made a particular contribution to the art of book illustration with his work on Anthony Armstrong's trilogy *We Like the Country* (1940), *Village at War* (1941), and *Cottage into House* (1944); and then with Malcolm Saville's books for children. However, he turned increasingly to painting, and exhibited landscapes of England and France in both oil and bodycolour at the Royal Academy and the Arlington Gallery. While Prance settled with his family at Rudgwick, near Cranleigh, in Sussex, he retained contact with Bideford, and showed a particular interest in the foundation of its Burton Museum and Art Gallery just after the Second World War. A retrospective of his work would be mounted there in 1998.

His work is represented in the collections of the Burton Museum and Art Gallery (Bideford).

192

191

191

SONNIE (STRUGGLING WITH HIS HOMEWORK): 'DAD I WISH YOU'D TRANSLATE THIS PASSAGE FOR ME?' DAD (CONSCIENTIOUSLY): 'ME? I'M AFRAID IT WOULDN'T BE RIGHT' SONNIE: 'YOU CAN'T TELL UNTIL YOU'VE TRIED!'
signed
pen and ink
11 x 14 inches
Probably illustrated in *Passing Show*

192

LADY (PERSUASIVELY TO PROSPECTIVE NURSE): 'YOU WOULD SIMPLY LOVE MY CHILDREN, I AM SURE' APPLICANT: 'WHAT? AT £38 A YEAR? MADAM, YOU CAN'T EXPECT MUCH AFFECTION AT THAT SALARY!'
signed
pen and ink
11 ½ x 14 inches
Illustrated: *Passing Show*, 9 March 1929, page 19

193

194

VARIOUS MEMBERS OF THE SAVAGE CLUB

John Hassall, RI RMS (1868-1948): Illustrator, cartoonist, painter and artist of the famous poster, *Skegness is so Bracing* (1908). President of the London Sketch Club (1903-4); member of the Langham Sketching Club and the Savage Club.

Alister K Macdonald (active 1898-1947): Illustrator. Member of the Savage Club.

Christopher Richard Wynne Nevinson, ARA RBA RI ROI LG NEAC NS (1889-1946): Painter and printmaker. Member of the Savage Club.

Bertram Prance (1889-1958): see above.

Harry Rountree (1878-1950): Illustrator and cartoonist. President of the London Sketch Club (1914-15); member of the Savage Club.

George Loraine Stampa (1875-1951): Illustrator and cartoonist, who began to contribute to *Punch* in 1894. Member of the Langham Sketching Club and the Savage Club.

Sidney Strube (1892-1956): Cartoonist. Member of the London Sketch Club and the Savage Club.

Starr Wood (1870-1944): Cartoonist and journalist. Member of the London Sketch Club and the Savage Club.

193

THE MAN BELOW: 'HI, BOB!
CHUCK ME DAHN A SPARE BRICK,
WILL YE? I'M SHORT O' ONE IN
ME 'OD'
signed
pen and ink
12 ½ x 10 inches
Illustrated: *Passing Show*,
29 January 1927, page 15

194

TO PERCY ROSSER FROM THE
SAVAGE CLUB GOLFING SOCIETY
signed by different artists, including
John Hassall, A K Macdonald,
C R W Nevinson, Bertram Prance,
Harry Rountree, G L Stampa, Strube
and Starr Wood
pen ink, pencil and watercolour
15 ½ x 10 ½ inches

H M BATEMAN

HENRY MAYO BATEMAN

Henry Mayo Bateman (1887-1970)

For a biography of Henry Mayo Bateman, please refer to *The Illustrators*, 1997, page 102; for an essay on the revolutionary and reactionary aspects of the artist's work, see *The Illustrators*, 2000, pages 21-22.

Member of the London Sketch Club; contributed to the *Tatler* (1904-1907, 1919-36), his famous series of cartoons on social gaffes, 'the man who …' appearing from 1912; contributed to *Punch* (1916-25, 1930-35, 1948) His work is represented in numerous public collections, including the British Museum, the Cartoon Art Trust, the Victoria and Albert Museum, and the Ashmolean Museum.

Further reading: Anthony Anderson, *The Man who was H M Bateman*, Exeter: Webb & Bower, 1982

195

IF GEORGE BERNARD SHAW COMMANDED THE BRITISH ARMY

H M Bateman was sometimes criticised for avoiding the political situations of his time. He did pay attention to politics but was more concerned with its impact on human emotions, and his cartoons hardly ever convey a particular bias. While such contemporaries as David Low were committed to transmitting strong political messages through cartoons, Bateman preferred to illustrate the comic side of political debate.

In this cartoon Bateman lampoons George Bernard Shaw's political opinion of the First World War. Like many socialists, Shaw opposed Britain's involvement, feeling that war was an avoidable product of a bankrupt political system. Shaw expressed these opinions in a special war supplement to the *New Statesman* in November 1914 entitled 'Common Sense About the War', which proved fatal for his public stature and popularity in Britain. Bateman's humorous portrayal of complete pandemonium within the ranks, although seemingly light-hearted and comical, was executed at a time when the artist was experiencing serious feelings of guilt at not serving at the front alongside many of his friends. This could explain the sense of cynicism and irony apparent in the cartoon. [RC]

195

IF GEORGE BERNARD SHAW COMMANDED THE BRITISH ARMY

signed and dated '17

pen ink and watercolour with bodycolour

14 x 10 inches

Illustrated: *Bystander*, 29 August 1917, page 407;

The Humour of H M Bateman. More Drawings, London: Methuen, 1922, page 67

Exhibited: 'H M Bateman at the Leicester Galleries', February 1919, no 41

196

Between the years 1909 and 1914 Bateman produced a large number of cartoons featuring suburban life. From 1901 the electric trams in London offered greater mobility and the opportunity for people to move away from the busy city to the neat rows of villas that had sprung up in Clapham, Hampstead and other outlying areas. In his book entitled *The Suburbans*, published in 1905, T W H Crosland wrote, 'It is fair and reasonable to call Clapham the capital of Suburbia' (see Anderson, op cit, page 51). Bateman lived and worked in Clapham. It seems likely that he gathered inspiration for his cartoons from neighbours, who migrated from the town to the suburbs. One can quite imagine the Smythe-Robinsons feeling awkward and bohemian eating *al fresco*, as their neighbours gawp. Bateman was an expert in recognising not only people's social inadequacies but the amusement they gave others. Many of his cartoons illustrate a social occasion like a party, a game and, above all, a meal. It was here that his 'vision of a society obsessed by the done thing was most consistent' (Anthony Anderson, op cit, page 160). The Smythe-Robinsons are a wonderful variation on this comical theme. [RC]

197

196

DURING THE HOT WEATHER THE SMYTHE-ROBINSONS OF TIDLINGTON
TAKE THEIR MEALS IN A COOL AND SHADY SPOT OF THE GARDEN
signed and dated 1913
inscribed with title below mount
pen ink and monochrome watercolour
14 ½ x 8 ¾ inches
Literature: *Strand Magazine*, February 1916, page 218

CARD PLAYERS: DIAMONDS

A typically effective Bateman pun, 'diamonds' refers both to the fact that a card game is being played and to the jewels worn by the players. In this period of his career Bateman was quickly developing his characteristic approach, 'a way of looking at people that revealed more than just a personality: an essay on class, character, occupation and predilection' (Anderson, op cit, page 30). Here he shows a fascination with the *nouveau riche*, the comically vulgar display of diamonds betraying the true class of the card players. [RC]

198

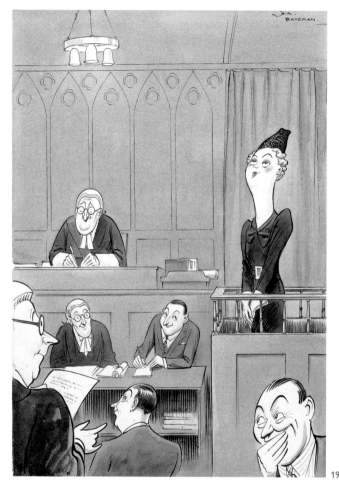

199

197
CARD PLAYERS: DIAMONDS
signed
pen ink and monochrome watercolour
9 ½ x 9 ¼ inches
Exhibited: Langton Gallery,
November 1958, no 37

198
THE PRIVATE VIEW
signed and dated 1914
inscribed with title below mount
pen ink and monochrome watercolour
14 x 9 ¾ inches
Illustrated: *The Humour of H M Bateman.More Drawings*,
London: Methuen, 1922, page 17

199
THE WITNESS 'WHO WOULD RATHER NOT SAY'
signed
inscribed with title below mount
pen ink and watercolour
14 ¼x 10 inches
Illustrated: *Tatler,* Christmas number, 1939

201

203

202

These three decorated tea menus are all inscribed on reverse:

Tea		
Bread & butter (3 slices)		*1*
Cup of tea		*2*
Ditto with cream		*1*
Cakes. Plain		*1*
	Iced	*2*
Ices	*2 and 3*	

Gratuities are not prohibited

200

200

THE GREAT WATER JOKE

signed

inscribed with title below mount

pen ink and watercolour

14 ½ x 10 inches

Probably illustrated in *Sporting and Dramatic News*

Exhibited: 'H M Bateman Centenary Exhibition', Royal Festival Hall and the National Theatre, May-June 1987, no 43

201

VIZIER

signed with initials and dated 1906

tea menu inscribed on reverse

pen ink and watercolour

5 ½ x 3 ¼ inches

Design for a menu card

202

LADY WITH A LONG NECK

signed with initials and dated 1906

tea menu inscribed on reverse

pen ink and watercolour

5 ½ x 3 ¼ inches

Design for a menu card

203

LITTLE MAN

signed with initials and dated 1906

tea menu inscribed on reverse

pen ink and watercolour

5 ½ x 3 ¼ inches

Design for a menu card

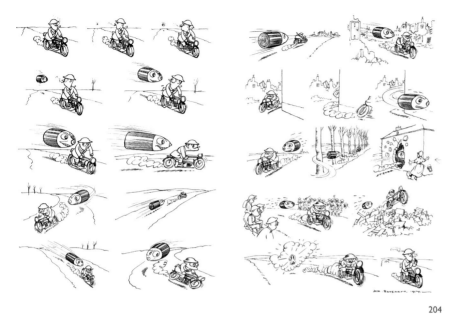

204

205 (detail)

LITTLE TICH

The diminutive Harry Relph (1868-1928) received his stage name while still a baby, as a result of his supposed likeness to the claimant in the famous Tichborne case [see note on page 25]. A regular performer in London music hall and pantomime, he was equally popular in Paris, becoming a friend of Toulouse-Lautrec. The dance in which he balanced on the tips of his exaggerated boots was particularly memorable.

THE DEMON SHELL

Of all the people who may be said to have influenced Bateman's work at some point in his career – Phil May, John Hassall, Henry Ospovat – none had such an obvious effect as Russian-born Caran d'Ache (1858-1909). Caran d'Ache published a number of cartoons in leading French magazines in an original format – the wordless strip. It was this breakthrough in the conveyance of narrative which led Bateman to introduce the concept of the strip to English cartooning, and to develop it from 1916 to the end of his career. *The Demon Shell*, drawn in 1917, is a perfect example of Bateman's early experimentation with this concept, and a departure from his earlier painterly style to a simpler linearity. [RC]

206

204

THE DEMON SHELL
signed and dated 1917
pen and ink
14 x 20 inches
Illustrated: G K Chesterton (introduction), *A Book of Drawings by H M Bateman*, London: Methuen, 1921, pages 78 and 79

205

LITTLE TICH
watercolour and pencil; 7 x 10 ¼ inches
Preliminary drawing for H M Bateman, *Burlesques*, London: Duckworth and Co, 1916, page 29

206

OLD ZOMERZET
signed and dated 47
pen ink and watercolour
14 ½ x 10 inches

THE FAIRY CHILD: WOMEN ILLUSTRATORS OF THE EARLY TWENTIETH CENTURY

ANNIE FRENCH

Annie French (1872-1965)

For a biography of Annie French, please refer to *The Illustrators*, 1997, pages 20-21.

Her work is represented in the collections of the Victoria and Albert Museum.

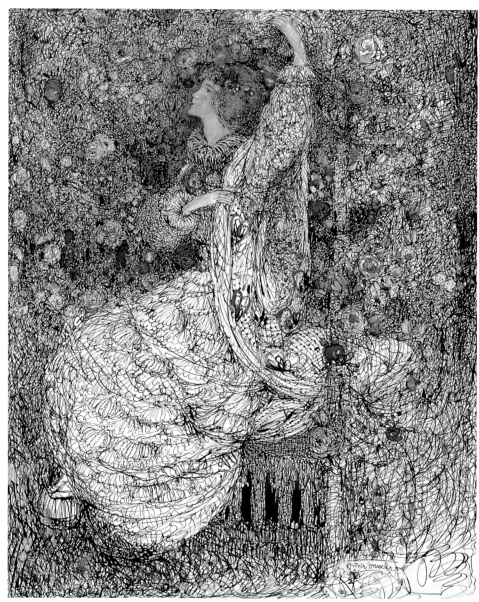

207
AMONGST ROSES AND
BUTTERFLIES
signed
pen ink and watercolour
9 ½ x 8 inches

207

JESSIE MARION KING
Jessie Marion King (1876-1949)

For a biography of Jessie M King, please refer to *The Illustrators*, 1997, pages 21-22.

Key work illustrated: William Morris, *The Defence of Guenevere and other Poems* (1908)
Her work is represented in the collections of the Art Gallery and Museum, Kelvingrove (Glasgow), and the Stewartry Museum (Kircudbright).
Further reading: Colin White, *The Enchanted World of Jessie M King*, Edinburgh: Canongate, 1989

THE QUEEN OF THE GARDEN

208

THE QUEEN OF THE GARDEN
signed
pen and ink with watercolour
12 ¼ x 10 ½ inches

MABEL LUCIE ATTWELL
Mabel Lucie Attwell, SWA (1879-1964)

For a biography of Mabel Lucie
Attwell, please refer to *The
Illustrators*, 1997, page 22.

Key works illustrated: *The Mabel
Lucie Attwell Annuals* appeared
between 1922-74
Further reading: Chris Beetles,
Mabel Lucie Attwell, London:
Pavilion Books, 1985; John Henty,
*The Collectable World of Mabel Lucie
Attwell*, Shepton Beauchamp:
Richard Dennis, 1999

Numbers 209-224, (except 211
and 215) are all from the Estate of
Mabel Lucie Attwell.

209

ALL FOR THE LOVE OF SOMEBODY
signed
*pen ink and watercolour with
bodycolour*
10 ¼ x 8 ¼ inches
Design for a postcard for Valentine
of Dundee, published three times:
No 4210: 'All for the Love of a
Soldier';
No 4589: 'All for the Love of
Somebody';
No 4702: 'I may not be good-
looking but I am good'
Literature: John Henty, *The
Collectable World of Mabel Lucie
Attwell*, London: Richard Dennis,
1999, pages 39 and 41

210

211

210
GOING THROUGH LIFE WITH A SMILE — A SONG — AN' HELPING ONE'S
FELLOW MAN ALONG!
watercolour with bodycolour
11 ½ x 9 inches
Illustrated: Design for postcard no 183a, for Valentine of Dundee
Literature: John Henty, *The Collectable World of Mabel Lucie Attwell*, London:
Richard Dennis, 1999, page 68

211
JUST HOPING FOR MY OLD AGE PENSION!
signed
watercolour and bodycolour
11 x 7 inches

213

214

212

212

I TAKES A PRETTY GOOD VIEW
OF YOU!

signed
watercolour and bodycolour
12 x 8 inches
Design for a postcard no 879, for
Valentine of Dundee;
Illustrated: Mabel Lucie Attwell
Calendar 1949 & 1950
Literature: John Henty,
*The Collectable World of Mabel Lucie
Attwell*, London: Richard Dennis,
1999, page 74

213

DON'T KNOW WHAT I WANTS
BUT I WANTS — IT SO BAD!

signed
watercolour and bodycolour
9 x 6 inches
Design for a postcard no 1441, for
Valentine of Dundee
Literature: John Henty,
*The Collectable World of Mabel Lucie
Attwell*, London: Richard Dennis,
1999, page 76

214

STILL GOING STRONG — HOW'S
YOURSELF!

signed
watercolour and bodycolour
7 x 5 inches
Design for a postcard no 1771, for
Valentine of Dundee
Literature: John Henty,
*The Collectable World of Mabel Lucie
Attwell*, London: Richard Dennis,
1999, page 77

215

ROOM FOR ONE ON TOP?
Giraffe and Jumbo have a cart,
And when the day is sunny,
Will often take folks for a ride,
To make a little money.
signed
pen ink and watercolour
8 ¾ x 8 inches
Probably illustrated in *Jolly Jingles*

216

216

IF YOU WANT TO GET GOING —
YOU MUST GET GOING!

signed

watercolour and bodycolour

8 ½ x 6 inches

Design for a postcard no 5844, for
Valentine of Dundee
Literature: John Henty,
*The Collectable World of Mabel Lucie
Attwell*, London: Richard Dennis,
1999, page 115

217

THIS IS SISTER AND THIS IS ME
WE'RE VERY ALIKE YOU WILL AGREE
FOLK FIND IT VERY HARD TO SEE
WHICH IS SISTER AND WHICH IS ME!

signed and inscribed with title

watercolour and bodycolour with pen and ink

9 ½ x 8 inches

Design for a postcard no 5137, for Valentine of Dundee, as
'Two happy ladies, where have they been?
They've been to London to see the Queen!'

217

218

THE LONELY FAIRY

*signed and inscribed 'illustration to
The Lonely Fairy' below mount*

pen and ink

5 x 11 ½ inches

219

GOT AWAY!

signed

pen and ink

10 x 8 inches

218

219

220

221

222

220

THERE ONCE WAS A LADDIE DON DOONE
WHO SAID 'I MUST FLY MY KITE SOON'.
HE DID — THE SMALL LAD
BUT WASN'T IT SAD
IT GOT IT'S TAIL CAUGHT ON THE MOON
signed
inscribed with title below mount
pen and ink
11 ½ x 11 inches

221

KING OF THE CASTLE!
signed
watercolour and bodycolour
8 x 5 ½ inches

222

THE LORD CHANCELLOR MADE A
LONG SPEECH
signed and inscribed with title and
'Illustrations: Why Tommy was late for
tea' below mount
pen and ink
10 x 5 inches

223

224

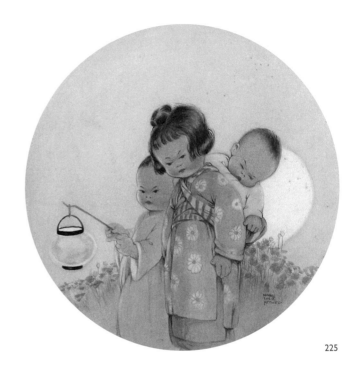

225

223
YOU SHOULD SEE MY BUBBLES!
signed
inscribed with title below mount
pen and ink
7 x 10 inches

224
CHRISTMAS GREETINGS
signed
watercolour and bodycolour
11 ½ x 11 ½ inches
Design for a Christmas card and
calendar for Valentine of
Dundee, 1949

225
LIGHTING THE WAY
signed
watercolour and bodycolour
14 inches diameter

IDA RENTOUL OUTHWAITE
Ida Rentoul Outhwaite (1888-1960)

For a biography of Ida Rentoul Outhwaite, please refer to *The Illustrators*, 1991, page 98.

Further reading: Marcie Muir and Robert Holden, *The Fairy World of Ida Rentoul Outhwaite*, Sydney: Craftsman House, 1985

Numbers 226-229 and 231, 233, 237-239 were all drawn for but not illustrated in Phyllis Power, *Legends from the Outback*, London: Dent & Sons, 1958

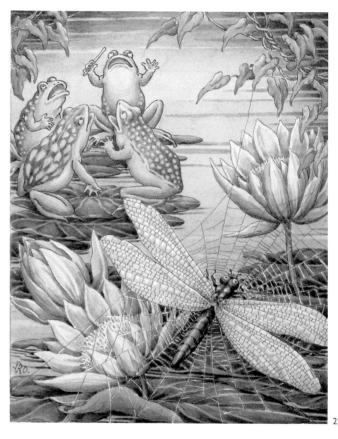

227

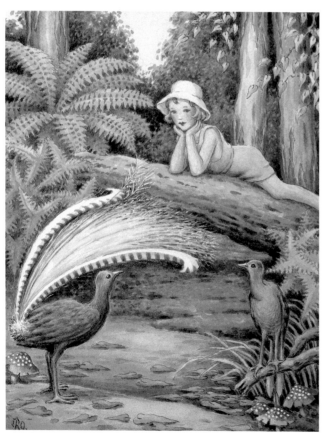

226

226

PRUE AND THE LYREBIRD
signed with initials
watercolour
7 ¼ x 6 inches

227

THE FROGS STILL HOLD CHOIR
PRACTICE EVERY NIGHT IN THE
BILLABONG
signed with initials
watercolour
7 ¼ x 6 inches
'The Legend of the Dragon-fly and
the Frog'

228

229

228
DANCING IN THE OUTBACK
signed with initials
watercolour
7 ¼ x 6 inches

229
PRUE AND THE NATIVE CATS
signed with initials
watercolour
7 ¼ x 6 inches

230

232

233

231

234

230

THE LYRE BIRD

signed with initials

pen and ink

7 ½ x 6 ¼ inches

Illustrated: Phyllis Power, *Legends from the Outback*, London: Dent & Sons, 1958, page 105, 'The Lyre Bird Legend'

231

EVERYTHING SEEMED QUIET AND PEACEFUL

signed with initials

pen and ink

6 ½ x 6 ½ inches

Illustrated: Phyllis Power, *Legends from the Outback*, London: Dent & Sons, 1958, page 23, 'The Legend of the Platypus'

232

PRUE AND THE KOOKABURRA

signed with initials

pen and ink

7 ¼ x 6 inches

233

PRUE AND THE POSSUM

signed with initials

pen and ink

7 ¼ x 6 inches

234

WARREN THE WOMBAT

signed with initials

pen and ink

4 x 5 inches

Illustrated: Phyllis Power, *Legends from the Outback*, London: Dent & Sons, 1958, page 64, 'The Legend of the Wombat and the Kangaroo'

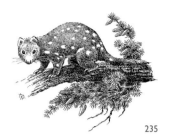

235

238

236

237

239

235

MG'RUE MOCH

signed with initials

pen and ink

4 x 5 inches

Illustrated: Phyllis Power, *Legends from the Outback*, London: Dent & Sons, 1958, page 59, 'Second Mg'rue Moch (or native cat) Legend'

236

KOALA AND BABY

signed with initials

pen and ink

5 ½ x 5 ½ inches

Illustrated: Phyllis Power, *Legends from the Outback*, London: Dent & Sons, 1958, page 119, 'Second Koala Bear Legend'

237

PRUE AND THE WOMBAT

signed with initials

pen and ink

7 ½ x 6 ¼ inches

238

PRUE AND THE NATIVE CATS

signed with initials

pen and ink

5 ½ x 6 ½ inches

239

KOALA

signed with initials

pen and ink

3 ½ x 3 ½ inches

MARGARET TARRANT
Margaret Winifred Tarrant (1888-1959)

For a biography of Margaret Tarrant, please refer to *The Illustrators*, 1997, page 24.

Further reading: John Gurney, *Margaret Tarrant and Her Pictures*, London: The Medici Society, 1982

240
WHITE CHRISTMAS
signed and inscribed with title
watercolour with pencil
6 x 5 inches

240

242

Numbers 241-245 are all from a sketch book, with an ink-stencilled monogram on the cover; signed, inscribed 'The Elms, Gomshall' and dated 'March 1934' on the inside cover.

241

BIG STRETCH

pencil; 5 x 2 ¼ inches

242

CROUCHING ON THE FLOOR

pencil; 5 ½ x 6 inches

243

ROLLING OVER

pencil; 6 x 4 ½ inches

244

SKETCHES OF DUCKS

pencil; 15 x 9 inches

245

SKETCHES OF BABIES

pencil; 15 x 9 ½ inches

241

246

HAPPY CHILDREN

inscribed with title

pencil; 13 x 10 inches

Preliminary cover drawing for sheet music, Harold Colombatti, *Enfants Heureux. Eight easy and progressive pieces for pianoforte*

247

GAMES AND SPORTS

pencil; 13 x 10 inches

Preliminary cover drawing for sheet music, John Brydson, *Games and Sports. Easy suite for pianoforte*

248

SEATED RATS

pen and ink; 1 ½ x 5 ½ inches

Illustrated: Robert Browning, *The Pied Piper of Hamelin*, London: J M Dent & Sons, 1912, page 3

249

THE END

pen and ink; 2 ½ x 3 ¼ inches

Illustrated: Robert Browning, *The Pied Piper of Hamelin*, London: J M Dent & Sons, 1912, page 41

SUSAN BEATRICE PEARSE
Susan Beatrice Pearse (1878-1980)

For a biography of Susan Beatrice Pearse, please refer to *The Illustrators*, 1996, page 67.

250

250

WATER BABY

watercolour with pencil

15 ¼ x 10 inches

DAPHNE ALLEN
Daphne Allen (born 1899)

Daphne Allen was the daughter of Hugh Allen, and possibly the grand-daughter of Ruskin's publisher George Allen. She was educated at Streatham College for Girls, and continued to live in that area of South London into adulthood.

While still a child, Allen produced watercolours inspired by the New Testament, which were published in 1912 by George Allen as *A Child's Visions*. In the same year, they were exhibited as 'A Child's Visions and Fancies' at the Dudley Galleries. In 1913, a second group was published as *The Birth of the Opal. A Child's Fancies*, and again exhibited at the Dudley Galleries.

Through her teens, Allen illustrated volumes by other authors for Headley Brothers: John Oxenham's *The Cradle of Our Lord* (1916), *A Garden of Love from Herrick & the Other Poets of the 17th Century* (1917), and Janet Dykes and Christine Standing's *The Man Who Chose Poverty – The Story of St Francis* (1917). She also exhibited alongside Annie French and others at the Burlington Gallery in December 1919. Later exhibitions include one of 'landscapes and imaginative watercolours' at B F Stevens & Brown (1928) and another of paintings at the Little Burlington Gallery (1937).

Her further activities included painting memorials (including one for Christ Church, Newcastle, New South Wales), designing stained glass (for Scotby Church, Northumberland), and producing drawings for the *Illustrated London News* (at least until the end of 1952).

251a

251b

251c

251

CASSONE DECORATED WITH THREE PANELS:
VISITED BY ANGELS;
GATHERING SPRING FLOWERS;
AMONG CHILDREN
painted wood
27 inches high, 53 inches wide, 22 ¼ inches deep
a) left-hand panel: 11 ½ x 14 inches
b) central panel: 11 ½ x 28 ½ inches
c) right-hand panel: 11 ½ x 14 inches

251

KATHLEEN HALE

Kathleen Hale, OBE (1898-2000)

For a biography of Kathleen Hale, please refer to *The Illustrators*, 1996, page 239.

Key work written and illustrated: *Orlando the Marmalade Cat. A Camping Holiday* (1938)
(the first of eighteen adventures)
Further reading: *Kathleen Hale. Artist. Illustrator*, London: The Gekoski Gallery, 1995

252

252

ESKIMO ORLANDO
signed
pencil with watercolour and bodycolour
8 x 10 ¼ inches
Exhibited: 'Yet Even More Cats of Fame and Promise', Michael Parkin Gallery, December 1976, no 26, as 'Ice Age'

HONOR APPLETON
Honor Charlotte Appleton (1897-1951)

For a biography of Honor Appleton, please refer to *The Illustrators*, 1997, page 22.

Key work illustrated: H C Cradock, *Josephine and her Dolls* (1916) (the series continuing until 1940)
Her work is represented in the collections of Brighton and Hove Museums.
Further reading: Fiona Halpin, *Honor C Appleton*, London: Chris Beetles Ltd, 1990

253

253

ALL IN A HEAP ON THE LAWN
signed
inscribed with title below mount
watercolour with bodycolour
9 ½ x 7 inches
Illustrated: Mrs H C Cradock,
Josephine's Christmas Party, London:
Blackie and Son, 1927, facing page 12

254

254

QUACKY'S WALK WAS REALLY
DREADFUL!
signed
inscribed with title below mount
watercolour with bodycolour; 9 ½ x 7 inches
Illustrated: Mrs H C Cradock,
Josephine's Christmas Party, London:
Blackie and Son, 1927, facing page 36

255

256

257

255

HE LOOKED SO TERRIBLY PROUD AND
IMPORTANT
signed
inscribed with title below mount
watercolour with bodycolour
9 ¾ x 7 inches
Illustrated: Mrs H C Cradock, *Josephine Keeps
House*, London: Blackie and Son, 1931, facing
page 29

256

DOROTHY TELLS THE CHILDREN A STORY
signed
inscribed with title below mount
watercolour with bodycolour
9 ½ x 7 inches
Illustrated: Mrs H C Cradock, *Josephine Keeps
House*, London: Blackie and Son, 1931, facing
page 20

257

I AM ALMOST AFRAID HE PUT OUT HIS TONGUE
signed
inscribed with title below mount
watercolour with bodycolour
9 ½ x 7 inches
Illustrated: Mrs H C Cradock, *Josephine Keeps
House*, London: Blackie and Son, 1931, facing
page 36

258

259

260

258

SHE GAVE A LITTLE SHRIEK

signed

inscribed with title below mount

watercolour with bodycolour

9 ½ x 7 inches

Illustrated: Mrs H C Cradock, *Josephine's Pantomime*, London: Blackie and Son, 1939, facing page 21

259

PATRICK PUT THE PEARLS IN HIS POCKET

signed

inscribed with title below mount

watercolour with bodycolour

9 ½ x 7 inches

Illustrated: Mrs H C Cradock, *Josephine's Pantomime*, London: Blackie and Son, 1939, facing page 28

260

JOSEPHINE, JOHN AND THE PUPPY

pen and ink

11 x 7 inches

Illustrated: Mrs H C Cradock, *Josephine, John and the Puppy*, London: Blackie and Son, 1920, title page

EILEEN SOPER

Eileen Alice Soper, RMS SWLA (1905-1990)

For a biography of Eileen Soper, please refer to *The Illustrators*, 1997, page 190.

Her work is represented in the collections of the British Museum, Blackpool Art Gallery and the Art Gallery of Ontario (Toronto). Further reading: Duff Hart-Davis, *Wildings*, London: Witherby, 1991; David Wootton, *The Art of George and Eileen Soper*, London: Chris Beetles Ltd, 1995; David Wootton, *Catalogue Raisonné of the Prints and Etchings of George and Eileen Soper*, London: Chris Beetles Ltd, 1995

The estate and copyright of George and Eileen Soper are now in the care of Chris Beetles Ltd through Longmores Solicitors on behalf of AGBI. The gallery mounted a highly successful retrospective in June 1995, and followed it with a show devoted to Eileen's achievement as a printmaker.

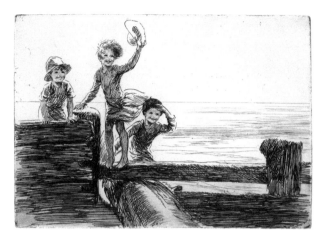
262

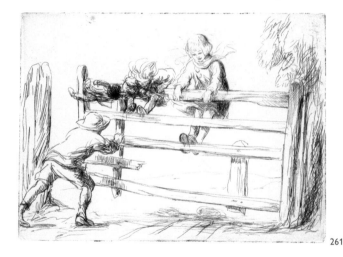
261

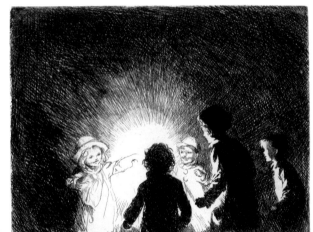
263

Numbers 261-273 are all from the Estate of George and Eileen Soper. They are illustrated in David Wootton, *Catalogue Raisonné of the Etchings of George and Eileen Soper*, London: Chris Beetles Ltd, 1995

261
LA BARRIERE CASSEE
signed
etching (laid)
5 x 7 inches
Literature: *Catalogue Raisonné*, no 6

262
THE SEAPLANE
signed
drypoint (laid)
5 ½ x 8 inches
Literature: *Catalogue Raisonné*, no 132

263
NOVEMBER 5TH
signed
etching (laid)
6 x 7 ¾ inches
Literature: *Catalogue Raisonné*, no 121

264

266

268

265

267

269

270

264

THE LINNET'S FREEDOM

signed

etching

4 ½ x 7 inches

Literature: *Catalogue Raisonné*, no 89

265

SWINGING

signed

etching

7 x 8 ¾ inches

Literature: *Catalogue Raisonné*, no 123

266

THE HURT PAW

signed

etching (laid)

4 ¾ x 8 inches

Literature: *Catalogue Raisonné*, no 60

267

THE MIGHTY ATOM

signed

etching (laid)

5 ½ x 8 inches

Literature: *Catalogue Raisonné*, no 129

268

PRACTICE

signed

drypoint (laid)

3 ¾ x 6 ¾ inches

Literature: *Catalogue Raisonné*, no 77

269

A VOYAGE OF DISCOVERY

signed

etching

5 x 7 ½ inches

Literature: *Catalogue Raisonné*, no 118

270

A MERRY XMAS

etching (laid)

4 ½ x 3 inches

Literature: *Catalogue Raisonné*, no 65

271

SEA URCHINS

drypoint (laid)

6 x 8 inches

Literature: *Catalogue Raisonné*, no 134

272

THE SPRING IS HERE AND ON THE HILLS / LAMBS DANCE AMONG THE DAFFODILS

watercolour and bodycolour

10 x 11 inches

Drawn for the unpublished volume, Eileen Soper, *Chuckles for Spring*

273

CHARLOTTE

signed; inscribed with title below mount

pen and ink

5 x 6 ¼ inches

E H SHEPARD

ERNEST HOWARD SHEPARD

Ernest Howard Shepard, MC OBE (1879-1976)

For a biography of Ernest Howard Shepard, please refer to
The Illustrators, 1999, page 150; for essays on various aspects
of the artist's achievement, refer to *The Illustrators*, 1999,
pages 151-152; and *The Illustrators*, 2001, pages 28-32.

Key works illustrated: Contributed to *Punch* from 1907,
becoming second cartoonist in 1935, and chief cartoonist
from 1945 until 1949; A A Milne, *When We Were Very Young*
(1924); E V Lucas, *Playtime and Company* (1925); A A Milne,
Winnie-the-Pooh (1926); Samuel Pepys, *Everybody's Pepys*
(1926); A A Milne, *The House at Pooh Corner* (1928); Kenneth
Grahame, *The Wind in the Willows* (1931); Richard Jeffries,
Bevis (1932); E V Lucas, *As the Bee Sucks* (1937)
His work is represented in the collections of the British
Museum, the Victoria and Albert Museum, and the Shepard
Archive at the University of Surrey.
Further reading: Rawle Knox (editor), *The Work of E H
Shepard*, London: Methuen, 1979

274
PICNICS
signed
pen and ink
11 ¾ x 9 inches
Illustrated: *Punch,* 16 May 1923,
page 473;
Euphan, *The Seventh Daughter,*
London: Burns Oates &
Waterbourne, 1935, page 62

275

275

PIGLET WAS BUSY DIGGING A
SMALL HOLE IN THE GROUND
OUTSIDE HIS HOUSE
pen and ink
2 ¼ x 2 ¾ inches
Illustrated: A A Milne, *The House at
Pooh Corner*, London: Methuen,
1928, page 57

276

SET OF TEA-THINGS IN THE
TOY-SHOP WINDOW
*signed, inscribed with title and artist's
address on reverse*
pen and ink
5 ½ x 6 ½ inches
Illustrated: Kenneth Grahame, *The
Golden Age*, London: John Lane at
The Bodley Head, 1928, page 148

276

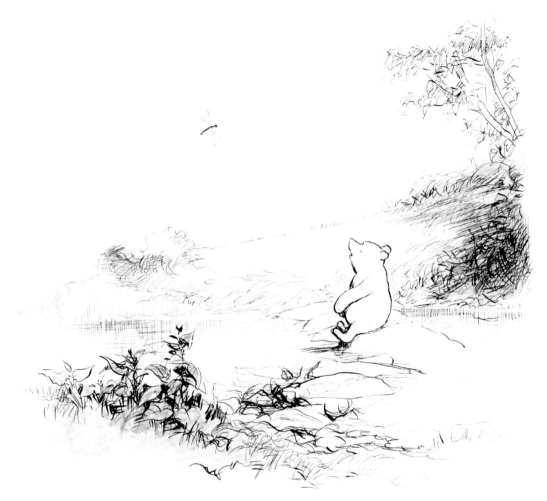

277

277

THE SUN WAS SO DELIGHTFULLY WARM, AND THE STONE, WHICH HAD
BEEN SITTING IN IT FOR A LONG TIME, WAS SO WARM, TOO, THAT POOH
HAD ALMOST DECIDED TO GO ON BEING POOH IN THE MIDDLE OF THE
STREAM FOR THE REST OF THE MORNING

pen ink and watercolour
8 ½ x 9 ½ inches
Illustrated: A A Milne, *The House at Pooh Corner*, London: Methuen, 1928,
page 55

278

279

NEAR SIGHTED DAME: 'OH DEAR, THESE NEW FANGLED PILLAR
BOXES. WHERE DOES ONE PUT THE LETTER IN?'
signed and inscribed with title
signed and inscribed with artist's address on reverse
pen and ink
11 ½ x 8 ½ inches
Illustrated: *Punch*, 24 December 1924, page 719

280

YOU'RE THE VERY IMAGE OF HER
signed with initials twice and inscribed with title
inscribed with 'Wind in the Willows' below mount
pen and ink
5 x 5 inches
Illustrated: Kenneth Grahame, *The Wind in the Willows*,
London: Methuen, 1931, page 180

278

WHERE AM I GOING? THE HIGH ROOKS CALL
signed with initials
pen and ink
6 x 5 inches
Illustrated: A A Milne, *When We Were Very Young*, London: Methuen,
1926, page 34

280

281

281

DOWN TO THE WOOD WHERE
THE BLUE-BELLS GROW
pen and ink
2 ½ x 3 ½ inches
Illustrated: A A Milne, *When We
Were Very Young*, London: Methuen,
1926, page 35

282

LOOK HERE! I FIND I'VE LEFT MY
PURSE BEHIND
signed with initials
signed on reverse
pen and ink
5 x 3 ½ inches
Illustrated: Kenneth Grahame, *The
Wind in the Willows*, London:
Methuen, 1931, page 185

282

Numbers 283-293 are all illustrated in Kenneth Grahame, *Dream Days*, London: The Bodley Head, 1930

283

284

283

I IN MY SUNDAY KNICKERBOCKERS
SHE IN HER PINK AND SPANGLES
signed
*signed, inscribed with title, artist's
address and 'Dream Days' on reverse*
pen and ink
9 ½ x 7 ¼ inches
Illustrated: *Dream Days*, page 67

284

HAROLD WENT STRAIGHT FOR
THE RIGHT BUSH
signed
*signed, inscribed with title, artist's
address and 'Dream Days' on reverse*
pen and ink
5 ¼ x 7 inches
Illustrated: *Dream Days*, page 5

285

IN LOVE, ONE SOUGHT THE
ORCHARD
signed with initials
*signed, inscribed with title, artist's
address and 'Dream Days' on reverse*
pen and ink
8 x 6 inches
Illustrated: *Dream Days*, page 161

286

HAROLD TOILED ON WITH
GRUNTS AND CONTORTIONS
signed with initials
*signed, inscribed with title, artist's
address and 'Dream Days' on reverse*
pen and ink
5 ½ x 5 inches
Illustrated: *Dream Days*, page 165

285

286

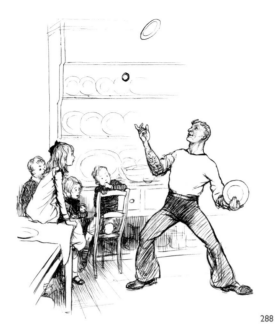

291

292

287

SHE HAD MANAGED... TO GET UP
INTO THAT CROWS-NEST
signed with initials
signed, inscribed with title, artist's
address and 'Dream Days' on reverse
pen and ink
7 ½ x 4 ¾ inches
Illustrated: *Dream Days*, page 77

291

TO THE DULL EYE ...IT MIGHT
HAVE APPEARED UNROMANTIC &
UNRAFTLIKE
signed, inscribed with title, artist's
address and 'Dream Days' on reverse
pen and ink
5 ½ x 6 inches
Illustrated: *Dream Days*, page 91

292

THE END
signed, inscribed with artist's address
and 'Dream Days' on reverse
pen and ink
4 x 6 ½ inches
Illustrated: *Dream Days*, page 168

289

288

THEN HE WAS CALLED UPON FOR
TRICKS, JUGGLINGS
signed with intials
inscribed 'Dream Days' below mount
signed, inscribed with title, artist's
address and 'Dream Days' on reverse
pen and ink
8 ¼ x 6 ½ inches
Illustrated: *Dream Days*, page 22

289

SO WE MET IN MY CABIN
signed with initials
signed, inscribed with title, artist's
address and 'Dream Days' on reverse
pen and ink
7 x 9 inches
Illustrated: *Dream Days*, page 103

290

THE LORD MAYOR WAS WAITING
THERE TO RECEIVE US
signed with initials
signed, inscribed with title, artist's
address and 'Dream Days' on reverse
pen and ink; 7 ½ x 10 inches
Illustrated: *Dream Days*, page 106

293

THIS IS NOT SUCH A BAD SORT
OF HOUSE AFTER ALL
signed with initials
signed, inscribed with title, artist's
address and 'Dream Days' on reverse
pen and ink; 9 ½ x 7 ½ inches
Illustrated: *Dream Days*, page 81

294

296

295

294

MUSIC IN JERMYN STREET

signed and inscribed with title

pen and ink

13 x 9 ½ inches

Illustrated: *Punch*, 19 March 1952,

page 371

295

AND THE COOK WILL ENTERTAIN

TO 'AIDA'

inscribed with title

pencil

4 x 8 ¼ inches

296

MOODIWARPS

inscribed with title

pen and ink

11 ½ x 8 ½ inches

Illustrated: *Punch*, 17 August 1949, page 182

Mouldiwerf, a word of Saxon origin apparently indicating one who throws mould… 'The moodiwarps have been laikin' with the loom under the low … I was privileged to see the moodiwarp at work. He was working roughly from north to south; and I waited patiently, hoping to see a corresponding line of warped mould springing up from east to west.'

– R P Lister

297

THEIR NEW HOUSE WAS IN

SOUTHAMPTON STREET, NUMBER

27, JUST A FEW MINUTES FROM

DRURY LANE

indistinctly inscribed

pencil; 9 ¼ x 7 ¼ inches

Preliminary drawing for Anna Bird

Stewart, *Enter David Garrick*,

Philadelphia & New York:

J B Lippincott, 1951, page 177

298

301

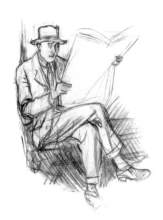

299

300

302

303

Numbers 297-299 and 301-303 are all from the Estate of the Artist

298

ELDER BROTHER (HAVING BEEN TOLD OF THE ARRIVAL OF A LITTLE SISTER): 'I SAY YOU FELLOWS IT'S A GIRL AND THIS JUST ABOUT MUCKS UP OUR CRICKET TEAM'
inscribed with title
pencil; 8 x 11 ½ inches
Exhibited: 'E H Shepard', Fine Art Society, 2002

299

SEEN MR GLADSTONE AT A PRIVATE VIEW
pencil
7 x 5 inches
Preliminary drawing for E H Shepherd, *Drawn from Memory*, London: Methuen, 1957, page 140; Exhibited: 'E H Shepard', Fine Art Society, 2002

300

THE CRAMMER
'Surely it's pretty simple! you multiply your gains by ten and divide your losses by twenty; and shout as loud as you can.'
pencil; 11 x 8 ¾ inches
Preliminary drawing for *Punch*, 21 August 1920, page 189

301

RUGBY SCRUM
pencil; 6 ½ x 9 ½ inches
Exhibited: 'E H Shepard', Fine Art Society, 2002

302

SEATED IN THE CARRIAGE
pencil; 6 x 4 ½ inches

303

SAYING GOODBYE
pencil; 7 ½ x 4 ¾ inches

CARTOONISTS FROM BETWEEN THE WARS

WILLIAM LEIGH RIDGEWELL

William Leigh Ridgewell (1881-1937)

William Leigh Ridgewell was born in Brighton on 8 September 1881, the son of William Ridgewell, a commercial traveller and talented amateur illustrator. On leaving Brighton Grammar School, he became apprenticed to an engraver, and from him learned Heraldic Art, Lithographic Drawing and Seal Engraving. In his spare time, he studied at Brighton School of Art and took a correspondence course in black-and-white illustration. His first publications, at the age of seventeen, were six postcards, and he subsequently worked as a freelance commercial artist producing advertisements and posters.

From the outbreak of the First World War, Ridgewell served in India (1914-19), teaching Lithography to Sepoys and designing posters for the India War Loan and for recruitment purposes. While there, he also drew cartoons and sketches for *India Ink* and *The Looker-On*. Back in Britain, he established himself as an illustrator and – particularly – a cartoonist, contributing to numerous periodicals, including the *Bystander*, the *Humorist*, *London Opinion*, *Passing Show* and *Punch*.

In 1937, Ridgewell jumped from a window while the 'balance of his mind was disturbed', and died on 7 November in Cassell Hospital, Penshurst, Sevenoaks, Kent.

His work is represented in the collections of Brighton Museum and Art Gallery.

305

304

304

1ST PARK PLAYER: 'HULLO!
PACKING UP ALREADY?'
2ND PARK PLAYER: 'YES, WE'VE
HAD A BIT OF HARD LUCK — LOST
OUR BALL.'
signed and inscribed with title
pen and ink
9 ½ x 11 inches

305

DEGREES
signed
pen and ink
13 x 10 inches
Illustrated: *Punch*, 14 September
1927, page 291

FOUGASSE

Cyril Kenneth Bird, CBE, known as 'Fougasse' (1887-1965)

For a biography of Fougasse, please refer to *The Illustrators*, 1996, page 193.

Contributed to *Punch* (1916-52, including periods as Art Editor and Editor)
His work is represented in the collections of the Imperial War Museum, the Tate Gallery and the Victoria and Albert Museum.
Further reading: Bevis Hillier (editor), *Fougasse*, London: Elm Tree Books, 1977

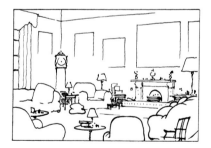

306

306

THE NEIGHBOURS: AN ANIMAL ANTHOLOGY
signed and inscribed with title
pen ink and watercolour
11 ¾ x 14 ½ inches
Illustrated: Fougasse (compiler), *The Neighbours: An Animal Anthology*, Published for the Universities Federation for Animal Welfare, London: Methuen, 1954, cover and spine

307

ANOTHER CHANGING FACE
DOMESTIC ARCHITECTURE
The central pivot of a room used to be the fireplace now, of course, it's the television
signed and inscribed with title
pen and ink
9 ¼ x 6 inches
Provenance: Simon Bond
Illustrated: Fougasse, *Us*, London: Methuen, 1951, page 76

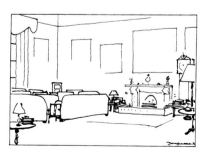

307

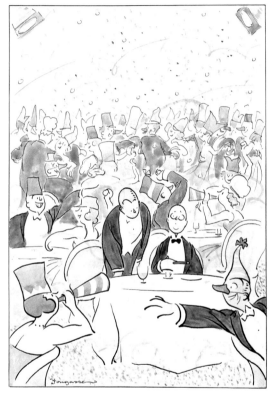

308

308

WAITER, BRING ME A SQUEAKER PLEASE — AND A FAKE NOSE:
I HATE APPEARING CONSPICUOUS
signed and inscribed with title
pen ink and watercolour
12 ½ x 8 inches
Probably illustrated in the *Strand Magazine*
Exhibited: Fine Art Society, June 1966, no 102

SILLINCE

William Augustus Sillince, RBA RWS FSIA SGA, known as 'Sillince' (1906-1974)

Sillince was born in Battersea, London, on 16 November 1906, the son of a Royal Navy marine engineer. He was educated at Osborne House, in Romsey, Hampshire, and studied at Regent Street Polytechnic and the Central School of Arts and Crafts (1923-28). Working first as an advertising artist, he turned to freelance cartooning in 1936, once *Punch* had begun to accept his contributions regularly. From 1941, his cartoons were published in volume form by Collins, who treated Sillince as a successor to Pont, a fellow *Punch* artist who had died in 1940. A number of commissions for book illustrations followed.

Like Pont, Sillince was a master of both the large finished cartoon and the vignette, but he was distinguished by his frequent use of soft pencil on textured paper. A student of W P Robins, he produced watercolour landscapes, and was elected to the membership of the Royal Society of Painters in Water-Colours (ARWS 1949, RWS 1958), and the Royal Society of British Artists (1949). In the post-war period, he became a part-time lecturer at Brighton College of Art (1949-52) and in Graphic Design at Hull Regional College of Art (1952-71). He also wrote on cartooning for the *Artist* magazine.

While living in East Yorkshire, Sillince created the series *John Bull's Other Region* for BBC TV (North), contributed to the *Yorkshire Post* (1964-74) and designed the Alice in Wonderland Room for Burton Constable Hall (1967). He died on 10 January 1974.

His work is represented in the collections of the British Museum, the Imperial War Museum, the Science Museum, Ferens Art Gallery (Hull), Sunderland Museum and Art Gallery, Worthing Museum and Art Gallery, and the National Gallery of New Zealand.

HERBERT HARRIS

Herbert H Harris (active 1920-1946)

While working as an artist with the advertising agency, S H Benson, Herbert Harris invented the character 'Pyjama Man' in order to promote Bovril. The first of the advertisements, published in 1920, represented 'a smiling shipwrecked man, still wearing his green-striped pyjamas, sitting astride a giant floating jar of Bovril with the slogan "Bovril prevents that *sinking* feeling"' (Bryant, 2000, page 104). Related drawings continued to appear into the 1930s, by which time Harris was producing cartoons for the *Bystander* and *Passing Show*. Then, in the 1940s, he created a number of children's books, including *Jolly Junior's Fairy Tales* (1945), *Junior's Jolly ABC* (1945) and *What Fun* (1946).

310

HIS SERVE — LOVE THIRTY
signed
inscribed with title below mount
watercolour with bodycolour and
pastel
18 x 13 ¾ inches

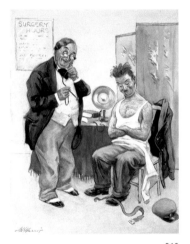

310

309

'COME, COME. HAVE NEITHER OF
YOU BOYS HEARD OF
ARBITRATION?'
''GARN,'OPPIT! AIN'T YOU NEVER
'EARD OF NON-INTERVENTION?'
signed
pencil
6 ½ x 9 inches
Illustrated: *Punch*, 5 April 1939,
page 370

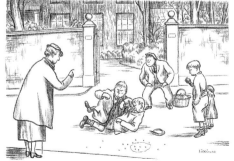

309

ILLUSTRATORS FROM BETWEEN THE WARS

REX WHISTLER
Reginald John Whistler (1905-1944)

Rex Whistler was born in Eltham, Kent, on 24 June 1905. He was the son of an architect and estate agent, and elder brother of the writer and glass-engraver Laurence Whistler. Discovering his talent while still a very young child, he won prizes from the Royal Drawing Society every year from 1912 to 1923. Indeed his backwardness in other lessons – at Haileybury School (1919-22) – made inevitable a career in art. Yet he was considered incompetent by the staff of the Royal Academy Schools, where he spent his sixteenth year, and so transferred to the Slade School of Fine Art to work under the sympathetic direction of Henry Tonks (1922-26). Making a great success for himself there, he won a scholarship to the British School in Rome which he took up in 1928 on completing murals at Shadwell and in the Tate Gallery.

Whistler had a genius for pastiche, and echoes of eighteenth-century elegance haunt these murals as they do all his work as a painter, decorator and illustrator. His illustrative work is well exemplified by an edition of *Gulliver's Travels* (1930), which transforms Swift's biting verbal satire into a visually delightful *jeu d'esprit*. However, the vein of more earthy contemporary humour, apparent in his magazine illustrations and elsewhere, should not be underestimated.

During the 1930s, Whistler worked on his great mural scheme at Plas Newydd, Anglesey and began to develop a further career as a stage designer. But joining the Welsh Guards as a volunteer in 1940, he was killed on active service in Normandy on 18 July 1944.

His work is represented in the collections of the British Museum, the National Portrait Gallery, the Tate Gallery, the Victoria and Albert Museum, and the Royal Pavilion (Brighton).
Further reading: Jenny Spencer-Smith (editor), *Rex Whistler's War*, London: National Army Museum, 1994; Laurence Whistler, *The Laughter and the Urn*, London: Wiedenfeld, 1985; Laurence Whistler and Ronald Whistler, *The Work of Rex Whistler*, London: Batsford, 1960

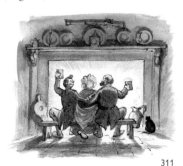

311

312

311

THE FIRELIGHT TOAST
inscribed with publication details on reverse
pen ink and monochrome watercolour
3 ½ x 4 inches
Illustrated: *Nash's Pall Mall Magazine*, December 1935

312

SAILING YACHTS
inscribed with publication details on reverse
pen ink and monochrome watercolour
4 x 8 ¾ inches
Illustrated: *Nash's Pall Mall Magazine*, August 1935

313

THE CARAVAN
inscribed with publication details on reverse
pen ink and monochrome watercolour
4 x 5 ¼ inches
Illustrated: *Nash's Pall Mall Magazine*, December 1935

314

BOXING
pencil
two images each 9 x 6 ½ inches
pencil sketch of a hooded man on reverse

CHARLES FOLKARD

Charles James Folkard (1878-1963)

For a biography of Charles Folkard, please refer to *The Illustrators*, 1997, page 274.

Presented his strip cartoon 'Teddy Tail' for the first time in the *Daily Mirror* in 1915 (until 1960)

Numbers 315-321 are all illustrated in *Grimms' Fairy Tales*, London: J M Dent & Sons, 1949

317

315

316

318

315

THE TURNIP
signed with monogram
pen and ink with bodycolour
7 x 8 ½ inches
pencil sketch of a dragon on reverse
Illustrated: *Grimms' Fairy Tales*, page 334
A poor man gives his only prize possession, a giant home-grown turnip, to the King. The King is so flattered that in return he gives the farmer riches beyond his dreams. This angers the poor man's wealthy brother who tries to win the King's favour by giving him many valuable gifts. The King rewards his generosity with the only thing he believes worthy of it; the huge turnip. This makes him furious and he resolves to kill his brother. He employs three villains to ambush his brother and drown him, but they are incompetent murderers and the farmer escapes, a wiser and richer man.

[EAF]

316

THE SLEEPING BEAUTY
signed with monogram
pen and ink with bodycolour
5 ½ x 7 inches
Illustrated: *Grimms' Fairy Tales*, page 175

318

THE FISHERMAN AND HIS WIFE
signed with monogram
pen and ink with bodycolour; 5 x 7 ¼ inches
Illustrated: *Grimms' Fairy Tales*, page 253
An enchanted fish grants a fisherman wishes in return for showing mercy but his nagging wife is never satisfied and eventually loses them everything.

317

CINDERELLA
signed with monogram
pen and ink with bodycolour
8 x 8 inches
pencil sketch of Cinderella and the two Ugly Sisters on reverse
Illustrated: *Grimms' Fairy Tales*, page 195

[EAF]

319

JORINDA AND JORINGEL

signed with monogram

pen and ink with bodycolour

7 ½ x 8 inches

Illustrated: *Grimms' Fairy Tales*, page 67

A young maiden is turned into a beautiful bird by a wicked witch and hung in a cage in an enchanted castle. Her beloved, a shepherd boy, dreams that a rare blood-red flower will protect him against the witch and bring his beautiful Joringel back. After a long search, he finds the flower and rescues his bride. [EAF]

320

THREE SPINNING FAIRIES

signed with monogram

pen and ink with bodycolour

6 ½ x 8 inches

Illustrated: *Grimms' Fairy Tales*, page 204

An exasperated mother is caught by a Queen punishing her lazy daughter for her idleness. Ashamed to be found beating her only child she pretends to the Queen that it was her daughter's continous and over-zealous spinning that had forced her to beat her, for they were so poor that there was not enough money to buy fresh flax. Amazed by the girl's industrious nature, the Queen promises the girl her son's hand in marriage and many riches if she will spin all the flax in her palace. Alone, the girl is distraught but three very ugly fairies come to her aid so long as she promises to invite them to her wedding. She keeps her word and on her wedding day the bridegroom asks them how they came to look so odd. When they tell him that spinning has given them a big foot, a large under-lip and a broad thumb respectively, he is horrified and vows that his beautiful new wife must never go near a spinning wheel again. [EAF]

321

THE RAVEN

signed with monogram

pen and ink with bodycolour

7 ½ x 8 ½ inches

Illustrated: *Grimms' Fairy Tales*, page 180

A princess is turned into a raven and is doomed to live forever in a dark wood. A young man riding through the forest responds to her sad call. She tells him that if he takes shelter in the old woman's house nearby and refuses the food and drink he is offered the curse will be broken and she will be freed. However he fails this task on three consecutive nights and has to resort to his own cunning to rescue her. [EAF]

ARTHUR SZYK

Arthur Szyk (1894-1951)

'Art is not my aim, it is my means.'

Arthur Szyk made use of propagandist illustration to raise public aware-ness of the persecution of European Jews at the hands of the Nazis during the Second World War. He has come to be remembered as more than just an illustrator and illuminator, his political messages and his devotion to Judaism and to Poland eventually becoming as strong a driving force as his artistic passions.

Arthur Szyk was born in Lodz, Poland, on 3 June 1894, at a time when it was part of the Russian Empire. He studied in Paris (1910-14), and later at the Academy of Fine Arts, Krakow, under Teodor Axentowicz.

At the outbreak of the First World War, Szyk was forced to return to Poland and was there conscripted into the Russian Army. Following the independence of Poland in 1918 he served in the Polish army against the Bolsheviks for two years and, as a result, was exposed to the massive pogroms carried out against the Jewish population in Eastern Europe. In 1921 he returned to Paris remaining there for a further decade. During this period he exhibited in group shows, most notably at the Bibliothèque Nationale, and illustrated many books including the *Book of Esther* (1925), Flaubert's *La Tentation de Saint Antoine* (1926) and Pierre Benoit's *Le Puits de Jacob* (1927). The *Book of Esther* concerns the biblical tale of a young orphan girl who became Queen of Persia and saved the Jews from massacre, and Szyk's illuminations were intended as an allegory of the heroism of the Jewish people. In 1929, Szyk illuminated and published the *Statute of Kalisz*, which had granted rights to the Jews in 1264, through the generosity of the Grand Duke of Poland. This work contributed substantially to a revival of interest in the art of illumination, and in turn to the recognition that Szyk was the foremost living exponent of this long-forgotten art.

In 1931, Szyk started to produce decorations for the Société des Nations in Geneva. However, these were never completed because in the same year he was sent by the Polish government to the US to present to the Library of Congress in Washington a series of thirty-eight miniatures on the American Revolution. For this he received the George Washington Bicentennial Medal; and these works were then exhibited at the Library of Congress exhibition 'Washington and His Times' and many museums. After this he returned to Poland.

In 1932, Szyk illustrated the *Haggadah*, a history of the Jews in Egypt, which he dedicated to George V, King of England, though it was not published until 1940. By 1937 Szyk was living in London, and in April of that year there was an exhibition at the Arlington Gallery, 'Exhibition of Miniatures and Illuminated Manuscripts by Arthur Szyk'. His miniatures, devoted to the Poles in America, also formed an important artistic feature of the Polish Pavilion at the New York World's Fair.

When Germany invaded Poland in September 1939, Szyk abandoned work on his illuminated manuscripts, turning his attention instead to anti-fascist cartoons, satires, and caricatures to fight oppression and tyranny, and to encourage the reluctant American public to support the Allied cause. His early wartime work focused on themes such as 'the brutality of the Germans, the more primitive savagery of the Russians, the heroism of the Poles, and the suffering of the Jews' (Tom Cooney of the United States Holocaust Memorial Museum). It was these themes which were the subjects of his 1940 exhibition 'War and "Kultur" in Poland'. Although it has never been confirmed, Szyk always maintained that his mother and brother had been murdered by Nazis in the Polish ghetto where they had lived, which increased his determination to expose the evil of Nazi tyranny.

In 1940 Szyk emigrated to Canada, and by 1941 had settled in New York. He rapidly became America's leading political caricaturist because, unlike many other artists working during the Second World War, his political messages were easily understood by the general public. This is due to his strong Jewish identity, and his unswerving commitment to put-ting an end to the persecution of his race. He realised that, combined with his connections, his artistic talents gave him a very powerful propagandist position, which he was determined not to waste. Once America had entered the conflict in 1941, following the attack on Pearl Harbour, he began to use his art to ease public fear.

An important album of caricatures, *The New Order*, appeared in 1942. Critical of the Nazis, its contents were reminiscent of the work of the contemporary German satirists, Otto Dix and George Grosz. Americans soon became familiar with Szyk's illuminated manuscripts and political cartoons as they appeared on and between the covers of popular magazines such as *Esquire*, *Time* and *Collier's*. Although at this time the subjects of his work were incredibly varied, ranging from biblical illuminations to advertisements for US Steel and Coca Cola, they were unified by his unique style.

Stephen Luckert, co-curator of the exhibition 'The Art and Politics of Arthur Szyk', explains that 'Szyk dedicated more time and energy than

any other artist of his time to the plight of the Jews in Nazi Europe. He understood that Nazi anti-Semitism was fundamentally different and worked to convince the allied powers of this.' Szyk's contribution to the campaign to create a Jewish homeland in Palestine did not cease after the end of the Second World War; for instance in 1948 he produced the highly-decorated Declaration of Independence of the State of Israel. Although he chose not to live in Israel once it had been made an independent state, and was a non-observant Jew, he had made it his life's mission to see the Jews triumph over oppression. By the time Arthur Szyk died on 13 September 1951, this had become reality. [RC]

His work is represented in the collections of the Arthur Szyk Society (California), Burlingame Library (North East Kansas), Spertus Museum (Chicago), the United States Holocaust Memorial Museum (Washington DC), and the University of Scranton Art Gallery (Pennsylvania).
Further reading: Elizabeth Koszarski-Skrabonja, 'The Drawing of Arthur Szyk', *Kosciuszko Foundation Newsletter*, Summer 1994

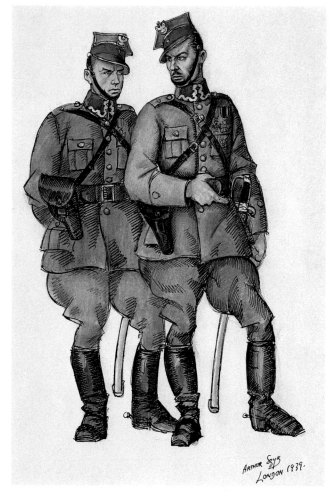

322

322
TWO POLISH OFFICERS
signed and dated 'London 1939'
pen ink, pencil and watercolour
8 x 5 ½ inches

STEPHEN TENNANT

Stephen James Napier Tennant (1906-1987)

Stephen Tennant was born at Wilsford Manor, near Salisbury, in Wiltshire, on 21 April 1906. His father, the first Baron Glenconner was from a family of self-made industrialists, while his mother was descended from the aristocracy. Treated as a girl for much of his childhood, he grew up to become an adrogynous and flamboyant leader of the exclusive social circle now known as the 'Bright Young Things'. Tuberculosis in youth proved, if anything, an advantage, helping to emphasise his fine, even decadent, appearance. On the death of his father in 1920, he inherited a large sum of money and two properties, and decided to take up painting. A year later, at the age of just fifteen, he exhibited in London, at the Dorien Leigh Gallery, and subsequently studied at the Slade School of Fine Art. Living in London, he became a member of the wealthy artistic circle which included Cecil Beaton, Rex Whistler, the Sitwells – and Siegfried Sassoon, with whom he had an intense homosexual relationship.

Though also studying ballet, and dancing before Diaghilev, Tennant established himself as an illustrator and writer. His career was launched, in 1925, with *The Vein in the Marble*, a collaboration with his mother, Pamela Grey. His later work as an illustrator included contributions to Lady Cynthia Asquith's anthology, *The Treasure Ship* (1926); his own *Leaves from a Missionary's Notebook* (1929); and three poems by Siegfried Sassoon, published by Faber in its Ariel series (1930-31). Exhibitions of his work were later held at the Redfern Gallery (1953), Anthony d'Offay (1976) and the Michael Parkin Gallery (1985, 1987). However, Tennant himself became much less an exhibitionist and, indeed, increasingly reclusive. He died at Wilsford Manor on 28 February 1987. After his death, the contents of the house were sold at a newsmaking two-day country house sale.

Further Reading: Philip Hoare, *Serious Pleasures: The Life of Stephen Tennant*, London: Hamish Hamilton, 1990

323

324

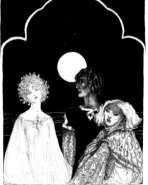

325

323

THE BAT
pen and ink with watercolour
12 ¼ x 9 ¾ inches
watercolour sketch of head of a
woman on reverse

324

THE MOON FOR COMPANY
pen and ink with watercolour
10 x 8 inches
Illustrated: Pamela Grey, *The Vein
in the Marble*, London: Philip
Allan, 1925, facing page 1

325

SOD AND SOUL
pen and ink
10 x 8 inches
Illustrated: Pamela Grey, *The Vein
in the Marble*, London: Philip
Allan, 1925, facing page 34

JOHN AND ISOBEL MORTON-SALE

JOHN AND ISOBEL MORTON-SALE

John Dalton Morton-Sale (1901-1990)

Isobel Laurie Morton-Sale (née Lucas) (1904-1992)

For a biography of John and Isobel Morton-Sale, please refer to *The Illustrators*, 2002, pages 46-47.

Key work illustrated: Ann Driver and Rosalind Ramirez, *Something Particular* (1955)
Further reading: David Wootton, *John & Isobel Morton-Sale*, London: Chris Beetles Ltd, 1996

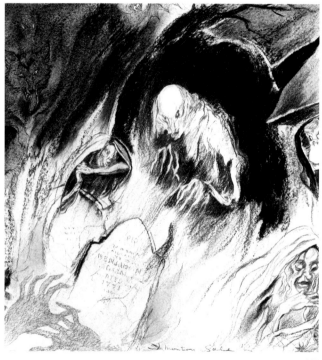

327

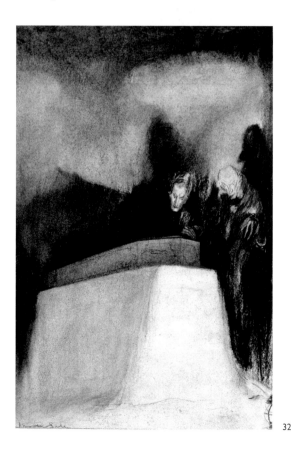

326

Numbers 326-334 are all from the Estate of John and Isobel Morton-Sale

JOHN MORTON-SALE

326
THE HOUSE OF USHER
signed
inscribed with title and 'Edgar Allan Poe' below mount
charcoal with varnish
12 x 8 inches

327
WEREWOLVES
signed
inscribed with title below mount
charcoal
11 x 10 ½ inches

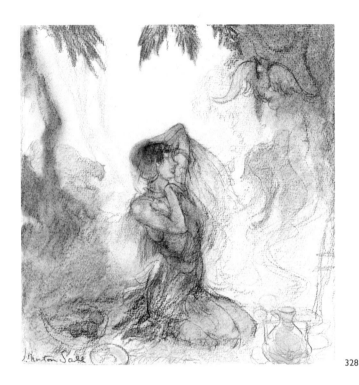

329

328

330

JOHN
MORTON-SALE

328

AFRICA

signed

signed, inscribed with title and
publication details

charcoal with watercolour

8 ¾ x 8 ¼ inches

Probably illustrated in the
Christmas Bookman

329

NOTHING TO REPORT

signed

watercolour

17 x 12 inches

Illustrated: Caroline Oman,
Nothing to Report, London: Hodder
and Stoughton, 1940, front cover

330

LOVERS DANCING

signed and dated 1931

pastel

16 x 11 inches

332

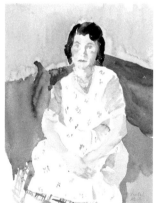

333

334

331

ISOBEL MORTON-SALE

331
THE RED COAT
signed
watercolour and charcoal
13 x 10 inches
Illustrated: Elizabeth Goudge,
Gentian Hill, Devon: Parnassus
Books, 1950

332
TOASTING BY THE FIRE
signed
watercolour and charcoal
10 x 9 inches

333
WOMAN WITH GREEN NECKLACE
signed
watercolour
11 ½ x 9 inches

334
BALLOON SELLER
signed
watercolour
19 ¾ x 13 ½ inches

ILLUSTRATORS AFTER THE SECOND WORLD WAR

EDWARD ARDIZZONE

Edward Jeffrey Irving Ardizzone, CBE RA RDI (1900-1979)

For a biography of Edward Ardizzone and an essay on his illustrations to Cyril Ray's *Merry England*, please refer to *The Illustrators*, 1999, pages 193-195.

Key works written and illustrated: *Little Tim and the Brave Sea Captain* (1936); *Tim All Alone* (1956)
Key works illustrated: Contributed to *Radio Times* (from 1932) and the *Strand Magazine* (from 1942); H E Bates, *My Uncle Silas* (1939); *Poems of François Villon* (1946); Walter de la Mare, *Peacock Pie* (1946); Anthony Trollope, *The Warden* (1952) and *Barchester Towers* (1953); William Thackeray, *The Newcomes* (1954); Eleanor Farjeon, *The Little Bookroom* (1955); Cervantes, *Exploits of Don Quixote* (1959)
His work is represented in numerous public collections, including the British Museum, the Imperial War Museum, the Tate Gallery and the Victoria and Albert Museum.

Further reading: Brian Alderson, *Edward Ardizzone: a bibliographic commentary*, London; The British Library, 2002; Dr Nicholas Ardizzone, *Edward Ardizzone's World. The Etchings and Lithographs*, London: Unicorn Press/Wolseley Fine Arts, 2000; Gabriel White, *Edward Ardizzone*, London: Bodley Head, 1979

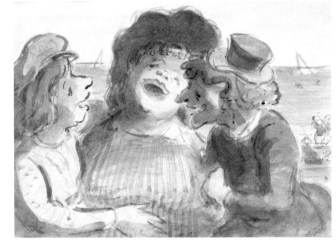

336

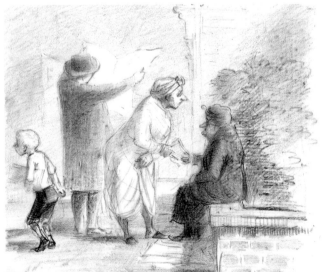

335

335

THE GOSSIPS

signed with initials
black chalk on plastic
10 ¼ x 11 ½ inches

336

GIRLS AT SOUTHEND

signed with initials
watercolour
7 x 9 ¾ inches

Swanhilda-of-the-Swans
by Dana Faralla

Swanhilda-of-the-Swans
by Dana Faralla

Blackie

Illustrated by Edward Ardizzone

337

337

SWANHILDA-OF-THE-SWANS
watercolour
8 ½ x 13 ¼ inches
Illustrated: Dana Faralla,
Swanhilda-of-the-Swans, London:
Blackie & Sons, 1964, cover
and spine

HUGH CASSON

Sir Hugh Casson, PRA RIBA FSIA (1910-1999)

For a biography of Hugh Casson, please refer to *The Illustrators*, 2002, page 77.

An architect, his key buildings include: Arts Faculties, Sidgwick Site, Cambridge University (from 1952); the Elephant House, London Zoo (1965); the Ismaili Centre, South Kensington, London (from 1978); also a number of projects for the Royal Family
His work is represented in numerous public collections, including Hertfordshire County Council, the Royal Institute of British Architects and the University of East Anglia.
Further reading: José Manser, *Hugh Casson. A Biography*, London: Viking, pages 188-189

Numbers 338-364 were all sent to Lady D'Avigdor Goldsmid, Casson's lifelong friend.

340

342

341

338

339

343

338

TO MY VALENTINE
inscribed with title
pen and ink
3 ¼ x 2 ¼ inches

339

TWO CHAIRS
BAR HARBOUR — MAINE
FOR ROSIE
signed with initials, inscribed with title and dated 'Xmas 1968'
pen ink and watercolour
4 ¼ x 3 ¾ inches

340

FOR ROSIE
TOURISTS, JERUSALEM
signed with initials and inscribed with title
pen ink and watercolour
3 ¼ x 5 ½ inches

341

FOR ROSIE, 1970
signed with initials and inscribed with title
watercolour
3 ½ x 3 ½ inches

342

FOR ROSIE, LAKE PALACE UDAIPUR
signed with initials
inscribed 'Darling Rosie, this you brought with you in Kyoto...and painted on the wrong side because it looked snow-flakey and marbley at the same time! it came with my much love and hopes to meeting from — if only over the wallpaper in the entrance hall! have a lovely Christmas. Hugh x'
on reverse
pen ink and watercolour
5 ¼ x 4 ¾ inches

343

TO DARLING ROSIE ON HER BIRTHDAY - JULY 1953....BUT WILL IT EVER PISCINE?....
signed and inscribed with title
pen ink and watercolour
8 x 12 ½ inches

344

345

346

347

348

350

349

351

344

TRESCO — COAST ROAD
FOR ROSIE
signed with initials, inscribed with
title and dated 'Christmas 1994'
pen ink and watercolour
5 ½ x 8 inches

345

APPROACHING STORM TRESCO
FOR ROSIE WITH LOVE
signed with initials and inscribed
with title
watercolour with bodycolour
5 x 6 inches

346

LUNCH BREAK...ROAD TO THE
GREAT WALL
signed with initials and inscribed
with title
watercolour with pen and ink
2 ¾ x 7 inches

347

TOWCESTER. THE RACECOURSE
signed with initials and inscribed with
title and 'R, just found this — done in
1960, remember Jackson Sarps? H x'
coloured ink; 4 x 5 inches

348

TO DARLING ROSIE
QUEEN OF NIGHT AND DAY
signed with initials, inscribed with
title and dated 'Monday July 21st '69'
pen ink and watercolour
5 x 8 inches

349

PALM IN THE BREEZE
watercolour with pencil
4 ¾ x 2 ¾ inches

350

THE RIVER BED, AHMEDABAR
(FROM THE GARDEN OF THE RITZ)
signed with initials
inscribed with title on reverse
pen ink and watercolour
5 ½ x 9 ½ inches

351

EVEN THE SAINTS OF STONE FROM
S.GIOVANNI CATERANO MAKE
GREETINGS TO ROSIE ON HER
BIRTHDAY
signed with initials, inscribed with
title and dated 'July '68'
pen and ink
1 ¾ x 6 ¼ inches

352

355

353

356

354

357

358

359

361

362

352

LITTLE LOVE HEART

ink

1 ¼ x 1 ¼ inches

353

IN CASE OF EMERGENCY

BREAK GLASS

pen ink and watercolour

1 ¼ x 1 ¼ inches

354

VIEW OF CASTLE

pen ink and watercolour

1 ¼ x 1 ¼ inches

355

BUCKINGHAM PALACE

FOR ROSIE

signed with initials and inscribed

with title; inscribed 'Rosie' on reverse

pen ink and watercolour

1 ¼ x 1 ¼ inches

356

COUPLE STROLLING

signed with initials

pen ink and watercolour

1 ¼ x 1 ¼ inches

357

WALKWAY

inscribed 'for my Valentine x' on reverse

pen ink and watercolour

1 ¼ x 1 ¼ inches

358

A FOREST WALK

signed

pen ink and watercolour

9 ¼ x 7 ¾ inches

359

REPOSE BY JOHN ALEXANDER 1895

inscribed with title and 'with love for

Rosie from Margaret and Hugh'

pen ink and watercolour

5 x 8 inches

360

FOR DARLING ROSIE FROM THE

CASSONS, KYOTO

signed with initials and inscribed with

title

watercolour

5 ¼ x 4 ½ inches

361

FOR DARLING ROSIE

signed with title and dated 'August

1970'

pen ink and watercolour

6 ½ x 9 inches

362

PARACHAIA AEGINA

FOR ROSIE WITH LOVE

signed with initials, inscribed with

title and dated 'Aug '78'

pen ink and watercolour

6 x 3 ½ inches

363

CRUISE SHIP

pen and ink with watercolour

4 ½ x 6 ¼ inches

364

PURPLE HAZE

watercolour

5 ½ x 4 ¾ inches

ERIC FRASER

Eric George Fraser (1902-1983)

For a biography of Eric Fraser, please refer to *The Illustrators*, 1997, page 162.

Key works illustrated: Contributed to *Radio Times* (1926-82); Ippolito Nievo, *The Castle of Fratta* (1954)

His work is represented in the collections of the British Museum and the Victoria and Albert Museum.

Further reading: Sylvia Backemeyer, *Eric Fraser. Designer & Illustrator*, London: Lund Humphries, 1998; Alec Davis, *The Graphic Work of Eric Fraser*, Uffculme: The Uffculme Press, 1985 (2nd edition)

367

367

CINDERELLA

signed with monogram

pen and ink with bodycolour

9 ½ x 7 inches

An advertisement for Mond Nickel, 1951

365

365

HERODOTUS

signed with initials

inscribed with title on reverse

pen and ink

6 ½ x 5 ½ inches

Exhibited: 'The Artists of the *Radio Times*', Chris Beetles Ltd, September 2002, no 84

366

VOICES OUT OF THE AIR

signed

pen and ink with bodycolour

12 ½ x 4 inches

Illustrated: *Radio Times*, 21 December 1956, page 3

Exhibited: 'The Artists of the *Radio Times*', Chris Beetles Ltd, September 2002, no 99

368

368

THE TALISMAN

signed with initials

watercolour and bodycolour

8 x 6 ¾ inches

Illustrated: Sir Walter Scott, *The Talisman*, London: J M Dent, 1956, (Everyman Library, no 144), dust jacket

Exhibited: 'The Artists of the *Radio Times*', Chris Beetles Ltd, September 2002, no 93

369

HANS KOHLHAAS

signed with initials

pen and ink

3 ¾ x 3 inches

Illustrated: *Radio Times*, 21 June 1973, page 29

Exhibited: 'The Artists of the *Radio Times*', Chris Beetles Ltd, September 2002, no 98

JOHN MINTON
Francis John Minton, RBA LG(1917-1957)

John Minton was born at Great Shelford, Cambridgeshire on 25 December 1917, the son of a solicitor. He was educated at Northcliffe House, Bognor Regis, and at Reading School, and then studied in London, under Patrick Millard and Kenneth Martin at St John's Wood School of Art (1935-38). During his time there he met Michael Ayrton who, though several years his junior, encouraged him to absorb the influence of the French Neo-Romantics both from books and from visits to Paris and Les Baux in Provence (1938-39). These experiences first bore fruit in collaborations with Ayrton, in designs for John Gielgud's production of *Macbeth*, and in a joint show at the Leicester Galleries (both 1942). Though he had considered himself a conscientious objector at the outbreak of the Second World War, he entered the Pioneer Corps in 1941, and was commissioned for a short time two years later, being released on medical grounds. On his return to London, he shared a studio with Scottish painters Robert Colquhoun and Robert MacBryde, and taught illustration at Camberwell School of Art (1943-46). He then shared a studio with Keith Vaughan (1946-52) and taught at the Central School of Art (1946-48) and the Royal College of Art (1948-57).

During the late 1940s, Minton synthesised the influence of contemporary French and British painters, and such Romantic artists as Samuel Palmer, to form his mature style. He then established himself as a leading Neo-Romantic figure with emotionally charged paintings, often of young men in landscape settings, which he exhibited in regular solo shows at the Lefevre Gallery (from 1945), and also at the Royal Academy (from 1949). By the end of the decade, he was known as a varied designer as well as painter, and especially as the illustrator of such notable volumes as an English edition of Alain-Fournier's *Le Grand Meaulnes* (1947) and Alan Ross's travel book on Corsica, *Time Was Away* (1948). These projects marked his fascination with isolated and exotic terrains and, travelling extensively in search of new subjects, he visited Spain (1948 and 1954), the West Indies (1950) and Morocco (1952).

After 1950, Minton felt increasingly at odds with international fashions in modern art, arguing with Francis Bacon and criticising the critic David Sylvester. He found compensation in his celebrated position at the centre of bohemian London and, more than ever living for the moment, frequented Soho's pubs and clubs. The last part of his working life was again devoted to designs for the stage, including *Don Juan* and *The Death of Satan*, two plays by Ronald Duncan produced in 1956 at the Royal Court. Ill at ease with his homosexuality, he made two attempts to take his own life and finally committed suicide through an overdose of drugs on 20 September 1957. The Arts Council organised a memorial exhibition of his work during the following year.

His work is represented in numerous public collections, including the Tate Gallery, the Victoria and Albert Museum, and the Fitzwilliam Museum. Further reading: Frances Spalding, *Dance till the Stars Come Down: A Biography of John Minton*, London: Hodder & Stoughton, 1991

370
BUT JUST THEN CRACK! CRACK! CRACK!...MERRY TUMBLED HEAD FOREMOST INTO THE EXCAVATION
inscribed with title below mount
pen and ink
5 ½ x 6 inches

Illustrated: Robert Louis Stevenson, *Treasure Island*, London: Paul Elek (Camden Classics), 1947, page 202

370

MERVYN PEAKE

Mervyn Laurence Peake (1911-1968)

For a biography of Mervyn Peake, please refer to *The Illustrators*, 1997, page 197.

Key works written and illustrated: *Captain Slaughterboard Drops Anchor* (1939); *Titus Groan* (1946); *Gormenghast* (1950); *Titus Alone* (1959)
Key works illustrated: *Ride a Cock Horse, and Other Nursery Rhymes* (1940); Samuel Taylor Coleridge, *The Rime of the Ancient Mariner* (1943); Robert Louis Stevenson, *Treasure Island* (1949); Lewis Carroll, *Alice's Adventures in Wonderland and Though the Looking Glass* (1954)
His work is represented in the collections of the Imperial War Museum, the National Portrait Gallery and Manchester City Art Gallery; his papers are held by University College London.
Further reading: John Batchelor, *Mervyn Peake. a biographical and critical exploration*, London: Duckworth, 1974; John Watney, *Mervyn Peake*, London: Michael Joseph, 1976; G Peter Winnington, *Vast Alchemies. The Life and Work of Mervyn Peake*, Peter Owen, 2000; Malcolm Yorke, *Mervyn Peake: My Eyes Mint Gold: A Life*, London: John Murray, 2000

371

GREETINGS FROM UNCLE SAM

pen and ink

7 x 4 ¼ inches

OSBERT LANCASTER

Sir Osbert Lancaster (1908-1986)

For a biography of Osbert Lancaster, please refer to *The Illustrators*, 1997, page 154.

Key works written and illustrated: *Pillar to Post* (1938); contributed pocket cartoons to the *Daily Express* (from 1939)
His work is represented in the collections of the Cartoon Art Trust, the National Portrait Gallery, the Royal Opera House, the Tate Gallery, and the Victoria and Albert Museum. Further reading: Richard Boston, *Osbert*, London: Collins, 1989; Edward Lucie-Smith, *The Essential Osbert Lancaster*, London: Barrie & Jenkins, 1988

372

373

AND IT LOOKS TO ME VERY MUCH AS THOUGH THEY'D GOT AWAY WITH A COUPLE OF PROOF-READERS INTO THE BARGAIN
signed
inscribed with title on reverse
pen and ink with crayon
9 ¼ x 5 ¼ inches
Illustrated: *Daily Express*, 16 May 1967

372

ARGYLL AND BEDFORD SAY IT'S THOROUGHLY UNDEMOCRATIC AND THAT A JOB WITH THAT AMOUNT OF PUBLICITY SHOULD HAVE BEEN OPEN TO ALL DUKES, REGARDLESS OF PRECEDENCE
signed
inscribed with title on reverse
pen and ink with crayon
10 x 5 ½ inches
Illustrated: *Daily Express*, 26 July 1962

374

DO YOU REALISE THAT DURING THE TIME YOU'VE SPENT IN THERE MARGARET ARGYLL HAS CROSSED THE ALPS AND IS NOW HALF WAY TO AFRICA!
signed
inscribed with title on reverse
pen and ink with crayon
9 ¾ x 5 ¼ inches
Illustrated: *Daily Express*, 23 January 1976

375

ZULEIKA DOBSON

Zuleika Dobson is a conjuror with an international reputation. However, her reputation is based more on her appearance than her skills at prestidigitation. When she visits her grandfather, the Warden of Judas College, Oxford, all the undergraduates fall in love with her. Chief among these is the extremely eligible Duke of Dorset, the only Oxonian who truly attracts Zuleika. However, she cannot love someone who loves her. This perverse situation leads the Duke to commit suicide by drowning. His fellow students – with but a single exception – follow suit. The novel is a tragedy written as comedy, and ends on an upbeat with Zuleika leaving Oxford ready to face further adventures.

376

377

THE STUDIES FOR THE ZULEIKA DOBSON MURALS

The eightieth birthday of Max Beerbohm, in 1952, allowed Osbert Lancaster to pay homage to his model and demonstrate his distinction from him. First he made a set of illustrations for Beerbohm's classic Oxford novel *Zuleika Dobson*, originally published in 1911, which Beerbohm announced as 'flawless'. Then, with the help of Judyth Simmons, a recent graduate of the Ruskin School, he transformed these illustrations into large-scale murals for Oxford's Randolph Hotel. Beerbohm suggested slight changes to these to Lancaster on receiving photographs. But the lively false naivety of the final results are best compared not to work by Beerbohm but to murals that Edward Bawden had made for Basil Blackwell's Oxford bookshop. Indeed Lancaster owed much to the style developed by the Class of '22 at the Royal College of Art. And his reuse of the Zuleika designs as sets for a dramatisation of the novel (Savile Theatre 1957) paralleled their ingenuity. Nearly two decades after the death of Beerbohm in 1956, Lancaster returned to *Zuleika Dobson*, and illustrated it again, for publication by the Shakespeare Head Press (1975). The project allowed him a last detailed review of his years in Oxford and his relationship with the man widely known as 'The Incomparable Max'.

Numbers 375-379 are all finished studies for the murals, depicting scenes from *Zuleika Dobson*, in the ballroom of the Randolph Hotel, painted in 1952. Each completed mural was used to illustrate Max Beerbohm, *Zuleika Dobson*, Oxford: The Shakespeare Head Press, 1975.

375

HIS STRAW HAT WAS ENCIRCLED WITH A RIBAND OF BLUE AND WHITE
signed
inscribed 'Fresco for Zuleika Dobson Randolph Hotel Oxford' on reverse
watercolour and bodycolour
17 x 23 inches
Study for the illustration in *Zuleika Dobson*, between pages xvi-1

376

GREAT BEADS OF PERSPIRATION GLISTERING ON THE BROWS OF THOSE EMPERORS
oil on canvas
28 x 36 inches
Study for the illustration in *Zuleika Dobson*, between pages 2-3

377

THE RAFT WAS THRONGED WITH OLD JUDASIANS
oil on canvas
28 x 36 inches
Study for the illustration in *Zuleika Dobson*, between pages 54-55

OSBERT LANCASTER

378

378

AND HE KNEW AT ONCE — <u>SHE</u>
WAS COMING
oil on canvas
28 x 36 inches
Study for the illustration in *Zuleika
Dobson*, between pages 150-151

379

AND ALWAYS THE PATIENT RIVER
BORE ITS AWFUL BURDEN
TOWARDS IFFLEY
oil on canvas
28 x 36 inches
Study for the illustration in *Zuleika
Dobson*, between pages 154-155

379

CARTOONISTS AFTER THE SECOND WORLD WAR

ROWLAND EMETT

Frederick Rowland Emett, OBE (1906-1990)

For a biography of Rowland Emett, please refer to *The Illustrators*, 1997, page 258.

Key works illustrated: Walter de la Mare, *Bells and Grass* (1941); contributed to *Punch* (1939-51)
His work is represented in the collections of the Cartoon Art Trust, the Tate Gallery, and the Victoria and Albert Museum; his open-air sculptures can be seen in Nottingham and Basildon, and at the Houston Space Center, the Smithsonian Institute (Washington), and the Ontario Science Museum.
Further reading: Jacqui Grossart, *Rowland Emett: From Punch to Chitty-Chitty-Bang-Bang and beyond*, London: Chris Beetles Ltd, 1998

381

382

380

380
DESIGN FOR THE LUCAS B90
IMMEDIATE EXCHANGE SCHEME
signed
pen and ink
13 x 15 inches

381
IN PRAISE OF OLDER NUTS
& BOLTS
signed
pen ink, watercolour with bodycolour
6 x 12 ½ inches
Illustrated: *Daily Telegraph*, circa 1970, 'In Praise of Older Nuts & Bolts'

382
MUMBLING MAGNA AND LITTLE
FIEFIELD 'WINGS FOR VICTORY'
WEEK
signed
pen and ink
10 ½ x 13 inches
Illustrated: *Punch*, 12 May 1943, page 392

JOHN WHITFIELD TAYLOR
John Whitfield Taylor (1908-1985)

John Whitfield. Taylor was born in Stoke-on-Trent, Staffordshire, on 11 May 1908. He was educated at the Orme Boys' School, Newcastle-under-Lyme, and went on to read French at Manchester University. While there he drew for *Rag Bag*, the university paper. He had first showed an interest in cartoons at the age of fourteen when he received a collection of Frank Reynolds' drawings as a Christmas present.

After university Taylor returned to Staffordshire, becoming a school-teacher in the Potteries. It was during this time that he began to take art lessons from Percy Bradshaw's 'Press Art School', a correspondence course. His first cartoons were accepted by *Punch* in 1935, and soon after *Men Only*, *London Opinion*, *Lilliput* and others all published his work. He also contributed to *Eagle* (the 'Educating Archie' strip), the *Staffordshire Evening Sentinel* and, whilst Headmaster of Holden Lane High School, Stoke-on-Trent, *The Teacher*. In his 1957 *A History of Punch*, R G G Price described Taylor as 'one of the most consistent of the crazy artists…perhaps best when barest, nothing distracting attention from the purity of his nonsense' (page 292).

Taylor was a member of the Savage Club and the Society of Staffordshire Artists. He died on 12 December 1985. His son, David, was Editor of *Punch* from 1986 to 1989. [RC]

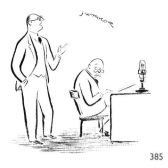

385

386

388

383

383
THE ARTISTS
signed
pen and ink
10 ¼ x 6 ½ inches
Illustrated: *Punch*, 11 August 1948, page 133

384
AND REMEMBER NOT TO MENTION YOUNG ROGER — HE WENT OVER TO RUGBY LEAGUE
signed with initials and inscribed with title
pen and ink; 5 ¼ x 4 ½ inches
Illustrated: *Punch*, 6 December 1961, page 821

385
FINALLY, REPEAT THE ADDRESS FOR SUBSCRIPTIONS; HOLD YOUR BREATH TILL THE RED LIGHT GOES OFF; AND THEN AHEAD WITH WHEW, THANK HEAVEN THAT'S OVER, I WAS TOO AWFUL, ETCETERA ETCETERA ETCETERA
signed and inscribed with title
pen and ink
11 ¾ x 8 ¼ inches
Illustrated: *Punch*, 29 December 1943, page 552

386
AS A MATTER OF FACT I THOUGHT AT FIRST I <u>WOULDN'T</u> RING YOU
signed and inscribed with title
pen and ink with watercolour
6 ¼ x 4 ½ inches
Illustrated: *Punch*, 19 July 1944, page 47

387
AND HERE'S A GOUACHE OF ME AND BABY PADDLING, WITH OUR HOTEL IN THE BACKGROUND
signed
inscribed with title below mount
pen and ink; 6 ½ x 10 inches
Illustrated: *Punch*, 15 October 1952, page 482

388
HAND UP THE GIRL WHO STOPPED A RUNAWAY TANK IN HIGH STREET THIS MORNING
signed and inscribed with title
pen and ink
10 x 8 inches
Illustrated: *Punch*, 1 July 1942, page 548

389
POVERTY OF IDEAS AT LIME GROVE SHE <u>SAYS</u>
signed
pen and ink; 8 ½ x 11 inches
Illustrated: *Punch*, 17 November 1954, page 633

VICKY

Victor Weisz (1913-1966)

'Beginning with our issue of 2 January [1954] *Vicky will contribute weekly an impression of a well-known personality. Each will be accompanied by a candid character sketch. Amongst early "victims" will be: R A Butler, Cyril Connolly, Lord Goddard, Edith Sitwell, Evelyn Waugh...'*

New Statesman, 19 December 1953

This was how, in the penultimate issue of 1953, the *New Statesman and Nation* announced the arrival of 'Profiles', a weekly column which was to become so popular that it became an institution in itself. These profiles – comprising character studies and cartoons – were republished in a book by Phoenix House in 1957. In the foreword to the book, *New Statesman* editor Kingsley Martin recalled how the series had originally been intended to be a light-hearted look at the 'real' personality behind the public persona. It was not the first time that the *New Statesman* had used caricature in an attempt to reveal people in public life. In 1934 David Low had been commissioned by the *Star* to draw the portraits of the fifty most distinguished people in Britain including George Bernard Shaw, Arnold Bennett, H G Wells and Arthur Conan Doyle. After a disagreement with the editor about how this should be presented in the *Star*, Low eventually had them published in the *New Statesman* to great acclaim. The drawings were accompanied by short comments on the personalities and careers of the subjects, some more acerbic than others.

This time round the Vicky cartoons were printed alongside a longer, more searching essay on the nature of the personality in question and a biographical survey which supported the points being made. Needless to say, not all the text met with the approval of the subjects. Cyril Connolly wrote a scathing letter to the *New Statesman* correcting details and pouring patronising grandeur on the anonymous author of his profile. The cartoons were more often loved than disliked. In the greatest tradition of caricaturists like Spy and Max Beerbohm, Vicky portrayed his subjects as the public knew and loved them: the authoritative and cerebral Kenneth Clark, the brittle Gilbert Harding, the troubled and thoughtful Arthur Koestler. They varied enormously to suit the personality. Some, like Connolly, were more obviously caricatural; others, like that of Koestler, were more perceptive and aimed to show deeper understanding of the subjects. All, however, were incisive with impeccably drawn.

By 1954 Vicky had established himself as Britain's leading left-wing cartoonist, but his rise had been a struggle. Born in Berlin in 1913, Victor Weisz, a Hungarian Jew, had attended the Berlin School of Art before his father died in 1928 obliging him to leave and become the family bread-winner. He began a career as a successful caricaturist of theatrical and sporting personalities in German newspapers but it was his political cartoons that caught the public's eye. Weisz published his first anti-Hitler cartoon at the age of fifteen and soon attracted the attention of the Nazis. As a member of the Jewish community with socialist political opinions, he was hounded by the Gestapo and lost his job. Aided by friends and his Hungarian passport, he escaped to England in 1935.

In London, he found work as a cartoonist with a variety of newspapers and journals; the *Daily Herald* even gave him a brief but unsuccessful trial as staff cartoonist. It was not easy at first; he could barely speak English and his humour was alien, but 1939 saw his liberation from the rut of unfulfilling freelancing when he was introduced to Gerald Barry, editor of the *News Chronicle*. Barry immediately saw both his talent and his limitations. He paid Weisz a retainer and gave him a crash course in British humour and politics. Weisz was set reading homework of Dickens, A A Milne, Lewis Caroll and back issues of *Punch* and *Wisden*. He was sent on visits to the House of Commons, sporting and social events, watched Gilbert and Sullivan and listened continually to the BBC. In short, within two years he was word-perfect in English and knew every nuance and distinction in British Society and politics. It was this assimilation of knowledge that gave him the grounding to become the most popular cartoonist in the country over the next fifteen years at the *News Chronicle*. The man who had arrived in Britain knowing only the names of three politicians – Churchill, Chamberlain and Baldwin – was by the mid-fifties one the most insightful satirists of the British.

It is no surprise then that by 1953, there was genuine excitement at his arrival at the *New Statesman*. For Weisz too, it was a comforting association. Dissatisfied with the new editors of the *News Chronicle* who had increasingly refused to publish his most severe cartoons, he sought employment with more left-wing newspapers like the *New Statesman* and *Daily Mirror*.

Though he was paid little for the weekly *New Statesman* profile, he found it a relief from the pressures at the *Chronicle* and it was an immediate success for the paper. Weisz was soon drawing cartoons as well as the weekly impressions for the *New Statesman*, revelling in the benefits of drawing for a readership that needed fewer clues to unravel his literary allusions and political themes. Even at the height of his career, however, he was insecure and often depressed. He worried away at the world's problems and increasingly despaired of those, especially his friends, who were in power. Just over a decade later, he took a fatal overdose of sleeping pills on the night of the 22 February 1966. He became known as the visual chronicler of the fifties and early sixties. No public personality, particularly those personally known to him, escaped his mocking pen, though he often said 'I don't make fun of the face, I make fun of what is behind the face'. [EAF]

His work is represented in the collections of the British Film Institute, the Cartoon Art Trust, the National Portrait Gallery and the University of Kent Cartoon Centre.
Further reading: Russell Davies and Liz Ottaway, *Vicky*, London: Secker & Warburg, 1987

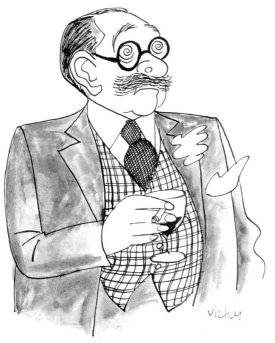

390

GILBERT HARDING

Gilbert Charles Harding (1907-1960) became one of the nation's best-loved broadcasting and television stars of the 1950s. He was born in Hereford and educated at Cambridge. His training for the Anglican priesthood was cut short by his conversion to Roman Catholicism, though he remained sympathetic to Anglicanism all his life. After brief spells as a teacher and a *Times* correspondent in Cyprus he joined the BBC during the war. In 1947 he was given his first personal show as quiz master in *Round Britain Quiz*. He also introduced BBC radio's *The Brains Trust* and *Twenty Questions*. From 1951 he became a national celebrity with his appearances as a grumpy but intuitive panellist in the long-running television game show *What's My Line?* For over a decade *What's My Line?*. The most dramatic event of 1960 on British television occurred when Gilbert Harding was interviewed by John Freeman for *Face to Face*, the live television interview programme. Answering what was clearly a distressing question for him, about death, the usually fractious Harding broke down and wept as he remembered the passing of his mother. He confessed to a startled nation: 'I'm profoundly lonely…I should be very glad to be dead.' [EAF]

390

GILBERT HARDING
signed
inscribed with title below mount
pen and ink
11 ½ x 9 ½ inches
Illustrated: *New Statesman and Nation*, 16 January 1954, page 64, 'The Soft-hearted Tiger'; *New Statesman Profiles*, London: Phoenix House, 1957, page 22

391

WE'VE <u>WON</u>, SIR
signed and inscribed with title
pen ink and coloured pencil
14 ½ x 20 ½ inches
Provenance: Estate of the late John Wells

390

KENNETH CLARK

Kenneth Mackenzie Clark, Baron Clark (1903-1983) was the best known art historian and critic of his generation. He studied History at Oxford but his main interest lay in art and, in 1925, he was invited to assist the renowned art historian Bernard Berenson in Florence. In 1931 he became Keeper of the Department of Fine Art at the Ashmolean Museum for four years; later he was appointed Director of the National Gallery in London, at the unprecedented early age of thirty-one. He was Slade professor of Fine Art at Oxford University twice (1946-50 and 1961-62) and was Chairman of the Arts Council of Great Britain (1953-60) and the Independent Television Authority (1954-57). However, it is in his role as an early television populariser of art history that he is most remembered. His television series and subsequent book *Civilisation* (1969) was shown in twenty-three countries and made him a celebrity. He received a Knighthood in 1938, became a Companion of Honour in 1959, received a peerage in 1969 and the Order of Merit in 1976. [EAF]

STEPHEN SPENDER

Sir Stephen Harold Spender (1909-1995), poet, novelist, playwright and critic, was born in London and educated at University College, Oxford. While an undergraduate he met the poets W H Auden, Louis MacNeice and Cecil Day-Lewis, and his early poetry – like theirs – was inspired by social protest. His association with the writer Christopher Isherwood began in 1930 and they spent the early years of that decade together in Berlin. His first book *Poems* was published in 1933.

In 1937 Spender went with the International Brigade to the Spanish Civil War and during the Second World War he enlisted in the London Fire Service. He also co-edited *Horizon* (1939-41) with Cyril Connolly and later edited *Encounter* (1953-66). In 1970 he became Professor of English at University College London.

Spender received a CBE in 1962 and was knighted in 1983. He died on 16 July 1995 at the age of 86. His books include an autobiography, *World Within World* (1951). [EAF]

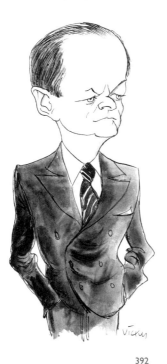

392
SIR KENNETH CLARK
signed
pen and ink
15 x 9 inches
Illustrated: *New Statesman and Nation*, 18 December 1954, page 822, 'The Admirable "K"'; *New Statesman Profiles*, London: Phoenix House, 1957, page 128

392

393
STEPHEN SPENDER
signed
pen and ink
17 x 8 inches
Illustrated: *New Statesman and Nation*, 20 January 1954, page 220, 'Lost Horizons, Brief Encounters'; *New Statesman Profiles*, London: Phoenix House, 1957, page 42

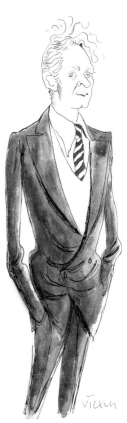

393

CYRIL CONNOLLY

The writer Cyril Connolly (1903-1974) was educated at Eton and Balliol College, Oxford. Thereafter he was employed as assistant to Logan Pearsall Smith, the wealthy memoirist and bachelor, and scraped a living as a freelance journalist. He was a regular contributor to the *New Statesman* in the 1930s, co-edited *Horizon* (1939-41) with Stephen Spender and later was briefly literary editor of the *Observer*. Connolly famously declared that it was the 'true function' of a writer to try to produce a masterpiece 'and that no other task is of any consequence'. A renowned gossip, hedonist, lazy and difficult man, he never achieved one himself. Books by Connolly include the novel, *The Rock Pool* (1938), *Enemies of Promise* (1938) and *The Unquiet Grave* (1944), a collection of aphorisms, reflections and essays. After the Second World War Connolly was the primary book reviewer of *The Sunday Times*. He also published several other books including *The Condemned Playground* (1945), *Previous Convictions* (1964) and *The Modern Movement* (1965). [EAF]

ARTHUR KOESTLER

The writer Arthur Koestler (1905-1983) was born in Budapest, Hungary, and educated in Vienna. He worked as a journalist in Palestine and Germany before settling in France in 1930 where he edited the anti-Hitler and anti-Stalinist weekly journal, *Zukunft*.

In 1932, Koestler joined the Communist Party and later spent time in the Soviet Union. He had an eventful political life: he was arrested in Spain during the Spanish Civil War in 1937, only narrowly escaping execution; he moved back to France but was interned as a suspect alien; he joined the French Foreign Legion and escaped to England but was once again arrested and interned. On his release he became a correspondent for the *News Chronicle*.

Koestler had become disillusioned with the activities of the Communist Party in the Soviet Union and Spain in the 1930s. His views on Joseph Stalin and totalitarian rule appeared in his second novel, *Darkness at Noon* (1940). Koestler committed suicide with his wife Cynthia Jefferies in 1983. Both were affiliates of Exit, the voluntary euthanasia group. [EAF]

394

395

394

CYRIL CONNOLLY

signed

inscribed with title below mount

pen and ink

15 x 10 1/2 inches

Illustrated: *New Statesman and Nation*, 13 March 1954, page 310, 'The Joker in the Pack'; *New Statesman Profiles*, London: Phoenix House, 1957, page 52

395

ARTHUR KOESTLER

signed

pen and ink

12 ½ x 10 ¾ inches

Illustrated: *New Statesman and Nation*, 3 July 1954, page 9, 'Last Train to Nowhere'; *New Statesman Profiles*, London: Phoenix House, 1957, page 99

REG WOOTTON
Reginald Wootton (died 1995)

396

Footballer Danny Blanchflower dubbed Reg Wootton 'Sport's Walter Mitty'. But the real star was his creation 'Sporting Sam'. The strip was published for more than thirty years (from 1933) on the back page of the *Sunday Express*, and ran concurrently in *Knockout Comic* (from 1949). His other work for comics included 'Sporty' (also *Knockout Comic*, from 1949) and 'Tubby' (*Buster*, from 1968).

Sporting Sam was the much-loved pint-sized British hero, with perfectly brylcreamed hair, pin-prick eyes, button nose and determined stance. Throughout his comic-strip fame the sportsman never broke his silence, relying instead on timeless visual gags reminiscent of silent movie slapstick. He was, perhaps, the Charlie Chaplin of the cartoon world.

Unfortunate yet irrepressible, Sam became a working-class hero, and was to football fans chasing the dream what Reg Smythe's 'Andy Capp' was to many a hen-pecked husband, complaining down the local about ''er indoors'.

Wootton himself was a keen sports enthusiast, who played cricket and rugby while at school. But his passion was football, and as an adult played for local sides in which he had more luck than his hapless alter ego, Sam. [HJM]

397

398

Numbers 396-412 are all inscribed '"Sporting Sam" *Sunday Express*, Fleet St EC4' below the mount

399

396
MUD CAST
dated 'Jan 2 1944' below mount
pen and ink
3 x 10 inches
Illustrated: *Sunday Express*, 2 January 1944

398
ONE MAN BAND
dated 'Feb 7 1945' below mount
pen and ink
3 x 10 inches
Illustrated: *Sunday Express*, 7 February 1945

400

397
SIDE KICK
dated 'Oct 1 1944' below mount
pen and ink
2 ¼ x 11 inches
Illustrated: *Sunday Express*, 1 October 1944

399
UNEXPECTED BLOCKAGE
dated 'Sept 2 1945' below mount
pen and ink
2 ¼ x 11 inches
Illustrated: *Sunday Express*, 2 September 1945

400
POSSIBLES V PROBABLES
IMPOSSIBLES V IMPROBABLES
inscribed with title
dated 'Aug 25th' below mount
pen and ink
3 x 10 inches
Illustrated: *Sunday Express*, 25 August 1946

401

405

402

406

403

404

401

FEELING DEFLATED

pen and ink

3 x 10 inches

Illustrated: *Sunday Express*,

4 November 1946

402

TO HELP YOU GROW

pen and ink

3 x 10 inches

Illustrated: *Sunday Express*,

12 January 1947

403

ADAPTING TO THE SLOPE

pen and ink

3 x 10 inches

Illustrated: *Sunday Express*,

26 January 1947

404

SELF SAVE

pen and ink

3 x 10 inches

Illustrated: *Sunday Express*,

11 May 1947

405

GETTING A BETTER VIEW

pen and ink

3 x 10 inches

Illustrated: *Sunday Express*,

20 March 1949

406

ALL ABOUT BALLET

inscribed with title

pen and ink

3 x 10 inches

Illustrated: *Sunday Express*,

9 April 1950

407

409

408

410

411

412

407

BEST SEAT IN THE HOUSE
pen and ink
3 x 10 inches
Illustrated: *Sunday Express*,
30 April 1950

408

ROVERS OR UNITED?
pen and ink
3 x 10 inches
Illustrated: *Sunday Express*,
3 September 1950

409

ALL OUT ATTACK
pen and ink
3 x 10 inches
Illustrated: *Sunday Express*,
3 December 1950

410

UNFAIR ADVANTAGE
pen and ink
3 x 10 inches
Illustrated: *Sunday Express*,
2 September 1951

411

WHICH CORNER?
pen and ink
3 x 10 inches
Illustrated: *Sunday Express*,
23 September 1951

412

LOOSE BOOT
pen and ink
3 x 10 inches
Illustrated: *Sunday Express*,
7 October 1951

WILLIE RUSHTON
William George Rushton (1937-1996)

Willie Rushton, cartoonist, satirist and much-loved raconteur, was born on 18 August 1937 and educated at Shrewsbury School. He found fame in the anti-establishment comic movement that emerged in the sixties when he appeared with David Frost in the BBC's *That Was The Week That Was*. Though he had no formal art training, he was the cartoonist for *Private Eye*, the satirical magazine he co-founded with Richard Ingrams, Paul Foot and Christopher Booker in 1961.

Over the next thirty-five years, Rushton became a favourite on radio panel games and comic shows and made frequent appearances on television and in films. On radio he recorded twenty-seven series of the long-running popular panel game *I'm Sorry I Haven't a Clue* and his distinctive voice was used in *The Tales of Winnie the Pooh* and the *Asterix* series. Rushton was also an accomplished writer and produced a number of best-selling works including *William Rushton's Dirty Book* (1964), *Superpig* (1976) and *W G Graces's Last Case* (1984). As an illustrator, he produced cartoons for a number of publications including the *Daily Telegraph*, *The Oldie* and *The Literary Review* as well as continuing his work for *Private Eye*. He also illustrated books such as Michael Rosen's *A Cat and Mouse Story* (1982), *The Diaries of Auberon Waugh 1976-1985* (1985) and *The Queen's English* (1985), written by his wife Dorgan Rushton.

He died at the age of 59 in 1996. In 2002 a blue plaque was placed in Mornington Crescent tube station in honour of his contribution to *I'm Sorry I Haven't a Clue*. [EAF]

His work is represented in the collections of the Victoria and Albert Museum.

Chris Beetles Ltd manages the artwork of the Estate of Willie Rushton. In Spring 2004 an appropriately large, jolly and entertaining exhibition will be held at the gallery in Ryder Street, St James's, London. All phases of his work will be shown from early *Private Eye* cartoons to late illustrations for articles by Auberon Waugh, including images from most of his irreverent books.

Willie Rushton's art will also be the main event at an international cartoon festival starting the weekend of 23 April 2004 in Shrewsbury. It will be organised by the European Federation of Cartoonists and the Shrewsbury Tourist Board in association with Chris Beetles Ltd.

413

413

GRETA GARBO IN THE GARDEN
signed with initial
pen ink and watercolour with crayon
10 ¾ x 10 ¾ inches
Illustrated: *Literary Review*, March 1995, front cover
(review by Wendy Holden of Barry Paris, *Garbo*, London: Macmillan, 1995)

414

414

AN EMPEROR EXPOSED
signed with initials and dated 90
pen ink and watercolour
7 ¾ x 8 inches
Illustrated: *Literary Review*, July 1990, front cover
(review by Anthony Blond of Barbara Levick, *Claudius*, London: Batsford, 1990)

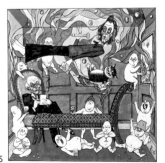

415

415

PSYCHEDELIC BABY
signed with initials and dated 96
pen ink and watercolour
10 ¼ x 10 ¼ inches
Illustrated: *Literary Review*, July 1996, front cover
(review by Anthony Clare of John Clay, *R D Laing: a Divided Self*, London: Hodder & Stoughton, 1996; and review by Anthony Storr of Frank Mclynn, *Carl Gustav Jung: a Biography*, London: Bantam, 1996)

RUSSELL BROCKBANK

RUSSELL BROCKBANK
Russell Partridge Brockbank (1913-1979)

For a biography of Russell Brockbank, please refer to *The Illustrators*, 2002, page 82.

Key works written and illustrated: *Round the Bend* (1948); *Up the Straight* (1953); *Over the Line* (1955); *Bees Under my Bonnet* (with R Collier, 1955); *The Brockbank Omnibus* (1957); *Manifold Pressures* (1958); *Move Over!* (1962); *The Penguin Brockbank* (1963); *Motoring Through Punch* (1970); *Brockbank's Grand Prix* (1973)

His work is represented in the collections of the University of Kent Cartoon Centre.

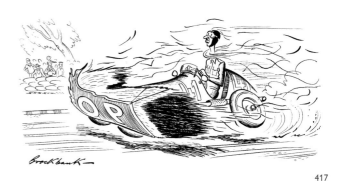

417

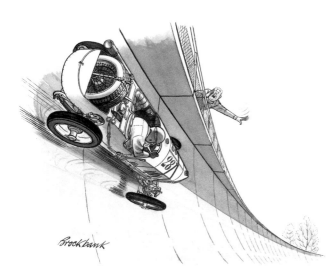

416

418

419

Numbers 416-439 (with the exceptions of 423, 430, 433 and 435) are all from the Estate of Russell Brockbank.

416
HERR UNLENAUT, PLEASE!
signed and inscribed with title
pen ink and monochrome watercolour
9 ¾ x 12 ½ inches

417
OVERHEATING PROBLEMS
signed and inscribed with title
pen and ink
5 ¾ x 11 ¼ inches
Illustrated: *Motor*, 28 January 1948

418
SUSPENSION TROUBLE
signed and inscribed with title
pen and ink
6 ½ x 11 ½ inches
Illustrated: *Motor*, 28 January 1948

419
LONDON TO BRIGHTON
signed with initials
pen ink and monochrome watercolour
6 ½ x 10 inches

420

421

423

422

420

SUMMER DRIVE

signed

watercolour with bodycolour

10 x 16 ½ inches

422

GOING TO A FUNERAL

signed

pen and ink

9 ¾ x 17 inches

421

SO WHAT'S WRONG WITH MY
DRIVING?

signed with initials

pen and ink

2 ½ x 5 ¾ inches

Probably illustrated in *Motor*

423

PETROL CRISIS

signed

pen and ink

19 x 13 inches

Probably illustrated in *Motor*

424

LOW CABLES

signed

pen and ink

16 ¼ x 5 ½ inches

Illustrated: Russell Brockbank, *The
Brockbank Omnibus*, London:
Perpetua, 1957, page 117

424

425

428

426

427

425

THE SOUND OF SPRING
signed
pen ink and watercolour
12 x 9 ½ inches

426

DINGBAT SALES
signed
pen and ink
8 x 9 ½ inches
Illustrated: *Motor*, 21 October 1970

427

RAVE IN EARLS COURT
signed
pen and ink
12 x 8 ½ inches
Illustrated: *Motor*, 22 October 1969

428

AMERICAN CARS IN THE OLD
WORLD
'This end of the car may have 10
minutes more time, but this end
has run out'
'My goodness, Mr Zinkbaum,
American cars get more
comfortable every year!'
'Anything we can do to help our
American friends is a pleasure, lady.'
European kids love travelling
playgrounds...
...but not many American cars like
British roads. [captions read top to
bottom and left to right]
*signed and signed with initials and
inscribed with title*
pen and ink
overall 13 ¼ x 19 ¾ inches
Probably illustrated in *Motor*

429

THE AMERICANS (WHO ARE
GENERALLY CLEAN OUT OF BRAKES)
signed and inscribed with title
pen and ink
7 x 18 inches

430

434

437

431

432

430

RUNNING IN

signed

pen and ink

14 ¾ x 14 inches

431

SEASICKNESS

signed in reverse

pen and ink

4 ½ x 11 ½ inches

Illustrated: *Motor*,

26 November 1969

432

BEWARE OF THE AU-PAIR GIRL

signed

pen and ink

3 ¾ x 10 ¾ inches

Illustrated: *Motor*, 17 May 1969

433

PASSING COMMENT

signed with initials

pen and ink

6 ½ x 7 inches

434

THE IDEAL CITY CAR

signed

pen and ink

10 ¼ x 10 inches

435

CITY GENTS

signed with initials

pen and ink

11 ¾ x 7 ¼ inches

436

FREE RIDE

signed

pen and ink

14 ½ x 10 ¼ inches

Illustrated: Russell Brockbank, *The Brockbank Omnibus*, London: Perpetua, 1957, page 113

437

HIGH SPEED CHASE

signed

pen and ink

3 ½ x 10 ¾ inches

Illustrated: *Motor*,

10 September 1969

438

THE HEATED REAR WINDOW

signed

pen and ink

9 x 10 ¾ inches

439

TWO GALLONS, PLEASE, AND DO YOU HAVE ANY OF THAT SPECIAL OIL THAT UNDOES RUSTY NUTS?

signed and inscribed with title

pen and ink

6 ¼ x 7 ½ inches

Illustrated: *Motor*,

9 September 1961

VICTORIA DAVIDSON

VICTORIA DAVIDSON

Lilli Ursula Barbara Davidson (née Comminchau), MSIA, known as 'Victoria Davidson' (1915-1999)

When *Lilliput* magazine and *Picture Post* began, they carried humorous drawings signed 'Victoria'. Never actually on the staff of either magazine, Victoria Davidson freelanced her way into the role of a British Institution. Her signature became widely familiar, and at one period *Lilliput* covers carried it for a full eighteen months. She began drawing for *Lilliput* from its third issue (in 1937), and for *Picture Post* in its first year (in 1938), and it soon became clear that the two magazines had decided to 'give her a run'. The run went on for twenty years.

Victoria Davidson was born Lilli Ursula Barbara Comminchau in Munich, Germany, on 8 January 1915. As a child, she had always loved drawing, but had an ambition to be a ballet dancer. This was ended by an accident to her spine and serious peritonitis. While convalescing, she began drawing again, and decided she wanted to go to art school. So, in September 1929, she went alone to Berlin, and there won a scholarship to study Fashion at the Lette Haus under Siebert-Wernekink (1930-1933). Fashion Design alternated with Life Drawing, Graphic Design and History of Costume. By the time she left, she had developed an unusual and

irreverent line in the art of Humorous Costume.

Around this time, Lilli met her future husband, Eric Victor, son of a South African pioneer, educated in Germany, of a Jewish family. She changed her name to 'Victoria', as the couple were known as Victor and Victoria by their friends. When Victoria graduated in 1933, she took an editorial job as a layout artist with the fashion magazine *Beyers Mode Fuer Alle*. Thanks to an art school friend circulating her portfolio, she also found freelance work illustrating articles on the history of fashion accessories. By the time she was twenty, she had a knowledge of journalism and had built herself a modest reputation for her humorous work.

However, things began to become difficult for Victoria and Eric as the political situation in Germany worsened. In one incident, Victoria was accosted while riding in a tram in the company of Eric, and another friend

reviled her for 'going about in the company of Jews'. Her successful freelance work on 'Costume through the Ages' was abruptly terminated when she received a communication stating that she 'was not considered fit to contribute to the National Press'. She appealed to one uniformed official after another but, when the next one turned out to be Goebbels himself, she lost her nerve.

In 1935, Victoria and Eric decided to leave Germany. He left for London and she followed a month or so later. They married, and she acquired British citizenship in the same year.

Victoria initially found it difficult to become professionally established in London, but eventually began a long period of extraordinary creativity and success. In 1937, the Hungarian Stefan Lorant launched the popular monthly pocket magazine *Lilliput* and Victoria was asked to contribute illustrations from the third edition. For the next twenty years her stylish drawings were a regular feature of covers and such articles as 'Gulliver's Diary', always signed either 'Victoria' or just just 'V'. When the Hulton Press began publication of *Picture Post* in 1938, again under the auspices of Stefan Lorant, Victoria became a regular contributor, particularly known for her illustrations to readers' letters, which she produced until the magazine ceased publication in the 1950s.

Victoria continued to work throughout the war, producing wicked lampoons of Hitler and the other Reich leaders. She also separated from Eric during this time and met her second husband, Dr Hans Davidson. They married in 1947.

Victoria's work appeared in Britain in the *Radio Times*, *Tatler*, the *Illustrated London News*, the *Sunday Mirror*, *Advertisers Weekly*, and the *Daily Sketch*, as well as *Die Neue Aslese* and *Suddeutsche Zeitung* in Germany. She drew for a number of advertising campaigns including Guiness, V P Wines, Stock Brandy, Nestlé, Kelloggs, Erinmore Tobacco, Mazda Lightbulbs, Bird's Custard, Persil and the GPO. She also wrote and illustrated several children's books. In the 1960s, Victoria began designing large posters, particularly for London Transport – some of which were exhibited in its centenary exhibition at the Royal Institute in 1963. Her graphic skills received recognition when she was elected Fellow of the Society of Industrial Artists.

In the same decade, Victoria began a new venture as an antiques dealer, opening a shop in Camden Passage, Islington. For a while, she combined

the two careers, but gradually the shop took over from her drawing. When her husband died of cancer in 1980, Victoria left London for good and moved to Boxford in Suffolk, where she opened an antiques showroom. In this last phase of her life, she was diagnosed with breast cancer and developed Parkinson's Disease. Yet, in spite of this, she remained creative to the end; in her last years writing and illustrating a book of poems about

444

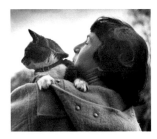

cats and humorous books about (and for) her friends and relations. She died in Boxford on 23rd November 1999. [CB]

Her work is represented in the collections of the Museum of Modern Art, New York.

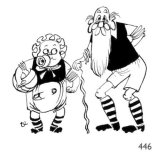

446

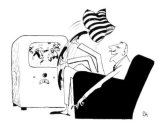

447

Numbers 440-466 are all from the Estate of Victoria Davidson

440

442

440
PRINCE HONOLULU AND HONEST JOE
pen and ink
4 ½ x 6 inches
Probably illustrated in *Picture Post*

441
SCOTTISH FOOTBALL
signed
pen and ink
7 ½ x 5 ½ inches
Illustrated: *Picture Post*,
22 April 1939

442
W G GRACE
signed with initial
pen and ink; 7 x 4 ½ inches
Illustrated: *Picture Post*,
24 August 1940

443
REAL GAME GIRL
signed with initial twice
pen and ink
5 ½ x 7 inches
Probably illustrated in *Picture Post*

444
KICKING THE ASS OUT OF ARSENAL
THE TEAM PHOTO
signed
pen and ink
6 ½ x 10 inches
Illustrated: *Lilliput*, November-
December 1953, page 3

*'Like twenty-five per cent of the
population of London, we have decided
to have a vested interest in Arsenal.
When that football club fails to win
any of its first eight matches of the
season we take it as a personal affront'*

445
THE OVERHEAD KICK
signed
pen ink and monochrome watercolour
4 ½ x 6 inches
Illustrated: *Picture Post*,
24 January 1952

446
KICKING THE ASS OUT OF ARSENAL
THE CENTRE-FORWARDS
signed with initial
pen and ink
5 ½ x 5 inches
Illustrated: *Lilliput*, November-
December 1953, page 5

*'What is old? six or sixty, with a
napkin or a white beard, if a man
plays well enough he picks himself.'*

447
ARMCHAIR SPORTSMAN
signed with initial
pen and ink
5 ½ x 7 ½ inches
Probably illustrated in *Picture Post*

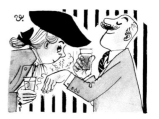

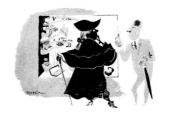

452 453

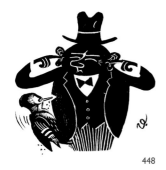

454

448

448

GULLIVER LISTENS TO A TAPPER
signed with initial
scraperboard
5 x 4 ½ inches
Illustrated: *Lilliput*, April 1949,
page 15

'A tapper is bloke wot gets a legitimate living from making touches or taps out of sum'dy who's got summink'

449

GULLIVER GOES SMUGGLING
signed
scraperboard
5 ½ x 10 ¾ inches
Illustrated: *Lilliput*, April 1947,
page 293

'When you reckon that a pair of stockings cost the equivalent of about 7s 6d in a New York shop...once they are over here they fetch two-ten or three quid a pair'

450

GULLIVER MAKES FISHY FRIENDS
signed with initial
pen and ink
10 ½ x 3 ½ inches
Illustrated: *Lilliput*, September 1950, page 17

451

GULLIVER AMONG THE NUDISTS
KETTERING
pen and ink
4 ½ x 7 inches
Illustrated: *Lilliput*, Holiday Special, August 1949, page 16

'Everyone rose. It was impossible not to notice the imprint of the wicker-work chairs.'

452

GULLIVER
THE KETTLE AND TEAPOT GAME
signed
scraperboard
8 x 10 ½ inches
Illustrated: *Lilliput*, January 1951, page 13

'He was holding, between pigskin gloved finger and thumb, a magnificent half loop diamond and emerald ring'

453

GULLIVER
A PRETTY DECENT PONG
signed with initial
pen ink and monochrome watercolour
4 ½ x 5 inches
Illustrated: *Lilliput*, December 1952-January 1953, page 7

'You might say that in love is a flower perfume that leaves a sense of sophistication when the top notes have died away...'

454

GULLIVER AMONG THE NUDISTS
THE GROUP PHOTO
pen and ink with crayon
4 ½ x 6 ½ inches
Illustrated: *Lilliput*, Holiday Special, August 1949, page 17

'We saw the lower portion of a very small photographer, the rest of him concealed by a black camera hood'

455

GULLIVER MEETS A JAIL BREAKER
signed
pen and ink
11 x 14 ½ inches
Illustrated: Lilliput, September 1947, page 177

'He was standing outside the chimpanzee cage at the zoo, leaning against the railings, chewing a match, and watching the anthropoid with an air of abstract speculation.'

456

457

456

VICTORIA AND HER CATS

pen and ink

5 x 4 inches

Probably illustrated in *Lilliput*

457

A MODEL TIE

pen ink and monochrome
watercolour

5 ½ x 7 ½ inches

Illustrated: *Picture Post*,
4 March 1953

458

THE FOOTBALL SANDWICH

signed

pen and ink

5 x 6 ½ inches

Illustrated: *Picture Post*,
24 January 1942

459

HOW TO OUTWIT A HOUSEMASTER

signed with initial

pen and ink

5 x 7 ½ inches

Illustrated: *Picture Post*,
16 December 1950

460

THREE GIRL GUIDES

signed

pen and ink

4 x 5 inches

Illustrated: *Picture Post*, 7 July 1951

461

THE STIFFS IN THERE 'AVE ALL
GOT SCALES ON

signed with initial

pen and ink

4 x 5 ½ inches

Illustrated: *Lilliput*, September
1950, page 15

462

LIGHT BLUE HARI KIRI

signed

pen and ink

5 x 7 inches

Illustrated: *Picture Post*,
19 December 1953

459

460

463

463

TAKING A BOW

pen and ink

5 x 4 inches

Probably illustrated in *Picture Post*

464

GULLIVER AMONG THE NUDISTS
WE TOOK OUR PLACE AT A LONG
TABLE

pen and ink with crayon

5 x 5 ½ inches

Illustrated: *Lilliput*, Holiday
Special, August 1949, page 16

*'Carrying plates of salad, spaghetti,
and other vegeterian dishes, the
waitresses appeared from the kitchen.
Not even an apron covered them. We
shrank back a little as ours leant
across our shoulder.'*

465

GULLIVER AMONG THE NUDISTS
THE ILLICIT VIEW

signed with initial

pen and ink

4 x 4 inches

Illustrated: *Lilliput*, Holiday
Special, August 1949, page 18

*'You know, there are some oldish men
that don't join exactly for the — well,
for the right purpose'*

466

GULLIVER AMONG THE NUDISTS
NUDIST MAGAZINES

pen and ink with crayon

6 x 8 inches

Illustrated: *Lilliput*, Holiday
Special, August 1949, page 17

*'Then we asked him about the nudist
magazines. weren't they, perhaps, a
little suggestive?'*

THE CREATORS AND CHARACTERS OF POPULAR CULTURE

WALT DISNEY
Walt Disney Studio (founded in 1923)

For an essay on the Walt Disney Studio, please refer to *The Illustrators*, 1999, pages 206-209.

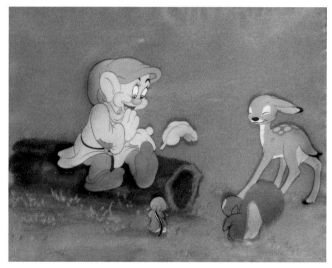

467

468

SNOW WHITE AND THE SEVEN DWARFS 1937
This version of the classic fairy tale was the first ever animated feature. It received a special Oscar in 1939, and was for a while the highest grossing film to date.

467
DOPEY WITH THE ANIMALS
hand painted cel on courvoisier background
7 ½ x 9 ¼ inches

468
SNOW WHITE CLUTCHED HER QUILT
hand painted cel on courvoisier background
7 x 6 inches

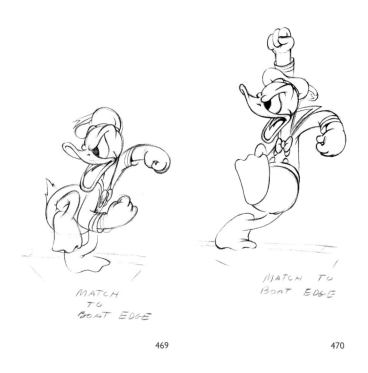

469 470 471

THE WHALERS 1938
This short film features Mickey Mouse, Donald Duck and Goofy who, while on a tramp steamer, encounter a whale. Goofy gets caught in the rope attached to the harpoon as it is shot at the whale. Donald sets out to rescue him and, when he fails, is in turn rescued by Mickey.

In these drawings Donald Duck is setting out to rescue Goofy.

469
DONALD DUCK
pencil and coloured pencil
6 ½ x 4 ½ inches

470
DONALD DUCK
pencil and coloured pencil
5 x 4 inches

THE JUNGLE BOOK 1967
This feature was based on Rudyard Kipling's tale concerning Mowgli (1894), a human boy raised in the jungle by wolves.

471
COLONEL HATHI, LEADER OF THE ELEPHANT HERD, HIS MAJESTY'S FIFTH PACHYDERM BRIGADE
pencil with coloured pencil
11 ¾ x 10 inches

472

473

474

HOLD THAT POSE 1950
In the 1950s, Goofy and Donald Duck were the stars of most of Disney's short cartoons. This short film features Goofy as a nature photographer, who so angers Humphrey Bear with his use of the flash.

MICKEY'S ORPHANS 1931
This film features Mickey and Minnie Mouse. A basket of kittens is left on Minnie's doorstep at Christmas, and Mickey and Minnie charitably bring it inside. But they soon regret their action as the cats wreck the house, strip the tree, and steal the presents and sweets. Directed by Bert Gillett, this film was nominated for an Academy Award. [RC]

ORPHANS' PICNIC 1936
This short film features Donald Duck, who is provoked into one of his patented fits of anger by unruly orphan mice at a summer picnic.

472
GOOFY
pencil with coloured pencil
7 x 5 inches

473
PLUTO
pencil
3 ½ x 4 ½ inches

474
DONALD DUCK
pencil with coloured pencil
5 x 5 inches

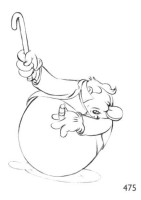

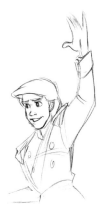

476

475

WOLFGANG REITHERMAN

Wolfgang Reitherman, known as 'Woolie' (active 1933-1980)

For a biography of Wolfgang Reitherman, please refer to *The Illustrators*, 1999, page 208.

477

MOTHER GOOSE GOES TO HOLLYWOOD 1938

A Silly Symphony cartoon film, directed by Wilfred Jackson. Pages from 'Mother Goose' come alive with famous motion picture stars, including W C Fields, Katherine Hepburn, Spencer Tracy, and Eddie Cantor, caricatured as nursery rhyme characters. [RC]

475

W C FIELDS AS HUMPTY DUMPTY
pencil with coloured pencil
6 x 4 inches
Walt Disney caricatured Hollywood and Jazz-Age musical stars in five 1930s cartoons. In this silly symphony, *Mother Goose to Hollywood*, they were cast in the role of nursery rhyme characters. Stage and film comedian W C Fields appeared as Humpty Dumpty opposite Charlie McCarthy. The feisty Fields takes a swipe at Charlie, loses his balance and has his great fall.

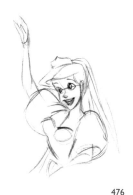

476

476

ARIEL AND ERIC
pencil
6 x 3 ¼ inches each image
This drawing depicts Ariel and Eric after their wedding as they wave to friends and family.

THE LITTLE MERMAID 1989

The modern resurgence of Disney animation began with the release of *The Little Mermaid*, based on a fairy tale by Hans Christian Andersen. It tells the story of a beautiful young mermaid, Ariel, who is fascinated by the human world, to the dismay of her father, King Triton. She spies Prince Eric and falls hopelessly in love. Sebastian the crab is sent by the King to keep an eye on Ariel. Ursula, the sea witch, plots to grant Ariel's wish to be human, in exchange for her beautiful voice, and as part of the larger scheme to gain control of Triton's realm. Eric finds himself falling in love with the now-human mermaid, but Ursula tricks him and Ariel, now mute, cannot warn him. Finally, Ariel and Eric together foil Ursula's evil plot, save the undersea kingdom, and receive Triton's blessing.

PETER PAN 1953

This feature was based on J M Barrie's famous children's play (1904) concerning the Darling children and their adventures with the magical boy who wouldn't grow up.

477

CAPTAIN HOOK
pencil with coloured pencil
9 x 13 inches
This powerfully animated scene depicts Captain Hook as he pursues Peter Pan into the ship's rigging.

FRED MOORE
Frederick Moore (1910-1952)

For a biography of Fred Moore, please refer to *The Illustrators*, 1999, page 207.

BILL TYTLA
Vladimir Tytla (died 1968)

For a biography of Bill Tytla, please refer to *The Illustrators*, 1999, page 207.

480

479

481

Numbers 480-482 are drawings for Walt Disney's *Snow White and the Seven Dwarfs* (1937). Snow White sends all the dwarfs off to work in the morning with a kiss. Grumpy starts to storm off but, as the realisation of the kiss sets in, he softens and shows Snow White his first sign of affection for her.

478

FUN AND FANCY FREE 1947
This feature comprises two stories, 'Bongo' and 'Mickey and the Beanstalk'.

478
MICKEY MOUSE
pencil with coloured pencil
5 ⅓ x 4 inches
In this scene from 'Mickey and the Beanstalk', Mickey Mouse tries to confound and confuse the dim-witted Giant Willie, while Donald Duck and Goofy rescue the singing harp.

479
GRUMPY
pencil with coloured pencil
5 ⅓ x 5 inches
Drawing for Walt Disney's *Snow White and the Seven Dwarfs* (1937). This drawing of Grumpy is from the sequence in which the dwarfs debate whether to provide Snow White with refuge from the evil Queen after they find her asleep in their beds. here Grumpy declares against allowing her to stay: 'Angel huh! she's a female – an' all females is poison. They're fulla wicked wiles!'

482

480
GRUMPY
pencil with coloured pencil
7 x 7 inches

481
GRUMPY
pencil with coloured pencil
6 x 7 ½ inches

482
GRUMPY
pencil with coloured pencil
5 x 8 inches

FRANK THOMAS
Frank Thomas (active 1934-1989)

For a biography of Frank Thomas, please refer to *The Illustrators*, 1999, page 208.

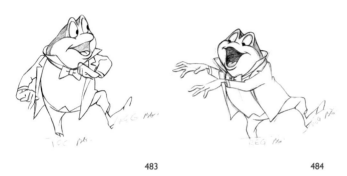

483 484

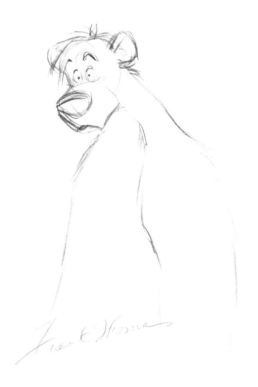

485

THE ADVENTURES OF ICHABOD AND MR TOAD 1949
This feature comprises two stories, versions of Washington Irving's
The Legend of Sleepy Hollow (1820) and an episode from Kenneth Grahame's
The Wind in the Willows (1908).

These two drawings show Mr Toad excited about his new gypsy cart
pulled by a horse called Cyril. In this scene, Toad is standing on the side of
the cart, talking to his friends Rat and Mole below. This is Toad in the grip
of one of his manias.

483

MR TOAD
signed
pencil with coloured pencil
7 x 7 inches

484

MR TOAD
signed
pencil with coloured pencil
6 ½ x 7 inches

485

BALOO
signed
coloured pencil
6 x 6 ½ inches
Drawing for Walt Disney's *The Jungle Book* (1967)

WARD KIMBALL
Ward Kimball (1914-2002)

Ward Kimball joined the Walt Disney Studio in 1934, and was an assistant animator on *Snow White and the Seven Dwarfs* (1937) and various shorts. Becoming one of Walt Disney's core animators, the 'Nine Old Men', he is best remembered for the creation of Jiminy Cricket in *Pinocchio* (1940). He later directed the Oscar-winning shorts, *Toot, Whistle, Plunk and Boom* (1959) and *It's Tough to Be a Bird* (1969). He worked in a variety of areas for the Walt Disney Company, and his love of trains not only started Walt on the hobby, but was reflected in his work as a consultant for the EPCOT attraction, The World of Motion. He was honoured with the Disney Legends award in 1989.

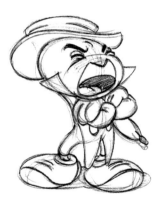

486

PINOCCHIO 1940
This feature was based on the Italian children's novel by Carlo Collodi (1880) concerning the wooden puppet who is promised that he can become a real boy if he earns it. It received Oscars for the best score and best song, *When You Wish Upon a Star*.

486
JIMINY CRICKET
pencil and coloured pencil
3 ½ x 3 ¼ inches
In this scene, Jiminy Cricket scolds Pinocchio and Lampwick for their misbehaviour on Pleasure Island.

NORM FERGUSON
Norman Ferguson, known as 'Fergy' (died 1957)

For a biography of Norm Ferguson, please refer to *The Illustrators*, 1999, page 207.

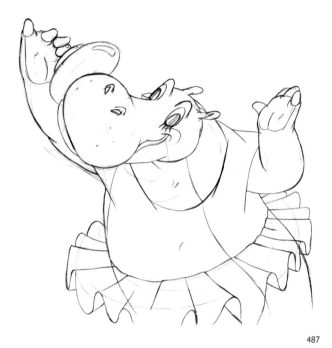

487

FANTASIA 1940
One of the most highly regarded of the Disney classics, this film consists of several sequences, in each of which a different Disney animator interprets a well-known work of classical music. The music was performed by the Philadelphia Orchestra, conducted by Leopold Stokowski. It premiered at the Broadway Theatre in New York. [RC]

487
HYACINTH HIPPO
pencil with coloured pencil
8 x 12 inches
Walt Disney loved the way that Hyacinth Hippo lampooned centuries of paintings of 'The Toilet of Venus'.

WALT KELLY
Walt Kelly (1913-1973)

Walt Kelly worked with Walt Disney for six years (1936-41). He started as a storyboard artist, later turning to animation, and especially the animation of Mickey Mouse. He contributed this skill to *Mickey's Surprise Party* (1939) and *The Nifty Nineties* (1941); and also to the features, *Fantasia* (1940), *Dumbo* (1941) and *The Reluctant Dragon* (1941). Leaving to become a comic-book artist, his greatest achievement was the creation of 'Pogo', a strip concerning a possum; developed in the early 1940s, it appeared in the *New York Star* from 1948.

DON LUSK
Don Lusk (active 1933-1961)

Don Lusk joined the Walt Disney Studio in 1933, and worked as an assistant animator on both Donald Duck shorts and the feature, *Snow White and The Seven Dwarfs* (1937). Soon he was animating the character of Cleo for *Pinocchio* and sections of *Fantasia* (both 1940), and drawing the Great Stag in *Bambi* (1942). He would continue to work on most features up until *101 Dalmatians* (1961).
Lusk animated J Thaddeus Toad in several scenes of *The Adventures of Ichabod and Mr Toad* (1949).

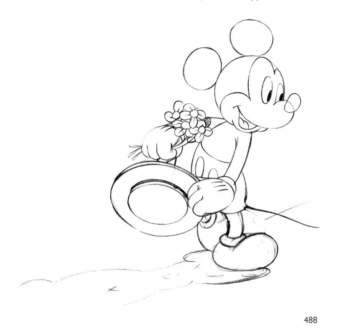

488

MICKEY'S SURPRISE PARTY 1939
This short film, featuring Minnie Mouse and Fifi the dog, was made as an advertisement for the National Biscuit Company (Nabisco) to be shown in that company's pavilion at the New York World's Fair. Minnie's attempts to bake a cake for Mickey are spoiled by Fifi, but Mickey saves the situation by buying Nabisco biscuits. This animated film was not publically screened after the 1939 World's Fair until it was released on home video in 1999.

489

488
MICKEY MOUSE
pencil with coloured pencil
7 ½ x 9 inches
In this scene, Mickey arrives at Minnie's house, unaware that he will find Minnie crying because her cake was a disaster. The note on the drawing tells the cel painters and the camera operators to paint the shadows on separate cels and double expose them in filming.

489
MR TOAD
signed
pencil with coloured pencil
6 ½ x 6 inches
Drawing for Walt Disney's
The Adventures of Ichabod and Mr Toad (1949)

NODDY

Noddy was created by Enid Blyton in 1949.

For an essay on Noddy, please refer to *The Illustrators*, 1999, pages 209-210.

Further reading: Brian Stewart and Tony Summerfield, *The Enid Blyton Dossier*, Penryn: Hawk Books, 1999

Enid Blyton's 'Noddy' is one of the most recognisable icons in British culture. Noddy was created when David White, the managing director of the publishers Sampson Low and Co was keen to begin a new series of books with Enid Blyton. He was looking for a popular character for younger children with bright and colourful illustrations. The first book, *Noddy Goes to Toyland,* was published in November 1949, with illustrations by Harmsen van der Beek. Other illustrators of Noddy have included Robert Tyndall and Mary Cooper. [RC]

490

ATHOLL MCDONALD

Atholl McDonald

Atholl McDonald, an identical twin, was born in Queens Park, Glasgow, on 30 January 1961. The son of an advertising artist, he was an enthusiastic draughtsman from an early age. On leaving school he studied art at Loughton College in Essex (for two years), and then worked in his father's studio. He recalls that although his ambition was to produce illustrations, most of his work comprised magic marker visuals for sales promotion.

In 1990 Atholl McDonald was asked to produce some sample 'Noddy' illustrations for a promotion involving the BBC which led to his appointment as artist for Noddy merchandise. Working with manufacturers, he illustrated Noddy for hundreds of different products from greetings cards to bed linen. As a result, the BBC offered him work on other characters. This increase in demand inspired Atholl to start up 'Character Image', a studio service employing other artists, working with big licensing companies on a wide range of popular cartoon characters.

In 1993, BBC Books began to publish Noddy, and the Enid Blyton Estate asked Atholl McDonald to illustrate them. He jumped at the opportunity, thus fulfilling a long-held wish to illustrate children's books, and decided to concentrate on book illustration, working full time from home. He has now illustrated over seventy books, mostly featuring licensed characters, yet Noddy remains his favourite. His latest project has been illustrating a series of books called 'The Adventures of Daisy and Tom' by Rose Waterstone. He is also currently working on his own book, the story of a boy and his pet dragon. He recalls showing his illustrations to his young son's class. When the teacher asked if there were any questions, a small boy put up his hand, 'Do you have a proper job?' Atholl replied 'No…and hopefully I never will!' [RC]

490

NODDY STEPS OUT

signed, inscribed with publication details and dated '94 below mount

pen ink and watercolour

6 x 5 ¼ inches

Illustrated: *Noddy and the Moon*, London: BBC Children's Books, 1994, title page

491

493

492

494

491

NODDY CAN'T FIND SAMMY
SAILOR, BUT HE'S SURE THAT HE'S
HERE SOMEWHERE
signed, inscribed with book title and
dated '95 below mount
pen ink and watercolour
8 ¾ x 16 ¾ inches
Illustrated: *Noddy plays Hide-and-*
seek, (a lift-the-flap story book),
London: BBC Children's Books,
1995, [unpaginated]

492

'GOOD MORNING, BIG-EARS,' SAYS
NODDY. 'COME FOR A DRIVE
WITH ME.'
signed, inscribed with book title and
dated '94 below mount
pen ink and watercolour
7 ¼ x 6 ¾ inches
Illustrated: *Noddy and the Hat*,
London: BBC Children's Books,
1994, [unpaginated]

493

AT FIVE O'CLOCK, NODDY HAS HIS
SUPPER. HE'S VERY HUNGRY
signed, inscribed with book title and
dated '95 below mount
pen ink and watercolour; 5 ½ x 7 inches
Illustrated: *Noddy Tells the Time*,
London: BBC Children's Books,
1995, [unpaginated]

494

NODDY AND MR PLOD
signed, inscribed with publication
details and dated '95 below mount
pen ink and watercolour
6 ¼ x 8 inches
Drawn for but not illustrated in
Noddy Tells the Time, London: BBC
Children's Books, 1995, front cover

497

495

498

499

495

JUST THEN, MR PLOD, THE
POLICEMAN, ARRIVED
*signed, inscribed with book title and
dated '94 below mount*
pen ink and watercolour
7 ¼ x 6 ¼ inches
Illustrated: *Noddy and the Moon*,
London: BBC Children's Books,
1994, [unpaginated].

Numbers 496 and 497 are both
illustrated in *Noddy plays Hide-and-
seek*, (a lift-the-flap story book),
London: BBC Children's Books,
1995, [unpaginated]

496

NODDY IS SURE SOMEONE IS
HIDING IN THE NOAH'S ARK.
*signed, inscribed with book title and
dated '95 below mount*
pen, ink and watercolour
8 ½ x 16 ¾ inches
Illustrated: *Noddy plays Hide-and-seek*

497

NOW IT'S NODDY'S TURN TO HIDE!
*signed, inscribed with book title and
dated '95 below mount*
pen ink and watercolour
8 ½ x 16 ¾ inches
Illustrated: *Noddy plays Hide-and-seek*

498

JUST THEN FARMER STRAW'S WIFE
ARRIVED BACK WITH A BASKET
FULL OF LOVELY FRESH EGGS. SHE
INVITED NODDY TO HAVE TEA
WITH HER AND FARMER STRAW
*signed, inscribed with book title and
dated '94 below mount*
pen ink and watercolour
7 ½ x 6 ½ inches
Illustrated: *Noddy and the Apples*,
London: BBC Children's Books,
1994, [unpaginated]

499

NODDY SAYS GOODBYE
*signed, inscribed with publication
details and dated '95 below mount*
pen ink and watercolour
5 ½ x 3 ¼ inches
Illustrated: *Noddy Tells the Time*,
London: BBC Children's Books,
1995, back cover

FRANK HAMPSON

Frank Hampson (1918-1985)

For a biographical essay on Frank Hampson and the creation of 'Dan Dare', please refer to *The Illustrators*, 2002, pages 95-97.

THE VENUS STORY

Numbers 500-507 are all from 'The Venus Story' – the first Dan Dare story to appear in *Eagle*. It ran for about seventeen months.

500

DIG'S PARALYSING PISTOL ASTOUNDS THE VENUSIANS

signed; pen ink and watercolour; 19 ¼ x 14 ¼ inches

Illustrated: *Eagle*, vol i, issue 12, page 1, 'Dan Dare'

Having crash landed on Venus, Dan and Digby are attacked by mysterious blue-skinned men. Digby valiantly fights them off, but as he and Dan make their escape they are pounced on again...

DAN DARE

Dan Dare was created by Frank Hampson as the front page strip 'that sold the *Eagle*' in 1950.

501

OH HIM — OLD BILIOUS FACE — HE WAS IN CHARGE OF THEM — COO LOOK AT THE NASTY LOOK IN HIS EYES. I'D HATE TO BE ONE OF HIS MERRY MEN WHEN THE PARALYSIS WEARS OFF IN A COUPLE OF HOURS

signed; pen ink and watercolour; 19 ¼ x 14 ¼ inches

Illustrated: *Eagle*, vol i, issue 12, page 2, 'Dan Dare'

502
FLYING OVER THE SOUTHERN HEMISPHERE OF VENUS, THE KINDLY
THERON TELLS DAN, HANK AND PIERRE THE STORY OF THE TREENS
signed; pen ink and watercolour; 19 ¼ x 14 ¼ inches
Illustrated: *Eagle*, vol i, issue 34, page 1, 'Dan Dare'

503
...AND SO RESULTED THE GREATEST DISASTER IN OUR HISTORY
pen ink and watercolour; 19 ¼ x 14 ¼ inches
Illustrated: *Eagle*, vol i, issue 34, page 2, 'Dan Dare'

Dan has been re-united with fellow spacefleet pilots Hank Hogan and Pierre Lafayette, and all are in the friendly hands of the Therons, the peaceful inhabitants of the southern hemisphere of Venus. Their history of conflict with the Treens is being explained, along with the fate of an ancient civilisation on earth who were contacted centuries ago by the Therons. But the warlike Treens have followed them…

504

IN THE TREEN INTELLIGENCE SECTION OF THE THERON GOVERNMENT
OFFICES...
pen ink and watercolour; 19 ¼ x 14 ¼ inches
Illustrated: *Eagle*, vol i, issue 40, page 1, 'Dan Dare'

505

YES, MR PRESIDENT. I'M ALL SET — LETS GO
signed; pen ink and watercolour; 19 ¼ x 14 ¼ inches
Illustrated: *Eagle*, vol i, issue 40, page 2, 'Dan Dare'

Dan's comrades have been captured by the Treens. All except his faithful batman Digby believe that Dan has perished. Dan is being disguised as an
Atlantine so that he can infiltrate the Treen forces in the northern hemisphere and rescue his comrades. He prepares to pilot a Theron submarine through
a secret river that runs under the flamebelt which separates the two hemispheres of the planet...

506

IT'S DAN – THEY'RE AFTER DAN!

signed; pen ink and watercolour; 19 ¼ x 14 ¼ inches
Illustrated: Eagle, vol ii, issue 6, page 1, 'Dan Dare'

Dan has captured the Mekon, but both have tumbled into the Mekontan sea. As some of the Treen guards rush to rescue the Mekon, others go after Dan. Digby rushes into the water to save him…

507

AS THE TREENS SWARM UP ASTERN, DAN FIRES THE OPENING SHOTS OF THE FIRST PITCHED BATTLE EVER FOUGHT IN SPACE.
AND STREAKING UP FROM THE SOUTH COME THE THERON SPACE FIGHTERS ALSO WITH ORDERS TO DESTROY DAN'S SHIP

pen ink and watercolour; 20 x 14 ¼ inches
Illustrated: *Eagle*, vol ii, issue 11, page 2, 'Dan Dare'

Dan, Digby, the Dapon and Sondar have captured a Treen Telezero Reflector Ship and escaped in it from Mekonta. Treen fighters are sent up to destroy them. A pitched battle ensues, then Theron fighters, also with orders to destroy the ship, suddenly appear and dive into action. [P&S H]

508

509

510

In addition to creating Dan Dare, Hampson illustrated a number of books for Ladybird (1964-71).

LADYBIRD BOOKS

Ladybird books are known and loved the world over. For millions of people, they evoke memories of early childhood – learning to read and discovering the magic of books.

In 1915 a Leicestershire printer started to publish 'pure and healthy literature' for children. However, It was only in 1940 that the format changed to the pocket-sized book that is still so recognisable. This new fifty-six page format, made from just one standard sheet of paper (40 x 30 inches), meant that quality books could be produced at a low price; the books remained at half a crown for thirty years.

After the war, Ladybird expanded into educational non-fiction, an area it was to dominate for the next four decades. Its global success was founded on a formula of brightly-coloured learning books written and illustrated by well-known authors and artists. Methods for helping children to learn to read and broaden their interests were developed. The Key Words Reading Scheme, launched in 1964, was based on the fact that just twelve words make up twenty-five percent of our conversation. The 'Learnabout Books', which helped children acquire new interests, proved a triumph amongst both children and adults, making Ladybird a byword for all-purpose essential knowledge on any given subject. Ladybird books have now been translated into sixty languages. [EAF]

Numbers 508-510 are all illustrated in *A First Ladybird Book of Nursery Rhymes*, Loughborough: Ladybird Books, 1966.

508

I LOVE LITTLE PUSSY
oil on board
8 ¼ x 5 ½ inches
Illustrated: page 48

509

ONE, TWO, THREE, FOUR, FIVE
oil on board
8 ¼ x 5 ½ inches
Illustrated: page 32

510

OLD MOTHER HUBBARD
oil on board
8 ¼ x 5 ½ inches
Illustrated: page 46

CONTEMPORARY ILLUSTRATORS

SHIRLEY HUGHES

Shirley Hughes, OBE (born 1927)

'Shirley Hughes is an artist who represents ordinary life in a way that makes adults and children alike fall in love with it.'

The Times

Shirley Hughes, was born in West Kirby, near Liverpool, on the 16 July 1927. She was educated at the local High School and went on to study Drawing and Costume Design at Liverpool School of Art. She then trained at the Ruskin School of Drawing and Fine Art, Oxford, where she was later a visiting tutor.

She became a freelance illustrator in the early 1950s when she moved to London, illustrating books by authors including Ian Serraillier and Noel Streatfeild.

It was only in 1960 – when she and her husband John Vulliamy, architect and etcher, had their first child – that Shirley Hughes wrote her first book *Lucy and Tom's Day*. She says that she wrote it because there were too few books available that were simple enough for very young children. Although the book was a huge success, it was a decade before she wrote the sequel. Throughout the 1960s and 1970s, she continued to illustrate books by other people (some two hundred in all).

In 1961, Blackie the publishers commissioned her to provide illustrations for an edition of *Hans Andersen's Fairy Tales*. In the beautifully accomplished results, inlcuded in this catalogue, her effortless application of pen and ink seems to respond to the fantasy worlds described in the tales. In 'The Fellow Travellers' she conjures up the sinister stare of a self-satisfied troll sitting on his throne [no 517], while in the next stroke she conveys the shy, watchful innocence of the Little Match Girl curled up in a corner [no 520]. These illustrations are reminiscent of Arthur Rackham, and the darker works of William Heath Robinson, who illustrated *Fairy Tales From Hans Andersen* in 1899 for J M Dent. Both illustrators were a great influence on Shirley Hughes as a young artist, as were E H Shepard, William Nicholson and Edward Ardizzone.

Shirley Hughes has illustrated over fifty of her own books, and is perhaps best known for her books for young children, such as the 'Lucy and Tom' series, the 'Alfie' and 'Annie Rose' books, and the *Nursery Collection*. Published in 1981, *Alfie Gets in First*, was the first in a very popular series featuring the little boy who, as she saw him, 'was positively pink in the face with determination to get into action'. His twentieth birthday was celebrated in March 2001, when The Bodley Head published *Alfie's Weather*. More recently she has written and illustrated more advanced books for older children, such as *Stories by Firelight* (1993), *Enchantment in the Garden* (1996) and *The Lion and the Unicorn* (1998), all published by The Bodley Head.

Her success as a children's illustrator is perhaps due to her convincing characterisation of children. They are always based on accurately observed drawings from real life, which makes them appealing and reassuring to her young readers. She says, 'Pictures help them make detailed observations and reinforce their own experience of life…young children can have their confidence dented by acres of print.'

Hughes has been the recipient of several accolades over the years, including the 1976 Other Award for her book *Helper*, and the 1977 Kate Greenaway Medal for *Dogger*. She was honoured for her outstanding contribution to children's literature in 1999, when she received an OBE, and in 2000, when she was made a fellow of the Royal Society of Literature. In the same year, The Bodley Head published *The Shirley Hughes Collection*, a treasury filled with some of Shirley's most famous titles including the Alfie stories, *Enchantment in the Garden*, and also featuring illustrations for other authors such as Dorothy Edwards' 'Naughty Little Sister' series.

In September 2002 The Bodley Head published Shirley Hughes's memoir, *A Life Drawing*, in which she talks about her life, work and influences. The book was accompanied by a retrospective exhibition at the Ashmolean Museum in Oxford. [HJM]

511

512

514

513

515

Numbers 511-513 were all drawn for but not illustrated in E Jean Roberton (reteller) and Caroline Peachey (translator), *Hans Andersen's Fairy Tales*, Glasgow: Blackie, 1961.

511

POOR THUMBELINA STOOD AT THE DOOR AND BEGGED FOR A LITTLE PIECE OF BARLEY-CORN
pen and ink with watercolour and bodycolour
8 ½ x 5 ½ inches
Illustrated: *Your Child*, issue 25, back cover

512

HIGH IN THE SKY
pen and ink with watercolour and bodycolour
9 ¼ x 5 ½ inches

513

THE SWINEHERD GOT HIS KISSES AND THE PRINCESS GOT THE POT
inscribed with title
pen and ink with watercolour and bodycolour
9 ¼ x 5 ¾ inches

Numbers 514-521 are all illustrated in E Jean Roberton (reteller) and Caroline Peachey (translator), *Hans Andersen's Fairy Tales*, Glasgow: Blackie, 1961.

514

THE FARMER RAISED THE LID OF THE CHEST GENTLY, AND PEEPED UNDER IT
pen and ink; 5 x 6 inches
Illustrated: page 181, 'Great Claus and Little Claus'

515

THEY OFTEN USED TO SIT ON THEIR LITTLE STOOLS UNDER THE ROSE TREES
pen and ink; 6 x 6 ¼ inches
Illustrated: page 139, 'The Snow Queen'

516

517

518

519

520

521

516

'WHY,' CRIED GERDA, 'THERE ARE NO ROSES IN THE GARDEN!'
pen and ink; 4 ½ x 6 ¼ inches
Illustrated: page 148, 'The Snow Queen'

517

ON THE THRONE SAT AN AGED TROLL WEARING A CROWN ON HIS UGLY HEAD AND HOLDING A SCEPTRE IN HIS HAND
pen and ink; 6 ½ x 6 inches
Illustrated: page 214, 'The Fellow Travellers'

518

SHE SEIZED HOLD OF HIM AND KEPT HIM ABOVE WATER
pen and ink; 5 ¾ x 6 inches
Illustrated: page 246, 'The Little Mermaid'

519

BLUE FIRE FROM THE VENOMOUS MOUTHS OF THE REPTILES
pen and ink; 6 x 5 ¾ inches
Illustrated: page 215, 'The Fellow Travellers'

520

IT WAS A BRIGHT, WARM FLAME, AND SHE HELD HER HANDS OVER IT
pen and ink; 6 ½ x 5 ½ inches
Illustrated: page 126, 'The Little Match Girl'

521

THEN HE HUGGED GERDA, WHILE SHE LAUGHED AND WEPT
pen and ink; 5 ½ x 4 ¾ inches
Illustrated: page 165, 'The Snow Queen'

QUENTIN BLAKE
Quentin Saxby Blake, OBE RDI (born 1932)

For a biography of Quentin Blake, please refer to *The Illustrators,* 1997, page 236.

Key works written: *Words and Pictures* (2000); *Laureate's Progress* (2002)
Key works written and illustrated: *Mr Magnolia* (1980); *Clown* (1995)
Key works illustrated: Michael Rosen, *Mind Your Own Business* (1974);
Russell Hoban, *How Tom Beat Captain Najork and His Hired Sportsman*
(1974); Roald Dahl, *The Giraffe and the Pelly and Me* (1985)
His work is represented in the collections of the British Museum, and the
Victoria and Albert Museum.
Further reading: Douglas Martin, *The Telling Line*, London: Julia MacRae
Books, 1989, pages 243-263.

Four highly successful exhibitions of work by Quentin Blake have been
held at Chris Beetles Ltd: in 1993, 1996, 2000 and 2002; the third helped
to celebrate the artist's appointment as the first Children's Laureate.
Further shows have been mounted by Chris Beetles Ltd during 2003, in
conjunction with the Hay Festival and the Guildford Book Festival.

523

522

522
HOLY WATER
signed
pen and ink
5 x 5 ¾ inches
Illustrated: *Punch*, 26 March 1969

For six months of 1969 Alan
Coren wrote a weekly column
'On Pleasure'. Quentin Blake
illustrated every one. Coren recalls
writing on everything from Rolls
Royce cars to Turkish Baths. This
image illustrates his visit to Dublin
as a guest of Guiness to report on
its place in the culture of Ireland.

523
ADORING PARENTS
pen ink and watercolour
4 x 4 ¾ inches

524

525

526

527

524
UNDERWATER LOVE
pen ink and watercolour
8 x 8½ inches
Design for a Woodmansterne
greetings card

525
FEATHERED GATHERING
signed; watercolour with pen and ink
5 x 9 inches
Drawn for but not illustrated in
Quentin Blake, *Up with Birds*,
London: Hamish Hamilton, 1998

526
FOLLOW THE LEADER
signed; watercolour with pen and ink
4 x 9 inches
Drawn for but not illustrated in
Quentin Blake, *Up with Birds*,
London: Hamish Hamilton, 1998

527
A MAIDEN WHO IS FORTY
signed
pen and ink
9 ¼ x 7 inches
Drawing for Roald Dahl, *Rhyme
Stew*, London: Jonathan Cape,
1989, page 17
Exhibited: Quentin Blake,
'Laureate's Progress', Chris
Beetles Ltd, October 2002

RAYMOND BRIGGS
Raymond Redvers Briggs (born 1934)

For a biography of Raymond Briggs, please refer to *The Illustrators*, 1993, page 165.

Key works written and illustrated: *Father Christmas* (1973), *The Snowman* (1978), *Ethel & Ernest* (1998)
Key work illustrated: *The Mother Goose Treasury* (1966)
His work is represented in the collections of Ditchling Museum.
Further reading: Douglas Martin, *The Telling Line*, London: Julia MacRae Books, 1989, pages 127-139, 'Raymond Briggs'

529

528

528

CHILDLINE CHRISTMAS

pencil, pen ink and crayon
6 ¼ x 4 ½ inches
Design for Childline
Christmas card

529

HAPPY CHRISTMAS

pencil with watercolour, bodycolour and crayon
8 ¼ x 6 inches
Design for Childline
Christmas card

JOHN BURNINGHAM

John Mackintosh Burningham (born 1936)

For a biography of John Burningham, please refer to *The Illustrators*, 1993, page 166.

Key works written and illustrated: *Borka. The Adventures of a Goose without Feathers* (1963); *Mr Gumpy's Outing* (1970)
Key work illustrated: Kenneth Grahame, *The Wind in the Willows* (1983)
Further reading: Douglas Martin, *The Telling Line*, London: Julia MacRae Books, 1989, pages 215-227, 'John Burningham'
His work is represented in the collections of the Chihiro Art Museum (Tokyo).

531

530

532

Numbers 530-533 are all illustrated in John Burningham, *A Grand Band*, London: Walker Books, 1989, [unpaginated].

530

AND WHEN I STRUM ON MY GUITAR, THE SONGS OF SPAIN AND FRANCE / THE BEAR HE LOVES TO TWIRL ABOUT, HE'S PROVING HE CAN DANCE!
pen, coloured ink and crayon
6 x 6 inches
Illustrated: *A Grand Band*, front cover

531

WE PLAY THE FLUTE AND THE FIDDLE, WE BOOM AND STRUM AND BLARE, / WE DANCE AND SING AND TINKLE, WE'RE A GRAND BAND — ME AND BEAR!
pen, coloured ink and crayon
3 x 4 inches
Illustrated: *A Grand Band*, back cover

532

WHEN I SLIDE ON MY TROMBONE, IT MAKES A BLARING SOUND; AND WHILE BEAR IS CONDUCTING, I CAN KNOCK HIM TO THE GROUND
pen, coloured ink and crayon
5 ½ x 6 inches
Illustrated: *A Grand Band*

533

I CLASH THE CYMBALS VERY LOUD, THEY MAKE A MIGHTY DIN; THE BEAR IS NOT EXPECTING IT AND JUMPS OUT OF HIS SKIN.
pen, coloured ink and crayon
5 ½ x 6 inches
Illustrated: *A Grand Band*

MICHAEL FOREMAN

Michael Foreman, RDI (born 1938)

For a biography of Michael Foreman, please refer to *The Illustrators*, 1997, page 236; for an essay on his illustrations to Kenneth Grahame's *The Wind in the Willows*, see *The Illustrators*, 2001, pages 40-41.

Key works written and illustrated: *The General* (1961, with Janet Charteris); *War Boy* (1989)
Key works illustrated: Alan Garner, *The Stone Book* (1976) (the first of 'The Stone Quartet', published until 1978); Terry Jones, *Fairy Tales* (1980); Leon Garfield, *Shakespeare Stories* (1985); Robert Louis Stevenson, *A Child's Garden of Verses* (1985)
His work is represented in the collections of the Victoria and Albert Museum.
Further reading: Douglas Martin, *The Telling Line*, London: Julia MacRae Books, 1989, pages 291-311, 'Michael Foreman'

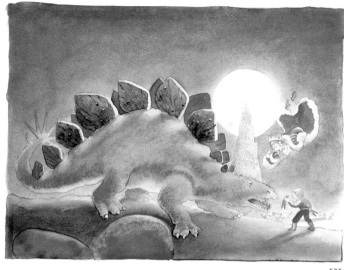

535

534

536

537

534

THE MONSTER AND THE MUSTARD
signed
watercolour
23 x 19 ¾ inches
Poster designed for the 'Salon du Livre de Jeunesse', Montreuil, Paris, 1991

Numbers 535-549 are all illustrated in Terry Jones, *Fantastic Stories*, London: Pavilion, 1992.

535

FANTASTIC STORIES
inscribed with title; watercolour
14 x 18 ¾ inches
Illustrated: *Fantastic Stories*, front and back cover

536

'RUN!' CRIED MICK
inscribed with story title
watercolour
6 x 14 ½ inches
Illustrated: *Fantastic Stories*, pages 84 and 85, 'Mick and Mack'

537

THERE ONCE WAS A DEVIL IN HELL NAMED CARNIFEX, WHO LIKED TO EAT SMALL CHILDREN
inscribed with story title
watercolour
3 ½ x 4 ½ inches
Illustrated: *Fantastic Stories*, page 73, 'The Flying King'

538

540

541

538

A WANDERING MINSTREL ONCE
COMPOSED A MAGICAL SONG
THAT MADE EVERYONE WHO
HEARD IT GLAD
inscribed with story title
watercolour
12 x 8 ¼ inches
Illustrated: *Fantastic Stories*,
page 103, 'The Song that brought
Happiness'

539

FOR WHAT SEEMED A
LIFETIME, HER EYES FEASTED
ON THE IMAGE BEFORE HER.
AND EVERYONE IN THE COURT
WAITED WITH BAITED BREATH
inscribed with story title
watercolour
11 ¼ x 8 ¼ inches
Illustrated: *Fantastic Stories*,
page 27, 'The Improving
Mirror'

540

GUARDS! SEIZE THIS BOY BY THE
EARS, AND THROW HIM IN JAIL!
inscribed with story title
watercolour
11 ½ x 8 ¼ inches
Illustrated: *Fantastic Stories*,
page 66, 'Toby Tickler'

541

IN THE GREAT LONG-AGO, THE
BADGER WAS PURE WHITE ALL OVER
inscribed with story title
watercolour
2 ¼ x 5 ½ inches
Illustrated: *Fantastic Stories*, page 53,
'How the Badger got his Stripes'

542

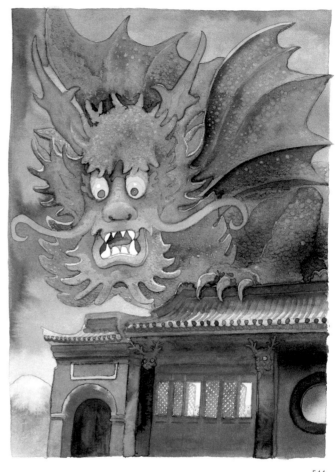

544

542
I'M ONLY BIG BECAUSE I
EAT...CABBAGES! AND...SAUSAGES!
AND...RADISHES! AND...
inscribed with story title
watercolour
12 ½ x 9 inches
Illustrated: *Fantastic Stories*,
page 93, 'The Slow Ogre'

543
THE LIGHT LANDED WHERE THE
BABY'S HEART WOULD BE. THEN
IT POURED INTO THE SNOW BABY
AND FILLED IT TOP TO TOE!
inscribed with story title
watercolour
11 ¼ x 8 ¼ inches
Illustrated: *Fantastic Stories*,
page 50, 'The Snow Baby'

544
'YOUR MAJESTY!' CRIED THE
MERCHANT. 'THE JADE DRAGON
HAS FLOWN DOWN FROM THE
JADE DRAGON SNOW MOUNTAIN
AND IS SITTING ON MY ROOF-TOP!'
signed and inscribed with story title
watercolour
12 x 8 ½ inches
Illustrated: *Fantastic Stories*,
page 13, 'The Dragon on the Roof'

545
THE FARMER RUBBED HIS EYES,
AND THEN HE LOOKED AGAIN, AS
THE HORSE SKIPPED AROUND THE
FIELD ON TWO LEGS, TURNING
PIROUETTES AND WHEELING AND
BOWING AND CURTSYING
AROUND AND AROUND THE FIELD
inscribed with story title
watercolour
3 ½ x 5 ½ inches
Illustrated: *Fantastic Stories*,
page 78, 'The Dancing Horse'

546

548

546

I AM GOING TO PUT A STOP TO
THIS NONSENSE ONCE AND FOR
ALL
inscribed with story title
watercolour
12 x 8 ¼ inches
Illustrated: *Fantastic Stories*,
page 109, 'Touch the Moon'

547

THE MINSTREL WANDERED
AROUND FROM COUNTRY TO
COUNTRY, SINGING HIS MAGICAL
SONG, AND BRINGING HAPPINESS
TO PEOPLE FOR AS LONG AS HE
SANG IT
inscribed with story title
watercolour
3 ¼ x 5 ½ inches
Illustrated: *Fantastic Stories*, page 102,
'The Song that brought Happiness'

548

AND THE MAKER OF ALL THINGS
DREW HIS FINGERS ACROSS THE
BADGER'S EYES, AND LEFT HIM
WITH TWO BLACK STRIPES – LIKE
A MASK – FROM EARS TO SNOUT
inscribed with story title
watercolour
11 ¾ x 8 ½ inches
Illustrated: *Fantastic Stories*,
page 56, 'How the Badger got
his Stripes'

549

THERE ONCE WAS A DOG WHO
COULD PERFORM THE MOST
AMAZING TRICKS
watercolour
inscribed with story title
3 ¼ x 5 ½ inches
Illustrated: *Fantastic Stories*,
page 19, 'The Star of the Farmyard'

HELEN OXENBURY
Helen Gillian Oxenbury (born 1938)

*'Her work is always wonderfully imaginative
as well as technically brilliant'*
Nicholas Tucker, *Country Life*

Helen Oxenbury is very much at the forefront of contemporary children's illustration, and is highly acclaimed by fellow artists. Born in Ipswich, Suffolk, on 2 June 1938, the daughter of an architect, she was educated at Ipswich High School for Girls. At the age of seventeen, she began two years of study at Ipswich School of Art, during which time she discovered her passion for the theatre. She pursued this path by specialising in Theatre Design at the Central School of Arts and Crafts in London between 1957-59. After college she worked in various theatres in England and spent three years in Tel Aviv, Israel, as a set designer and painter. On returning to London in 1962, she continued designing sets for film and television. Though highly successful in her chosen field, she abandoned work when she began to feel that theatrical and family life simply wouldn't mix. For she had just agreed to marry college sweetheart, John Burningham, the illustrator.

Jan Pienkowski, of the highly fashionable Gallery Five in London, convinced Oxenbury to design images for greetings cards. He instantly recognised her flair and was quick to point her towards children's book illustration; he has remained a supportive friend and artistic mentor. In 1973, she completed the transition to children's illustration while expecting Lucy, her first child. She believes that 'picture books are a child's entree into the world of books in general'. Though she had never concentrated on illustration at art school, she grew up with the work of such favourite illustrators as Edward Ardizzone and E H Shepard, and says she admires the skills of Giles and Norman Rockwell. Her first book, *Numbers of Things*, was published in 1967 and immediately established her as a major picture book artist. Her three series of board books for babies have sold several million copies and are regarded internationally as classics which completely revolutionised the board book form. Her other highly successful series of picture books for young children include 'Heads, Bodies and Legs', 'First Picture Books', and 'Pippo', the last of which originated as a comic strip in the French children's magazine, *Popi*.

In 1970 Helen Oxenbury was awarded the Kate Greenaway medal for her illustrations to Edward Lear's *The Quangle Wangle's Hat* and Lewis Carroll's *The Hunting of the Snark*. She was highly commended for the same award for Michael Rosen's *We're Going on a Bear Hunt* and Martin Waddell's

Farmer Duck, both of which won the Smarties Book Prize, in 1989 and 1991 respectively. [HJM]

Further reading: Douglas Martin, *The Telling Line*, London: Julia MacRae Books, 1989, pages 202-214, 'Helen Oxenbury'
Her work is represented in the colllections of Chihiro Art Museum (Tokyo).

ALICE'S ADVENTURES IN WONDERLAND

The latest work, by Helen Oxenbury is an edition of Lewis Carroll's *Alice's Adventures in Wonderland*. Published by the Candlewick Press, in 1999, it won the Kate Greenaway award for 2000. Generations have associated Carroll's literary phenomenon with John Tenniel's illustrations which first immortalised Alice over a century ago (being published by Macmillan, in 1865). Having grown up with Tenniel's version, Helen Oxenbury says she found the experience 'very daunting', but rose to the challenge none the less, and produced her greatest work to date. In her version, she reinvents and recreates the magic of the so familiar characters. Whilst retaining the otherworldly fantasy that is Wonderland, she injects a welcome degree of cosy modernity. The famously curious Alice has become very much a little girl of today, apparently inspired by Oxenbury's own daughter, with a blue smock dress and white sneakers; the Mad Hatter is reminiscent of a jaded bookie with bow tie, checked jacket and several hats jauntily piled high on his head; while the Queen of Hearts bears more than a passing resemblance to our present monarch. Oxenbury's interpretation of Carroll's creatures is equally distinctive, for she introduces a vitality and spontaneity quite different from Tenniel's solemnity, with the eccentric White Rabbit, and poor Bill the Lizard, conveyed with heartwarming delicacy. She is currently working on the illustrations to the sequel, *Through The Looking Glass*. [HJM]

552

551

553

Numbers 551-553 are all similar to illustrations in Lewis Carroll, *Alice's Adventures in Wonderland*, Cambridge, Massachusetts: Candlewick Press, 1999.

550

THREE FRENCH HENS
signed
pen ink and watercolour
7 x 5 ½ inches
Illustrated: Manghanita Kempadoo, *Letters of Thanks*, London: Heinemann, 1986

551

DRINK ME
signed and inscribed with title
pencil
8 x 6 ¼ inches
Similar to illustration on page 21

552

THERE COULD BE NO DOUBT THAT IT HAD A VERY TURN UP NOSE, MUCH MORE LIKE A SNOUT THAN A REAL NOSE
signed
watercolour with pencil
8 x 6 inches
Similar to illustration on page 101

553

BILL THE LIZARD UNDER THE WEATHER
signed
watercolour with pencil
8 ¾ x 8 ½ inches
Similar to illustration on page 67

NICK BUTTERWORTH

Nick Butterworth (born 1946)

For a biography of Nick Butterworth, please refer to *The Illustrators*, 2002, page 115.

555

554

556

554

THE FULL, CORKSCREW-TWISTING, DOUBLE-BACKWARD SOMERSAULT INTO CHAMPAGNE FLUTE, IS ALMOST CERTAINLY THE MOST DANGEROUS DIVE EVER ATTEMPTED AND CARRIES A 'DEGREE OF DIFFICULTY' TARIFF OF 27.4
signed
watercolour with pen and ink
27 x 8 ½ inches

555

THE RABBITS' SACK RACE, IN PERCY'S BOOTS, MADE IT LOOK LIKE PERCY HAD BEEN FOR A LONG WALK ACROSS SNOWY FIELDS
signed
watercolour with pen and ink
8 ½ x 26 ¾ inches

556

'STOP! STOP! I WANT TO GOBBLE YOU UP!' SHE SHOUTED
signed
watercolour with pen and ink
10 ¾ x 16 inches
Drawn for a Lynx deodorant advertisement

557

560

557

MOLE GETS LOST AGAIN
signed; inscribed with title on reverse
watercolour with pen and ink; 6 ½ x 5 ¼ inches
Design for a greetings card

558

HAPPY BIRTHDAY FOX!
signed; inscribed with title on reverse
watercolour with pen and ink; 6 ½ x 5 ¼ inches
Design for a greetings card

559

PERCY PREPARES FOR TELEVISION
signed; inscribed with title on reverse
watercolour with pen and ink
9 x 6 ½ inches

560

MOVING DAY
signed; inscribed with title on reverse
watercolour with pen and ink; 6 ½ x 5 ¼ inches
Design for a greetings card

561

561

PERCY'S CAP WAS USUALLY A SAFE PLACE TO
BE — BUT LOW BRANCHES COULD BE A
PROBLEM
signed
watercolour with pen and ink
11 x 9 inches

562

562

BE MY VALENTINE
signed; inscribed with title on reverse
watercolour with pen and ink; 10 x 6 ½ inches
Design for a Valentines card published by
Gordon Fraser

563

'I HAVE TO WEAR IT BECAUSE I'VE GOT A SORE
LEG,' SAYS RUFUS. Q POOTLE 5 IS PUZZLED.
'SHOULDN'T IT BE ON YOUR LEG, THEN?' HE ASKS
signed
watercolour with pen and ink; 12 x 13 ¾ inches

564

THE HEDGEHOG GOES ADVENTURING
signed; inscribed with title on reverse
watercolour with pen and ink; 6 ½ x 5 ¼ inches
Design for a greetings card

565

OF COURSE PERCY WAS RIGHT. THE
HEDGEHOG'S PLAN TO SLIDE DOWN THE KITE'S
STRING, IF HIS ARMS GOT TIRED, WAS NOT
GOING TO WORK. WHAT A GOOD JOB IT WAS
HE HAD BEEN DOING ARM-STRENGTHENING
EXERCISES WITH THE BADGER
signed; watercolour with pen and ink; 16 x 11 ¾ inches

MICHELLE CARTLIDGE
Michelle Cartlidge (born 1950)

Michelle Cartlidge was born in Hampstead, London, on 13 October 1950. On leaving school at the age of fifteen, she worked as an apprentice potter and pursued her fervent interest in drawing and painting in watercolour. Her achievement as potter and draughtsman gained her a place at Hornsey College of Art where she studied for a year before being invited to attend the Royal College of Art.

On leaving the RCA Michelle Cartlidge concentrated on drawing and developing ideas for children's books. Her first book, *Pippin and Pod*, won the Mother Goose Award in 1979. Since then she has published over fifty children's books worldwide, including *Teddy Trucks* (1981), *Mousework* (1982), the 'Little Mouse' series (1990-2000), *The Cats That Went to Sea* (1992), *The Mice of Mousehole* (1997); in 1998, she illustrated two books of poetry for young children by Brian Patten. *Teddy Trucks* was made into a popular animated series for the BBC in 1994.

Her latest book, *The Mouse Christmas House* has just been published by Michael O'Mara Books and *Brave Mouse*, published by Frances Lincoln, is due out in Spring 2004.

As well as illustrating books, Michelle Cartlidge has designed a bone-china gift collection for Wedgwood and a range of tins, greetings cards and gift wrap for Hunkydory. A group of her tins won the Metal Packaging Manufacturers Association's 'Best in Metals Award' in 1987 for innovative design.

Michelle Cartlidge is a keen observer of her surroundings and often uses real backgrounds for her illustrations. The mice in *The Mice of Mousehole,* for example, really seem to inhabit that village in Cornwall, while anyone familiar with Hampstead will surely recognise several spots featured in *Mousework*. [EAF]

568

Numbers 566-575 are all illustrated in Michelle Cartlidge, *Mousework*, London: Heinemann, 1982, [unpaginated].

566
ON BRIGHT SUNNY DAYS IN MOUSEVILLE, THE MICE LIKE TO TAKE WALKS IN THE PARKS
pen ink and watercolour
10 ¼ x 8 ¼ inches

567
THE BAKERS MAKE DELICIOUS BIRTHDAY CAKES AND TALL TIERED WEDDING CAKES
pen ink and watercolour
10 ¼ x 8 ¼ inches

568
I'D LIKE A CAULIFLOWER, SOME CHOCOLATE BISCUITS, AND SOME OF THOSE NICE GREEN APPLES PLEASE
pen ink and watercolour
10 ½ x 8 ½ inches

569
REPAIRING A CAR
pen ink and watercolour
10 ¼ x 8 ¼ inches

574

570

572

PICTURES OF MICE AND
LANDSCAPES ARE PAINTED BY THE
MOUSE ARTIST
pen ink and watercolour
4 x 3 ½ inches

574

THE GARDENERS WORK VERY
HARD TO KEEP THE PARKS
LOOKING NEAT AND TIDY
pen ink and watercolour
8 ¼ x 7 ¾ inches

570

THE DOCTOR EXAMINES HIS PAW
VERY CAREFULLY. THEN THE
MOUSE NURSE BANDAGES IT UP
AND HE IS READY TO GO BACK
TO WORK
pen ink and watercolour
10 ½ x 8 ¼ inches

571

AFTER WORK THE MICE TRAVEL
HOME. SOME IN BUSES...
pen ink and watercolour
4 ½ x 7 inches

573

IT GETS VERY NOISY UNDER THE
DRYER SO THEY HAVE TO SHOUT
WHEN THEY WANT TO TALK TO
EACH OTHER
pen ink and watercolour
8 ½ x 10 ½ inches

575

THE DENTIST MOUSE LOOKS
AFTER THE MICE'S TEETH. 'YOU
MUSTN'T EAT TOO MANY SWEETS,'
SHE ALWAYS TELLS HER PATIENTS
pen ink and watercolour
4 x 3 ½ inches

PAUL COX
Paul William Cox (born 1957)

For a biography of Paul Cox, please refer to *The Illustrators*, 1997, page 237.

Key work illustrated: Jerome K Jerome, *Three Men in a Boat* (1989)

Chris Beetles Ltd has mounted three exhibitions of the work of Paul Cox, in 1989, 1993 and 2001, the last in conjunction with the Molesworth Gallery, Dublin.

578

576

577

579

576

DOG ASLEEP ON BOAT HOOK
AND ROPE
signed with initials
watercolour with pen and ink
1 ¼ x 3 inches
Illustrated: Jerome K Jerome,
Three Men in a Boat, London:
Pavilion Books, 1989, page 102

577

SID SMITH WALKED SLOWLY,
PROUDLY, HAPPILY TOWARDS THE
WICKET
watercolour with pen and ink
5 ⅓ x 9 ¼ inches
Illustrated: Hugh de Selincourt,
The Cricket Match, London: Stanley
Paul, 1992. page 92

578

SHOULD WE CAMP OUT OR SLEEP
IN INNS?
signed, dated 89 and inscribed with
title below mount
watercolour with pen and ink
7 ½ x 10 ¼ inches
Illustrated: Jerome K Jerome,
Three Men in a Boat, London:
Pavilion Books, 1989, page 17

579

THE ANGELA RIPPON – STYLES
signed
watercolour with pen and ink
3 ¼ x 6 ½ inches
Drawn for but not illustrated in
Tim Heald, *Honourable Estates*,
London: Pavilion Books, 1992

Numbers 580-583 are all
illustrated in Tim Heald,
Honourable Estates, London:
Pavilion Books, 1992.

580
CRICKET AT STANSTED
inscribed with title below mount
watercolour with pen and ink
16 x 23 inches
Illustrated: pages 38 and 39

581
BEAULIEU
inscribed with title below mount
watercolour with pen and ink
2 ½ x 5 ½ inches
Illustrated: page 54

582
SANDRINGHAM
inscribed with title below mount
watercolour with pen and ink
12 ¼ x 9 inches
Illustrated: page 107

583
NORWICH UNION DRIVING TRIALS
— SANDRINGHAM HOUSE
watercolour with pen and ink
3 ¼ x 5 ¼ inches
Illustrated: page 106

584

585

586

584

LORD MAYOR'S DRIVER
signed
pen ink and watercolour
12 x 14 inches
Drawn for the Lord Mayor's series
of first day covers and stamps, for
the Post Office, 17 October 1989

Numbers 585-591 are all
illustrated in P G Wodehouse,
Thank You, Jeeves, London:
The Folio Society, 1996.

585

ENTERPRISE NEW YORK
monochrome watercolour
15 ½ x 10 ½ inches
Illustrated: *Thank You, Jeeves*,
frontispiece

586

YES BRINKLEY, I SHALL DINE OUT
monochrome watercolour
7 ½ x 9 inches
Illustrated: *Thank You, Jeeves*,
page 78

587

589

591

588

590

587

I FOUND A SMALL BOY IN THE FRONT
SEAT, PENSIVELY SQUEEZING THE BULB,
AND WAS ABOUT TO ADMINISTER ONE
ON THE SIDE OF THE HEAD WHEN I
RECOGNISED CHUFFY'S COUSIN,
SEABURY, AND STAYED THE HAND
monochrome watercolour
15 x 9 ½ inches
Illustrated: *Thank You, Jeeves*, page 38

588

CELEBRATIONS ON BOARD
monochrome watercolour
7 ¼ x 10 inches
Illustrated: *Thank You, Jeeves*,
title page

Numbers 589-591 were all drawn
for but not illustrated in P G
Wodehouse, the 'Jeeves' series,
London: Folio Society.

589

MEET FOR BREAKFAST
monochrome watercolour
3 x 4 ¼ inches

590

WHAT'S WRONG WITH IT?
monochrome watercolour
8 ½ x 8 ¼ inches

591

RESTING ON MASTER'S BOOK
monochrome watercolour
3 x 3 ½ inches

THEA KLIROS
Thea Kliros (born 1940)

Thea Kliros was born in New York City on 16 August 1940. She studied art and dance at Bennington College in Vermont, and then Fine Art at the Yale University School of Art and Design in New Haven Connecticut. She began her career as a painter, using mostly acrylics and oils and once worked on dioramas at the Natural History Museum in Washington DC. During the 1970s and 80s, she gained experience as a freelance illustrator, concentrating on fashion illustration, her work appearing in such magazines as *Woman's Wear Daily*, *Vogue*, *Seventeen* and *Good Housekeeping*.

However, over the past decade her focus has shifted from fashion to children's books. Between 1991 and 1999 she illustrated over twenty fairy stories and classics for Dover Publications and the 'Pixie Tricks' series for Scholastic Books. In 2000 she won Best of the Year from the Please Touch Children's Museum in Philadelphia for the Greenwillow Harper Collins publication *What Can you Do in The Rain?* Her recent books have included *Famous Bears and Friends*, *Three Little Pigs*, *Three Little Bears* and *Billy Goat Gruff* all for Harper Collins. *The Nutcracker*, *The Velveteen Rabbit* and *The Elves and the Shoemaker* are all due to appear in 2004. [EAF].

593

592

594

592
THE TOY CHEST FLEW OPEN. OUT CAME TOY SOLDIERS, PUPPETS, AND DOLLS. THE NUTCRACKER WAS THEIR LEADER. THE BATTLE BEGAN!
signed
watercolour with pencil
9 ½ x 17 ½ inches
Illustrated: E T A Hoffmann (adapted by Raina Moore), *The Nutcracker*, New York: Harper Collins, 2003, [unpaginated]

593
STAMP A TRAIL
signed
watercolour with pencil
8 x 15 inches
Illustrated: Anna Grossnickle Hines, *What can you do in the Snow?*, New York: Harper Collins, 1999, [unpaginated]

594
AND THEY LIVED HAPPILY EVER AFTER
signed
watercolour with pencil
8 ½ x 16 ½ inches
Illustrated: Raina Moore, *Three Little Pigs*, New York: Harper Collins, 1999, [unpaginated]

Numbers 595-598 are all illustrated in Raina Moore, *The Three Bears*, New York: Harper Collins, 2003, [unpaginated].

595

SOON AFTER THEY LEFT, A LITTLE GIRL CALLED GOLDILOCKS STUMBLED UPON THE BEAR'S HOUSE. SHE PEERED IN THE WINDOW AND CALLED, 'HELLO!' WHEN NO ONE ANSWERED, SHE DECIDED TO GO INSIDE
signed
watercolour with pencil
8 ¾ x 8 ¼ inches

596

ONCE UPON A TIME, IN A COZY COTTAGE DEEP IN THE FOREST, THERE LIVED A FAMILY OF BEARS — BIG, GRUFF PAPA BEAR; SOFT GENTLE MAMA BEAR; AND SWEET, LITTLE BABY BEAR
signed
watercolour with pencil
9 ¾ x 15 ¾ inches

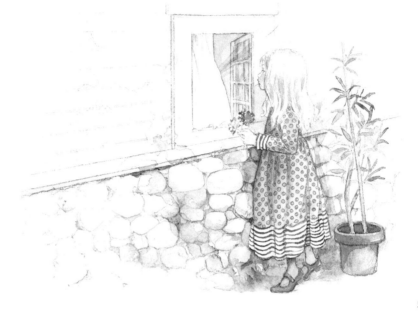

595

597

SOMEONE HAS BEEN EATING MY PORRIDGE!
signed
watercolour with pencil
9 ¾ x 15 ¾ inches

598

LETS TAKE A WALK IN THE FOREST WHILE THE PORRIDGE COOLS OFF
signed
watercolour with pencil
6 ½ x 8 ½ inches

599

ONE DAY MOTHER PIG SAID, 'YOU ARE ALL GROWN UP NOW. IT IS TIME FOR YOU TO GO OUT INTO THE WORLD AND BUILD YOUR OWN HOUSES. BUILD THEM STRONG AND YOU WILL BE SAFE FROM THE BIG BAD WOLF.'
signed below mount
watercolour with pencil
8 ½ x 8 inches
Illustrated: Raina Moore, *Three Little Pigs*, New York: Harper Collins, 1999, [unpaginated]

600

SHE WAS SURROUNDED BY AN ARMY OF HUGE MICE!
watercolour with pencil
8 ½ x 8 inches
Illustrated: E T A Hoffmann (adapted by Raina Moore), *The Nutcracker*, New York: Harper Collins, 2003, [unpaginated]

SARA MIDDA

Sara Midda (born 1950)

For a biography of Sara Midda, please refer to *The Illustrators*, 1993, pages 211-212.

Key work written and illustrated: *In and Out of the Garden* (1981)

601

PETER CROSS

Peter Cross (born 1951)

For a biography of Peter Cross, please refer to *The Illustrators*, 1997, page 277.

Key works written and illustrated: *1588 and all this...* (1988); *The Boys' Own Battle of Britain* (1990)

Best Friend

602

603

601

ITALIAN WHITE WINES

signed

watercolour; 5 ½ x 3 ¾ inches

Provenance: Simon Bond

602

BEST FRIEND

signed with initials

watercolour with pen and ink

4 x 3 ½ inches

603

FLOWERS FOR YOU

signed with initials

watercolour with pen and ink

2 x 2 inches

604 *(see frontispiece)*

THE ILLUSTRATORS 2003

signed with initials

watercolour with pen and ink

4 ½ x 3 ½ inches

605 *(see page 4)*

BIRDS OF PARADISE

THE HUGHIE BIRD

signed with initials

watercolour with pen and ink

5 ¼ x 3 inches

606 *(see page 4)*

WONDERS OF THE DEEP

NICK-NACK

signed with initials

watercolour with pen and ink

4 ¾ x 3 inches

607 *(see page 224)*

ENDANGERED SPECIES

GEOFFROY'S MARMOSET

signed with initials

watercolour with pen and ink

5 ¾ x 4 ¾ inches

CONTEMPORARY CARTOONISTS

EDWARD MCLACHLAN
Edward Rolland McLachlan (born 1940)

For a biography of Edward McLachlan, please refer to *The Illustrators*,
2002, page 110.

His work is represented in the collections of the University of Kent
Cartoon Centre.

608

609 610

609
WAIT — HE THAT IS WITHOUT SIN AMONGST YOU,
LET <u>HIM</u> CAST THE FIRST STONE
signed and inscribed with caption; pen and ink; 15 ½ x 11 inches
Illustrated: *McLachlan*, London: Methuen, 2001, page 172
Similar to the cartoon illustrated in the Cambridge University magazine,
Interface, in the late 1970s

611

608
I UNDERSTAND THE MARQUIS OF QUEENSBURY IS HERE TONIGHT
signed, inscribed with title and dated 2003
pen ink and watercolour
18 x 12 ¼ inches
Similar to *Punch*, May 1980, front cover

610
SUICIDE NOTE
signed
pen ink and watercolour
12 x 11 inches
Probably illustrated in the *Spectator*

611
I THOUGHT YOU SAID YOU'D
DONE THIS BEFORE
signed
pen and ink
9 ½ x 15 ¾ inches

FRANK DICKENS
Frank Huline Dickens (born 1931)

'Young Frank Dickens The Child Star' – as he is affectionately called by his friends – was born in Hornsey, North London, on 2 February 1931. Son of a painter and decorator, he left school at sixteen and worked as a buying clerk before becoming a racing cyclist (1946-70). After spending time in the National Service with Air-Sea Rescue, he went to Paris; there, as a self-taught artist, he made a living selling cycling cartoons to the French publications *Paris-Match* and *L'Equipe* (1959).

On his return to England in 1960, French Dickens began to contribute the cartoon strip 'Oddbod' to the *Sunday Times* and followed it up immediately with Bristow, his best-known strip, which has now been running in the *Evening Standard* for over forty years. Bristow records the ridiculous day-to-day life of a rebellious office clerk, eighteenth in line for the post of Chief Buyer of the Chester Perry Company. A household name, 'Bristow' not only appears on the web but is syndicated worldwide.

Frank Dickens has also written twelve episodes of Bristow for radio, six of which have been aired on BBC Radio Four (from 2001), starring actor Michael Williams as the voice of the man himself. He has even teamed up with composer Clement Ishmael (author and director of *The Lion King*) to turn Bristow into a West End musical.

Another strip, 'Albert Herbert Hawkins, The Naughtiest Boy in the World', has been running for twenty years in the *Daily Express* and

internationally (since 1967) and has been collected in five books. Dickens's latest cartoon, 'Patto' which chronicles the absurd capers of a hapless cat, has also proved successful on its appearances in the *Evening Standard* during the last eighteen months.

Over the years, Frank Dickens has published forty-two books including two thrillers, *A Curl Up and Die Day* (Peter Owen) and *Three Cheers for the Good Guys* (Macmillan).

His most recent offering comes in the form of *A Calmer Sutra*, a comic variation on the sex manual 'for those in the afternoon of their lives'. The reader is presented on the left–hand side with matter-of-fact statements referring to the sexual act (or 'Act of Congress'), juxtaposed on the right by coloured – and colourful – cartoons featuring Dickens' endearing rubicund characters – a trademark of his art – embroiled in all manner of hilarious dilemmas.

Frank Dickens 'hotly denies he is anywhere near pensionable age'. Retaining 'a twinkle in his eye and cunning in his brushstrokes', he remains one of Britain's favourite cartoonists. [HJM]

His work is represented in the collections of the University of Kent Cartoon Centre.

Numbers 612-616 are all illustrated in Frank Dickens, *A Calmer Sutra*, London: Time Warner Books, 2002, [unpaginated].

612

I SAID – YOU USED TO PLAY ON MY EMOTIONS AS THO' ON A LYRE..
signed
pen ink and watercolour
8 x 6 ½ inches

612

613

OF COURSE IT'S URGENT, YOU DAMN FOOL! IT'S COME TO A HALT HALFWAY UP THE STAIRS AND MY WIFE IS WAITING FOR ME IN THE BEDROOM...
signed
pen ink and watercolour
8 x 6 ½ inches

613

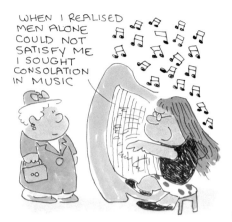

614

614

WHEN I REALISED MEN ALONE
COULD NOT SATISFY ME I
SOUGHT CONSOLATION IN MUSIC
signed
pen ink and watercolour
6 x 6 ¼ inches

615

616

615

FOR HEAVEN'S SAKE COME
TO BED...
signed
pen ink and watercolour
8 x 6 ½ inches

616

AFTER-SEX MINTS
signed
pen ink and watercolour
6 x 5 ½ inches

MIKE WILLIAMS
Michael Charles Williams (born 1940)

For a biography of Mike Williams, please refer to *The Illustrators*, 1999,
page 245.

His work is represented in the collections of the University of Kent
Cartoon Centre.

617

619

618

617

THE BATTERIES!! THE BATTERIES!!
signed; inscribed with title below mount
watercolour with pen and ink
12 x 8 inches

618

I'M THINKING OF HAVING MY
TOOTH CAPPED
signed
inscribed with title below mount
watercolour with pen and ink
12 x 8 inches

619

LOOK ON THE BRIGHT SIDE
CHUCK, AT LEAST YOU'VE
DISCOVERED THE CURE FOR
BALDNESS
signed
inscribed with title below mount
watercolour with pen and ink
8 x 11 ½ inches

PETER BROOKES

Peter Brookes (born 1943)

For a biography of Peter Brookes, please refer to *The Illustrators*, 1997, page 245.

Became political cartoonist of *The Times* in 1982
His work is represented in the collections of the Cartoon Art Trust.

Three exhibitions of Peter Brookes' famed 'Nature Notes', drawn for *The Times*, have been mounted with great success by Chris Beetles Ltd in 1997, 1999 and 2001.

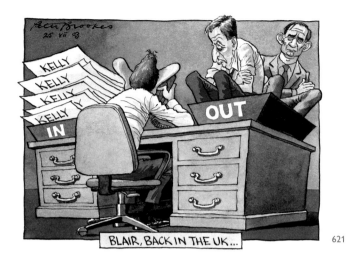

621

620

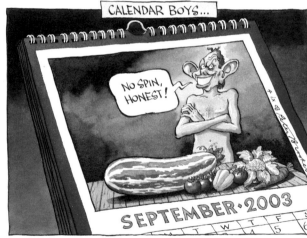

622

620

ENEMY OF THE DAY
signed and dated '17 vi 03'
pen ink and watercolour
8 ½ x 11 ¼ inches
Illustrated: *The Times*, 17 June 2003

621

BLAIR, BACK IN THE UK...
signed, inscribed with title and dated '25 vii 03'
pen ink and watercolour
8 ½ x 11 ¼ inches
Illustrated: *The Times*, 25 July 2003

622

CALENDAR BOYS...
signed, inscribed with title and dated '4 ix 03'
pen ink and watercolour
8 ¼ x 11 inches
Illustrated: *The Times*, 4 September 2003

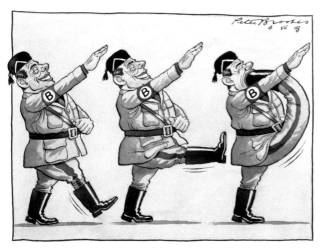

623

625

624

623

SILVIO BERLUSCONI

signed and dated '4 vii 03'

pen ink and watercolour

8 ½ x 11 ½ inches

Illustrated: *The Times*, 4 July 2003

624

SET ADRIFT

signed and dated '2 ix 03'

pen ink and watercolour

8 ½ x 11 ¼ inches

Illustrated: *The Times*,

2 September 2003

625

THE BENEFITS OF SARS

signed, inscribed with title and dated

'26 iv 03'

pen ink and watercolour

8 ¾ x 11 ¼ inches

Illustrated: *The Times*,

26 April 2003

GLEN BAXTER
Glen Baxter (born 1944)

For a biography of Glen Baxter, please refer to *The Illustrators*, 1997, page 263.

His work is represented in numerous public collections, including the Tate Gallery, and the Victoria and Albert Museum.

Chris Beetles Ltd has mounted two exhibitions of the work of Glen Baxter, launching the volumes *Blizzards of Tweed* (1999) and *Trundling Grunts* (2002).

Numbers 626-627 are both illustrated in Glen Baxter, *Blizzards of Tweed*, London: Bloomsbury, 1999 and exhibited in Glen Baxter, 'Blizzards of Tweed', October 1999.

TUESDAY EVENINGS WERE SET ASIDE FOR SEXUAL GRATIFICATION

627

NOT EVEN THE INTIMIDATING FIGURE OF MISS HOLLINGSWORTH, HEAD OF NEEDLEWORK, COULD STOP HER NOW

628

RUMOURS WERE ALREADY CIRCULATING THAT THE MATCH MIGHT HAVE BEEN FIXED

629

'NOW JUST SETTLE DOWN AND RELAX WHILE I TREAT YOU TO AN EVENING OF MY FAVOURITE LIMERICKS' BEAMED THOMAS

626

626
'NOW JUST SETTLE DOWN AND RELAX WHILE I TREAT YOU TO AN EVENING OF MY FAVOURITE LIMERICKS' BEAMED THOMAS
signed, inscribed with title and dated '96
pen ink and crayon
15 ½ x 10 ¼ inches
Illustrated: page 80
Exhibited: no 82

627
TUESDAY EVENINGS WERE SET ASIDE FOR SEXUAL GRATIFICATION
signed, inscribed with title and dated '97
pen ink and crayon
15 ½ x 10 ¼ inches
Illustrated: page 16
Exhibited: no 36

Numbers 628-630 and 632 are all illustrated in Glen Baxter, *Trundling Grunts*, London: Bloomsbury, 2002, and numbers 628-633 are all exhibited in 'Glen Baxter, *Trundling Grunts*', Chris Beetles Ltd, October 2002.

628

NOT EVEN THE INTIMIDATING FIGURE OF MISS HOLLINGSWORTH, HEAD OF NEEDLEWORK, COULD STOP HER NOW

signed, inscribed with title and dated 2002
pen ink and pastel
15 x 10 inches
Illustrated: page 89
Exhibited: no 87

629

RUMOURS WERE ALREADY CIRCULATING THAT THE MATCH MIGHT HAVE BEEN FIXED

signed, inscribed with title and dated 2001
pen ink and pastel
14 ¼ x 9 ¾ inches
Illustrated: page 73
Exhibited: no 71

630

ROGER RECOGNIZED GOOD DESIGN THE MOMENT HE SAW IT

signed, inscribed with title and dated 1999
pen ink and pastel
13 ½ x 7 ½ inches
Illustrated: page 6
Exhibited: no 4

631

'I THINK YOU'LL FIND THAT'S MY CAPUCCINO!' SNAPPED ERIC SOMEWHAT PETULANTLY

signed, inscribed with title and dated 1999
pen ink and pastel
13 ¼ x 9 ¼ inches
Exhibited: no 98

630

ROGER RECOGNIZED GOOD DESIGN THE MOMENT HE SAW IT

632

'HOLD ON TIGHT, FORBES. IT'S OUR ONLY CHANCE OF ESCAPE!' ROARED MᶜEWEN

631

'I THINK YOU'LL FIND THAT'S MY CAPUCCINO!' SNAPPED ERIC SOMEWHAT PETULANTLY

633

I SENSED IMMEDIATELY THAT I WAS IN THE PRESENCE OF A MAN UNUSED TO THE CONSTRAINTS OF RATIONAL DISCOURSE

632

'HOLD ON TIGHT FORBES. IT'S OUR ONLY CHANCE OF ESCAPE!' ROARED MCEWEN

signed, inscribed with title and dated 2002
pen ink and pastel; 13 ½ x 8 ½ inches
Illustrated: page 40
Exhibited: no 38

633

I SENSED IMMEDIATELY THAT I WAS IN THE PRESENCE OF A MAN UNUSED TO THE CONSTRAINTS OF RATIONAL DISCOURSE

signed, inscribed with title and dated 2000
pen ink and pastel; 12 ¾ x 8 ¾ inches
Exhibited: no 99

TONY HUSBAND
Tony Husband (born 1950)

Tony Husband was born in Blackpool on the 28 August 1950. A self-taught artist, he began a career as a freelance cartoonist in the mid 1970s after a succession of jobs including advertising and window dressing. His cartoons were published in the *Daily Mirror* and *Punch*, leading him to become a full-time cartoonist in 1984. Since then his work has continued to appear in *Punch* and also *Private Eye*, *The Times*, *The Oldie*, the *Sun*, *The Sunday Times*, *Playboy*, *Men Only*, *Readers Digest* and numerous publications in Germany. He won the title of Gag Cartoonist of the Year in both 1986 and 1987, and Strip Cartoonist the following year. In the meantime, he founded and co-edited *Oink!*, a children's comic, (from 1985-88) and, with the same team, co-wrote *Round the Bend*, a highly-acclaimed children's television programme which featured Spitting Image puppets. He also co-wrote and designed the play *Save the Human* with the playwright David Wood. He has published fifteen books in this country, such as *Use Your Head* (1984), *Animal Husbandry* (1986), *Yobs* (1988) and *Another Pair of Underpants* (1995), and ten in Germany, where he is a hugely successful cartoonist. He is also a best-selling greetings card artist with Hallmark and Carlton Cards. He is currently Gag Cartoonist of 2003 and continues to work with the poet Ian Macmillan on a touring live show of poetry and cartoons. He has become increasingly popular in The Illustrators exhibition at Chris Beetles Ltd, where the robust vulgarity of his gags throws a bleakly humorous light on the human condition. [EAF]

634

I SOMETIMES THINK WE SPOIL THAT DOG
signed and inscribed with title
pen and ink; 11 x 14 inches

SIMON DREW
Simon Brooksby Drew (born 1952)

For a biography of Simon Drew, please refer to *The Illustrators*, 1997, page 263.

Key work written and illustrated: *A Book of Bestial Nonsense* (1986)

chariots of fur 635

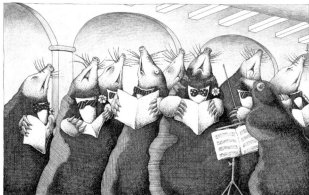

636

mole voice choir

635

CHARIOTS OF FUR
signed and inscribed with title
pen ink and coloured pencil
4 x 4 inches
Design for a greetings card

636

MOLE VOICE CHOIR
signed and inscribed with title
pen ink and coloured pencil
7 ¾ x 11 inches
Design for a greetings card

IN MEMORIAM: LARRY

LARRY
Terence Parkes, known as 'Larry' (1927-2003)

Larry was the cartoonist's cartoonist, highly respected by his peers for his consistently funny work, and cherished by them for his affability. In the autobiographical *Larry on Larry* (1994), he wrote 'I seem to have the reputation for being a beer-swigging Brummie cartoonist', and while each particular of that statement may have been true to the letter, its overall spirit suggests an essential modesty. He even expressed some reservations about the increasing seriousness with which cartooning was being taken, and yet was steeped in the history of his profession and, more widely, in the history of art. This combination of the easygoing and the erudite informed much of his work, in content and draughtsmanship, and he will long be remembered for both his frequent depiction of an Everyman figure, 'Larry's man', and his parodies of famous works of art.

Larry was born Terence Parkes in Birmingham on 19 November 1927, the son of a welding foreman in a motor-car factory. He began to reveal his artistic talents while at Handsworth Grammar School, and at only fifteen he passed the entrance exam to Birmingham School of Art. His studies were interrupted, however, by National Service in the Royal Artillery (1946-48). He remembered that time in *Larry on Larry*, as 'lumbering about in giant umpteen-tonner trucks, picking up fish-and-chips and beer from the town and ferrying them back to camp'. When he returned to art school he chose to specialise in book illustration. He was inspired in this by the example of Edward Ardizzone, and thought that his career might follow a similar path, comprising a combination of serious and light-hearted projects. However, from the publication of his first cartoons, in the *Birmingham Gazette* and the *Birmingham Sunday Mercury*, it was obvious that the lighthearted would win out.

On qualifying as an art teacher, Larry began work at Lincoln Road Secondary Modern School in Peterborough in 1951, teaching the sons of Perkins Diesel factory workers. It was they who gave him his nickname, after they saw the 1946 film *The Jolson Story*, which starred Larry Parks. Recalling the incident, Larry said, 'I've been Larry ever since. Besides, it's nice and short, so it saves time when it comes to signing your drawings'. He survived just three years as a teacher for, although he got on with his pupils, he found the environment restrictive, and his attempts to transform classroom into artist's studio were not encouraged.

After he resigned, Larry returned to Birmingham in 1954 to work in the Lucas Turbines factory as a progress-chaser, a job that gave him much time 'in the loo or behind packing cases' to hone his cartooning skills. In autumn 1956, he joined the staff of the *Daily Express*, and for three months shared an office with political cartoonist Michael Cummings and sports cartoonist Roy Ullyett. However, he had to leave when the Editor, returning from an operation, decided to sack all of the employees whom he himself had not hired. Nevertheless, Larry's drawings were appearing with sufficient regularity in such places as the *Daily Sketch* and *Punch* to make him think that he could succeed as a freelance. His contributions to newspapers and magazines were to be supplemented by commercial commissions from a wide variety of companies, including a high proportion of brewers. (He even claimed to have invented the slogan 'I'm only here for the beer' for Double Diamond.)

Always willing to take up a challenge, Larry would later produce cartoons and commentary for Granada TV's *Afternoon Edition* (1963-64); supplied material to television comedian Marty Feldman and two of the 'Carry On' films (1968-69); and, for a short time, painted scenery for Joan Littlewood's Theatre Royal, Stratford East (1973-74).

Larry made his name around 1960, with the creation of his Everyman figure, whom he likened to Bairnsfather's 'Old Bill', and who was initially known as 'Man in Apron'. The subject was suggested by Russell Brockbank, cartoonist and Art Editor of *Punch*, who thought that Larry could capitalise on the then novel idea of husbands contributing to the household chores. Big nosed and blank eyed, the 'Man' would put a masculine spin on the housework, by washing the dishes with a garden hose or draining potatoes by pummelling them with his fist. The resulting cartoons proved very popular, especially in the United States, where they appeared in volume form and were praised by Harpo Marx and Charles Schultz, among other eminent humorists. This success sealed Larry's relationship with Brockbank, whom he considered his mentor. It also affirmed the relaxed nature of his style, and encouraged him to adapt his 'Man' to a never-ending variety of circumstances. At different times, the character appeared in almost every newspaper and magazine, and can still be seen on packaging for W H Smith and Lakeland Plastics.

Larry absorbed a number of influences, which included not only graphic artists but such classic performers as Laurel and Hardy and Sid Field. Pondering the tradition in which he worked, he wrote: 'Perhaps the ones that have influenced me most have been the old *Punch* cartoonists,

particularly those who joined before the war. If I was asked to choose my all-time favourite cartoonist it would have to be Starke'. Though he tried out a number of strips in his early years, it soon became clear that his real skill was for the quick visual gag in a single wordless panel. As Alan Coren has written: 'His genius resides entirely in his extraordinary and astonishing visual breadth and penetration. With Chaplin and Keaton long gone, Larry is the only great silent comedian still in the business.'

This approach to cartooning proved the springboard for Larry's second major achievement: his comic reinterpretations of famous works of art, which frequently included figures by Rodin as an art historical equivalent to his 'Man'. Larry produced his first art cartoons in response to a commission from Tony Rushton, Art Director of *Private Eye*, and a budding publisher. The resulting volume, *Larry's Art Collection* (1977), was followed by a further collection, *Larry on Art* (1978), and opportunities to exhibit: in a retrospective at the Walker Art Gallery, Liverpool, and in a series of shows at Chris Beetles Ltd, beginning with 'Larry on Art' (1991). In the same year he received an honorary fellowship from Birmingham Polytechnic, an institution offering a postgraduate course in cartooning.

Chris Beetles revealed another of the artist's skills when he presented a number of unique coloured ceramics, which extended his drawings into three dimensions. If his sculptures emerged slowly, and as the result of great effort, they retained the spontaneity of his most swiftly executed drawings, and so appear at once substantial and alive.

Subsequent exhibitions at Chris Beetles Ltd further confirmed Larry's popularity and his fecundity as he responded to the Olympics (1992), football (1998 and 2001) and war (1995). However self-deprecating, he proved the life and soul of the private view parties, for which the Gallery would have to order in cans of Boddingtons, which he much preferred to the usual champagne; so the already relaxed atmosphere would, for a short time, seem like that of a saloon bar.

Larry responded to almost all of life's events, and was clear-sighted about every important rite of passage. In *Larry on Larry*, the artist said if *The Oldie* had interviewed him for its 'Death File' column, asking him about his ideal way to go, he would respond: 'Aged 99, flying to Disney World! It would be perfect: the plane would blow up so there wouldn't be any funeral arrangements and I would have been stopped from going somewhere I know I wouldn't have enjoyed!' Such a sense of humour remains at once timeless and timely, and Larry's cartoons will long remain in demand. He died in Stratford-upon-Avon on 25 June 2003.

With acknowledgements to *The Times*, and also to the *Guardian*, the *Independent* and Mark Bryant.

His work is represented in the collections of the British Museum, the Victoria and Albert Museum, Essex University and the University of Kent Cartoon Centre.

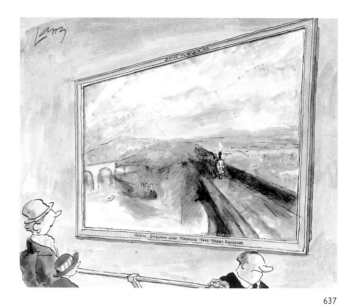

637

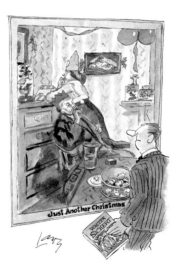

638

637
RAIN, STEAM AND THOMAS THE TANK ENGINE
signed
pen ink and watercolour
10 x 12 inches

638
JUST ANOTHER CHRISTMAS
WALTER SICKERT
signed
pen ink and watercolour
11 x 7 ½ inches

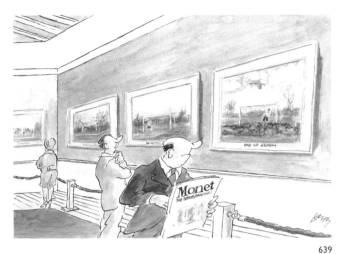

639

642

640

643

641

640
VAN GOGH
GAUGUIN'S
FOOTBALL BOOTS
signed
pen ink and watercolour
6 x 8 inches

639
MONET
THE SERIES PAINTINGS
signed
pen ink and watercolour
5 ½ x 8 inches

641
MONET
signed
pen and ink with watercolour
6 x 10 ½ inches

642
VINCENT AND PAUL
BY THE
POSTMAN ROULIN
signed
pen ink and watercolour
10 ¼ x 14 ¾ inches

643
THE CHURCH IN AUVERS
VINCENT VAN GOGH
signed
pen ink and watercolour
9 x 10 inches

IN MEMORIAM: LARRY

644

648

645

647

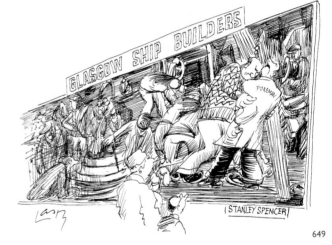

649

646

644

TOYS FOR THE BATH
signed
pen ink and watercolour
7 ½ x 10 ½ inches

645

RODIN'S DENTIST
signed
pen ink and monochrome watercolour
7 x 8 ¾ inches

646

FLORAL TEMPERATURE GAUGE
signed
pen and ink
5 x 6 inches

647

NEWYLN SCHOOL AHEAD
signed
pen and ink
5 ¾ x 8 inches

648

I'M ON THE WRONG TRAIN!
signed
pen ink and watercolour
5 ¾ x 8 ¾ inches

649

GLASGOW SHIP BUILDERS
signed
pen ink and monochrome watercolour
6 ½ x 8 inches

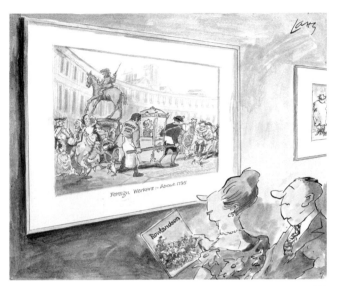

650

652

653

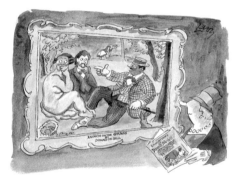

651

651
LUNCH ON THE GRASS
BY DONALD MCGILL
signed
pen ink and watercolour
6 ½ x 9 ¼ inches

654

650
FOREIGN WORKERS – ABOUT 1795
ROWLANDSON
signed
pen ink and watercolour
10 x 12 inches

652
THE ACUPUNCTURE LESSON
signed
pen ink and monochrome watercolour
8 x 8 inches

653
WINSTON CHURCHILL
signed
pen and ink
5 ¾ x 5 ½ inches

654
ROYAL ACADEMY ANNUAL DINNER
signed
pen ink and watercolour
10 x 12 inches

SELECT BIBLIOGRAPHY

Mark Bryant, *Dictionary of Twentieth-Century British Cartoonists and Caricaturists*, Aldershot: Ashgate Publishing, 2000

Mark Bryant and Simon Heneage, *Dictionary of British Cartoonists and Caricaturists 1730-1980*, Aldershot: Scolar Press, 1994

Susan P Casteras and Linda H Peterson, *A Struggle for Fame. Victorian Women Artists and Authors*, New Haven: Yale Center for British Art, 1994

John Christian (editor), *The Last Romantics: The Romantic Tradition in British Art*, London: Lund Humphries/Barbican Art Gallery, 1989

Alan Clark, *Dictionary of British Comic Artists, Writers and Editors*, London: The British Library, 1998

Thompson Cooper, *Men of the Time*, London: George Routledge and Sons, 1875

Dictionary of National Biography, Various publishers, from 1885

Margaret Drabble, *The Oxford Companion to English Literature*, Oxford University Press, 2000 (6th edition)

Penny Dunford, *A Biographical Dictionary of Women Artists in Europe and America since 1850*, Hemel Hempstead: Harvester Wheatsheaf, 1990

William Feaver, *Masters of Caricature. From Hogarth and Gillray to Scarfe and Levine*, London: Weidenfeld and Nicolson, 1981

Delia Gaze (editor), *Dictionary of Women Artists*, London: Fitzroy Dearborn publishers, 1997 (2 vols)

Richard Godfrey (introduction), *English Caricature, 1620 to the Present*, London: Victoria and Albert Museum, 1984

Hans Hammelmann and T S R Boase, *Book Illustrators in Eighteenth Century England*, New Haven: Yale University Press, 1975

Edward Hodnett, *Five Centuries of English Book Illustration*, Aldershot: Scolar Press, 1988

Alan Horne, *The Dictionary of 20th Century British Book Illustrators*, Woodbridge: Antique Collectors' Club, 1994

Simon Houfe, *The Dictionary of British Book Illustrators and Caricaturists 1800- 1914*, Woodbridge: Antique Collectors' Club, 1981; 1996 (revised editions)

David Kunzle, *The History of the Comic Strip. The Nineteenth Century*, Berkeley: University of California Press, 1990

John Lewis, *The 20th Century Book*, London: Herbert Press, 1967

David Low, *British Cartoonists, Caricaturists and Comic Artists*, London: William Collins, 1942

Edward Lucie-Smith, *The Art of Caricature*, London: Orbis Publishing, 1981

Huon Mallalieu, *The Dictionary of British Watercolour Artists up to 1920*, Woodbridge: Antique Collectors' Club, 1976 (2 vols)

Douglas Martin, *The Telling Line. Essays on fifteen contemporary book illustrators*, London: Julia MacRae Books, 1989

Ian Ousby, *The Cambridge Guide to Literature in English*, Cambridge University Press, 1993 (2nd edition)

Malcolm Pearce and Geoffrey Stewart, *British Political History 1867-1995. Democracy and Decline*, London: Routledge, 1992

Brigid Peppin and Lucy Mickelthwait, *The Dictionary of British Book Illustrators: The Twentieth Century*, London: John Murray, 1983

R G G Price, *A History of Punch*, London: Collins, 1957

Forrest Reid, *Illustrators of the Eighteen Sixties*, London: Faber & Gwyer, 1928

Dave Smith, *Disney A-Z. The Official Encyclopedia*, New York: Hyperion, 1996

M H Spielmann, *The History of 'Punch'*, London: Cassell and Company, 1895

Frank Thomas and Ollie Johnston, *Disney Animation. The Illusion of Life*, New York: Abbeville Press, 1981

Jane Turner (editor), *The Dictionary of Art*, London: Macmillan Publishers, 1996 (34 vols)

Joyce Irene Whalley and Tessa Rose Chester, *A History of Children's Book Illustration*, London: John Murray/Victoria and Albert Museum, 1988

Who Was Who 1897-1915, London: A & C Black, 1920

Christopher Wood, *The Dictionary of Victorian Painting*, Woodbridge: Antique Collectors' Club, 1995 (2 vols)

Geoffroy's Marmoset

606

CUMULATIVE INDEX OF CATALOGUES (1991-2003)

Dates in **bold** indicate entire chapters devoted to single illustrators

A

Abbey, Edwin Austin: 1997
Addams, Charles: 1991
Ahlberg, Janet: 1992
Aldin, Cecil: 1991, 1992, 1997, 1999
Allen, Daphne: 2003
Allingham, Helen: 1996, 1997
Anderson, Anne: 1991, 1996, 2001
Anton (Beryl Antonia Thompson and Harold Underwood Yeoman Thompson): 1991
Appleton, Honor: **1991**, 1992, 1993, 1997, 1999, 2002, 2003
Ardizzone, Edward: 1991, **1992**, **1993**, 1997, **1999**, 2001, **2002**, 2003
Atkinson, Maud Tyndal: 1997
Attwell, Mabel Lucie: 1991, 1992, 1993, 1996, 1997, 1999, **2000**, 2001, 2002, 2003
Austen, John: 1991, 1996
Ayrton, Michael: 1993, 1997

B

V A B: 1991
Badmin, Stanley Roy: 1993, 1997
Bailly, Louis: 2000
Bairnsfather, Bruce: 1992, 1999
Ball, Wilfrid: 1997
Banbery, Frederick: 1999, **2000**, 2002
Barker, Cicely Mary: 1991, 1992, 1993, 1999
Barrett, Angela: 1992, 1997, 1999
Bartlett, William: 1997
Barton, Rose: 1997
Bastien, A-T-J: 1992
Batchelor, Roland: 1993
Bateman, Henry Mayo: 1991, 1992, 1993, 1997, 1999, **2000**, 2001, **2003**
Batt (Oswald Barrett): 1997
Bauerle, Amelia: 1991
Baumer, Lewis: 1991, 1999
Bawden, Edward: 1993, 1997
Baxter, Doreen: 1992, 1997
Baxter, Glen: 1997, 2003
Baxter, William Giles: 1993, 1996, 1999, 2003

Beadle, James: 1997
Beardsley, Aubrey: 1999, **2000**
Beardsley, Aubrey, Follower of: 1999
Bedford, Francis Donkin: 1997
Beek, Harmsen van der: 1999
Beerbohm, Max: 1992, 1993, 1997, 1999, **2000**, 2002
Begg, Samuel: 1992
Belcher, George: 1991, 1992, 1993, 1996, 1997, 1999, 2002, 2003
Bell, Robert Anning: 1993, 1996, 1999, 2003
Bentley, Nicholas: 1991
Bernard, C E B: 1999, 2002
Bestall, Alfred: 1993, 1999
Biro, Val: 2002
Blackmore, Katie: 1997
Blair, Preston: 1993, 1999
Blake, Quentin: 1991, 1992, 1997, 1999, 2001, 2003
Blampied, Edmund: 1992, 1993
Blathwayt, Ben: 1992, **2000**
Bliss, Douglas Percy: 1993, 1997
Bond, Simon: 1993, 1997, 2001
Bone, Muirhead: 1992
Boswell, James: 1997
Boucher, William Henry: 1993
Bowman, Peter: 1992
Boyd, Tracey: 1992, 1993
Bradshaw, Percy: 1992
Brangwyn, Frank: 1992, **1999**
Brickdale, Eleanor Fortescue: 1991
Brierley, Louise: 1997
Briggs, Raymond: 1993, 2003
Brock, Charles Edmund: **1992**, **1993**, 1997, 1999
Brock, Henry Matthew: 1991, **1992**, **1993**, 1996, 1999
Brockbank, Russell: **2002**, 2003
Brookes, Peter: 1993, 1997, 1999, 2003
Browne, Gordon: 2003
Browne, Tom: 1991, 1992, 1997, 1999
Bryan, Alfred: 1993, 1999, 2003
Bull, René: 1991, 1992, 1997
Bunbury, Henry William: 1993
Burke, Chris: 1993
Burningham, John: 1993, 2002, 2003
Butterworth, Nick: 2002, 2003

C

Caldecott, Randolph: 1991, 1992, 1996, 1999, 2003

Cameron, John: 1992
Cameron, Katherine: 1993, 1997
Canziani, Estella: 1993, 1996, 1999
Caran d'Ache (Emmanuel Poiré): 1992, 1993, 1999
Carse, A Duncan: 1992, 2001
Cartlidge, Michelle: 2003
Casson, Hugh: 1991, 1992, **2002**, 2003
Chalon, Alfred Edward: 1993
Cham (Amedée Charles Henri de Noé): 1991
Chapman, Charles Henry: 1999, 2002
Chesterton, Gilbert Keith: 1991, 1993
Churcher, Walter: 1992
Clark, Emma Chichester: 1999
Clarke, Harry: 1991, 1996
Claxton, Adelaide: 2003
Cleaver, Reginald: 1991
Cloke, Rene: 1996, 1999
Cole, Richard: 1992, 1993
Collier, Emily E: 1996
Collins, Clive: 1993
Conder, Charles, Follower of: 1993, 1999
Courbold, Edward Henry: 2003
Courbold, Richard: 2003
Cowham, Hilda: 1993, 1999
Cox, Paul: 1993, 1997, 2003
Crane, Walter: 1996, 1997, 1999, 2002
Cross, Peter: 1991, 1992, 1993, 1996, 1997, 2001, 2002, 2003
Crowquill, Alfred: 1993, 2003
Cruikshank, George: 1991, 1996, 1999
Cruikshank jnr, George: 1997, 1999
Cruikshank, Isaac: 1991, 1993, 1996, 1999, 2003
Cruikshank, Robert: 1993
Cubie, Alex: 1993
Cummings, Michael: 1992, 1997, 1999
Cushing, Howard Gardiner: 1999

D

Dadd, Philip: 1997
Dadd, Richard: 1997
Daley, Mike: 1992
Davidson, Victoria: **2003**
Davis, Jon: 1991, 1992, 1993
Dawson, Eric: 1993
de Grineau, Bryan: 1992
de La Bere, Stephen Baghot: 1991, 1992, 1997, 2001
Dennis, Ada: 1996

Dickens, Frank: 1993, 1997, 1999, 2003
Disney, Walt (and the Disney Studio): 1991, 1993, 1999, 2000, 2002, 2003
Dixon, Charles: 1992
Doré, Gustave: 1997, 1999
Douglas (Thomas Douglas England): 1992, 1993
Doyle, Charles Altamont: 1991, 1992, 1997, 1999, 2002, 2003
Doyle, Richard: 1991, 1993, 1996, 1997, 1999, 2002
Draner, Jules-Renard: 1993
Drew, Simon: 1991, 1992, 1993, 1997, 1999, 2001, 2002, 2003
du Cane, Ella: 1997
Dulac, Edmund: 1991, 1993, 1996, 1997, 2001, **2003**
du Maurier, George: 1991, 1992, **1996**, 1997, 1999, 2003
Duncan, John: 1991
Duncan, Walter: 1996
Dyson, Will: 1993, 1997, 1999

E

Earnshaw, Harold: 1996
East, Alfred: 1997
Edwards, Lionel: 1992
Egan, Beresford: 1997
Elgood, George Samuel: 1997
Elliott, James: 1997, 1999
Emett, Rowland: 1991, 1992, 1993, 1996, 1997, 1999, 2000, 2001, 2003
Emmwood (John Musgrave-Wood): 1991, 1993, 1997, 2002

F

Ferguson, Norman: 1993, 1999, 2003
ffolkes, Michael: 1991, 1993, 1997, 1999
Fitzgerald, John Anster: 1991, 1997, 1999
Flanders, Dennis: 1992
Flather, Lisa: 1991
Fletcher, Geoffrey Scowcroft: 1993
Flint, Francis Russell: 1992
Flint, William Russell: 1993
Folkard, Charles: 1991, 1992, 1997, 2003
Ford, Henry Justice: 2002, 2003
Ford, Noel: 1993
Foreman, Michael: 1991, 1992, 1993, 1997, 1999, 2001, 2003

104